ARTISAN | NEW YORK

signs of resistance

a visual history of protest in america

bonnie siegler

Library of Congress Cataloging-in-Publication Data is on file.
978-1-57965-866-3

Design by Bonnie Siegler, Eight and a Half
8point5.com
Research assistant: Lucy Andersen

Published by Artisan
A division of Workman Publishing Co., Inc.
225 Varick Street
New York, NY 10014-4381
artisanbooks.com

Artisan is a registered trademark of Workman Publishing Co., Inc.

Published simultaneously in
Canada by Thomas Allen & Son, Limited

Printed in the United States
First printing, January 2018

1 3 5 7 9 10 8 6 4 2

It is the responsibility
of the patriot
to protect his country
from its government.

THOMAS PAINE

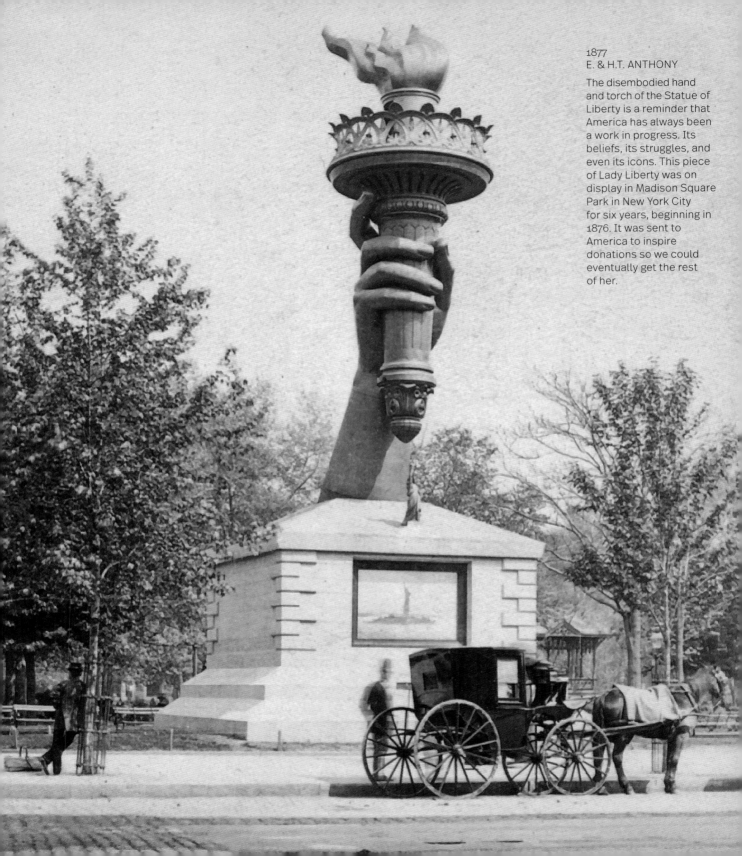

1877
E. & H.T. ANTHONY

The disembodied hand and torch of the Statue of Liberty is a reminder that America has always been a work in progress. Its beliefs, its struggles, and even its icons. This piece of Lady Liberty was on display in Madison Square Park in New York City for six years, beginning in 1876. It was sent to America to inspire donations so we could eventually get the rest of her.

WATCHING

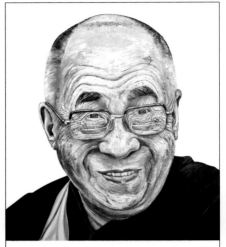

WAITING

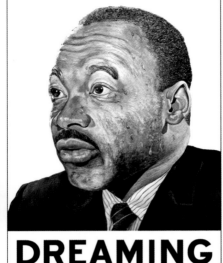

DREAMING

Introduction

2003
ROBBIE CONAL

Conal has made more than 100 street posters, many satirizing politicians and bureaucrats, but this one was created to honor his personal idols: Gandhi, the Dalai Lama, and Martin Luther King Jr.

Six months after Donald J. Trump was sworn in as forty-fifth president of the United States, I got a call from a conference planner, inviting me to speak at a big creativity conference in Las Vegas. She asked me to talk about the future of design.

I am a graphic designer and have owned my studio for twenty-five years, but I had no idea what the future of design held. Thanks to the election of a president who seemed to be systematically dismantling American democracy as we knew it, I had no idea what the future of anything held. She asked me what I would like to talk about, and I immediately replied, "All I can think about is the resistance."

In the months leading up to the 2016 election, I worked to spread the word about the dangers of a Trump presidency, fund-raising and creating media for Hillary Clinton and other Democratic candidates. It didn't work, and along with a majority of Americans, I was angry.

On the day after Trump's inauguration, I joined 400,000 protesters at the Women's March in Washington, DC. It was inspiring and empowering, but I was still angry.

I was also scared. For as long as I can remember, my grandfather told me about his escape from Nazi Germany, the day before Kristallnacht, with my grandmother and my mother, who was two years old. Most of his family remained in Berlin, convinced that Hitler's hate speech was simply rhetoric. They perished in the Holocaust.

Growing up under the weight of this history, it was impossible not to ask myself, What would I do in a similar circumstance? Would I have been able to see Hitler for who he really was? And more important: Would I be able to act on my convictions? Or would I stand by and watch as one group of people was isolated and identified as the root of all evil?

It's hard not to draw parallels with Trump's America today, and I have a difficult time believing that his fearmongering and racist, inflammatory words are just rhetoric. When the conference planner called me, I had already been researching what Americans had done in the past when they were angry, and in the process, uncovered protest art that was so compelling, so inspiring, it stirred something in me decades, even centuries, later. So I proposed a presentation on the design of resistance in America.

The resulting 140-image presentation led to impassioned debate in the audience, and when it was over, conference attendees kept approaching me, requesting copies. "I have to show this to my husband, my kids, my colleagues," they told me, picking up on the urgency and passion of the protesters throughout history, and no doubt inspired by our country's resilience when faced with seemingly insurmountable challenges. I was inspired, too, and decided to turn my presentation into what you're holding now.

This book is a collection of visual expressions of resistance throughout American history. They include broadsides, postcards, posters, greeting cards, sculptures, paintings, ads, book covers, magazine covers, handmade signs, projections, and the back sides of scrap paper. They were created by artists, designers, and everyday men, women, and children (!) who might not have had a lot of creative background but certainly had a lot to say. (In fact, as you'll see often in these pages, sometimes the cruder the art, the more powerful the response.) People used the weapons they had at their disposal: paper and pen. Their only "client" was their conscience. Every protest image was made because someone felt compelled to act out of a belief in what they felt was right.

Hopefully we can learn from these past movements, and apply those lessons to our resistance today. While I was compiling this book, I went back and forth between rage and hope—rage because, to quote a favorite sign at the Women's March, "I can't believe we are still protesting this shit." And hope because looking at these images reminded me that there have been other dark, shameful chapters in American history, and yet somehow democracy survived. Because we did what we do best: We kept fighting.

CHAPTER 1
The Early Years
America First

The spirit of resistance
to government is so valuable
on certain occasions, that I
wish it to be always kept alive.

THOMAS JEFFERSON

For Americans in the revolutionary era, the art of dissent was dictated by the technology available. With limited development of design tools, it was all about the words themselves, rather than persuasion through style.

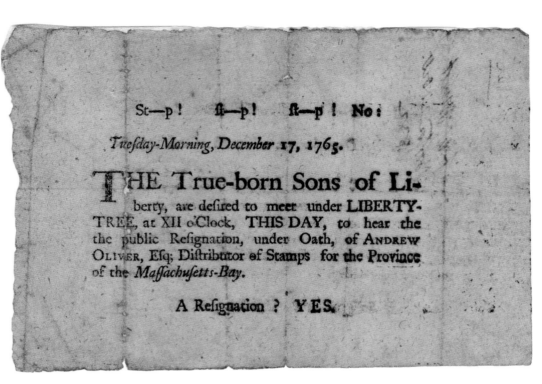

(TOP)
1765

The Sons of Liberty was a group formed in response to the Stamp Act, a law of Parliament that taxed all official documents and marked the beginning of the end of America's relationship with England. The Sons placed these small (approximately 5-by-7¼-inch) notices all over Boston to announce their first act of protest: a meeting to call for the public resignation of Andrew Oliver, the American official in charge of enforcing the Stamp Act. It worked. Oliver watched as the colonists hoisted his effigy, then resigned in front of all assembled.

(BOTTOM, LEFT)
1829

An engraving memorializing this history-altering act of resistance.

(BOTTOM, RIGHT)
1765

Protests come in all sizes: This parody stamp was created to mock the Stamp Act; the skull and bones symbolized the death of the free press.

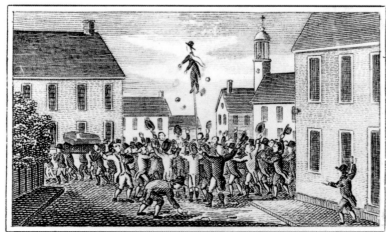

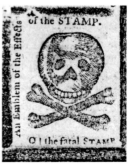

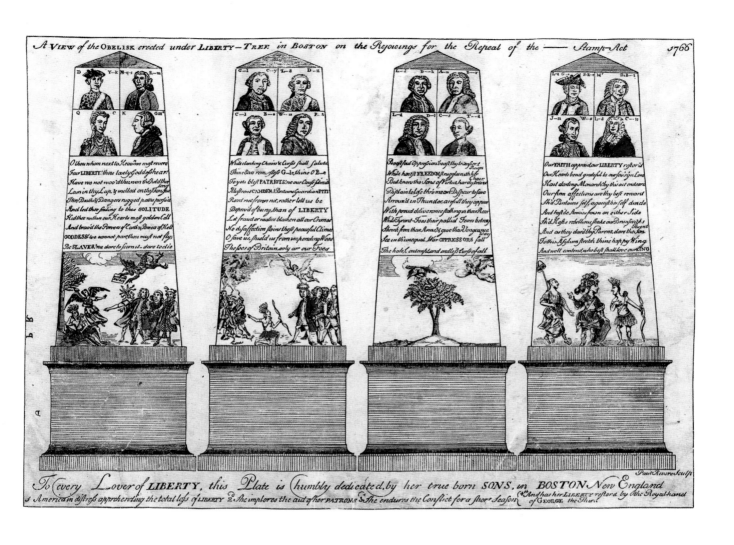

A View of the Obelisk erected under LIBERTY-TREE in BOSTON on the Rejoicings for the Repeal of the ——— Stamp-Act 1766

To every Lover of LIBERTY, this Plate is humbly dedicated, by her true born SONS, in BOSTON New England

1 America in distress apprehending the total loss of LIBERTY 2 She implores the aid of her PATRONS 3 She endures the Conflict for a short Season 4 And has her LIBERTY restored by the Royal hand of GEORGE the Third.

1766
PAUL REVERE

Revere, a silversmith by trade, was so thrilled by the success of the Stamp Act resistance, he celebrated by designing an obelisk to honor all the players involved.

3

Two approaches, same basic message: Behave!

BY THE

KING,

A

PROCLAMATION,

For Suppreffing Rebellion and Sedition.

GEORGE *R.*

HEREAS many of Our Subjects in divers Parts of Our Colonies and Plantations in *North America*, mifled by dangerous and ill-defigning Men, and forgetting the Allegiance which they owe to the Power that has protected and fuftained them, after various diforderly Acts committed in Difturbance of the Public Peace, to the Obftruction of lawful Commerce, and to the Oppreffion of Our loyal Subjects carrying on the fame, have at length proceeded to an open and avowed Rebellion, by arraying themfelves in hoftile Manner to withftand the Execution of the Law, and traitoroufly preparing, ordering, and levying War againft Us.

AND whereas there is Reafon to apprehend that fuch Rebellion hath been much promoted and encouraged by the traitorous Correfpondence, Counfels, and Comfort of divers wicked and defperate Perfons within this Realm : To the End therefore, that none of Our Subjects may neglect or violate their Duty through Ignorance thereof, or through any Doubt of the Protection which the Law will afford to their Loyalty and Zeal; We have thought fit, by and with the Advice of Our Privy Council, to iffue this Our Royal Proclamation, hereby declaring that not only all Our Officers, Civil and Military, are obliged to exert their utmoft Endeavours

1775
KING GEORGE III

The king issued this proclamation telling the colonists they were subject to severe penalty should they protest, "forgetting the allegiance which they owe to the power that has protected and sustained them." Naturally, the document achieved the exact opposite of its desired effect, transforming otherwise loyal subjects into angry, traitorous rebels.

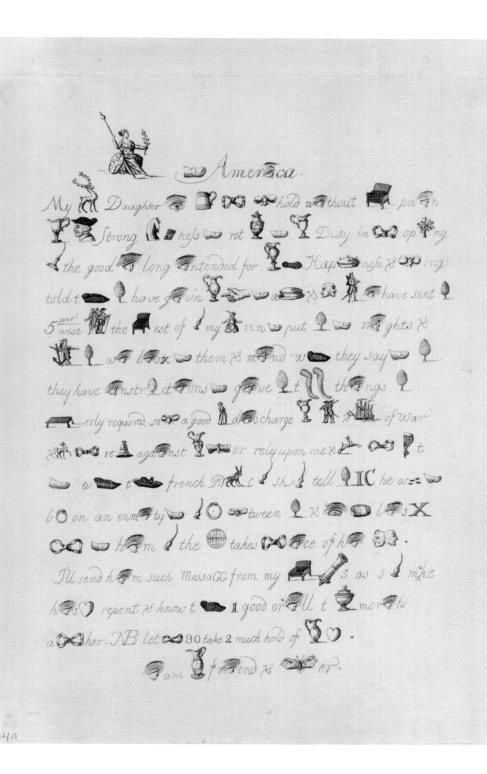

1778
MARY DARLY

If the king's proclamation was the official corporate position, this was the human version, written in rebus form from a mother (England) to a daughter (the colonies), pleading with her to break up with the French and stop rebelling. It was essentially England's last-ditch attempt to end the war and beg her "child" to come home again. To get you started: (Toe) Amer (eye) ca is To America.

Using as few words as possible paired with a graphic representation made the point emotionally resonant.

1754
BENJAMIN FRANKLIN

One of the earliest known American political cartoons, here shown in the *Pennsylvania Gazette*, this was designed to encourage the disparate colonies to unite during the French and Indian War, before being recycled for use during the Revolution. Franklin intuitively understood the principle of designing for impact and persuasion: Use as few words as possible and pair them with a graphic image. And that comma! It makes the tone of his command almost conversational. (Note: "N.E." represents the four colonies of New England, Delaware was likely omitted because it shared a governor with Pennsylvania, and Georgia was not included because the young colony could not yet contribute anything to common security.)

(OPPOSITE)
1775

This Continental army recruiting broadside appeared shortly after King George's proclamation and encouraged all able-bodied colonists to join General George Washington in the fight for independence. Here, the images are as important as the words. The appeal was all about wearing that uniform—that *American* uniform.

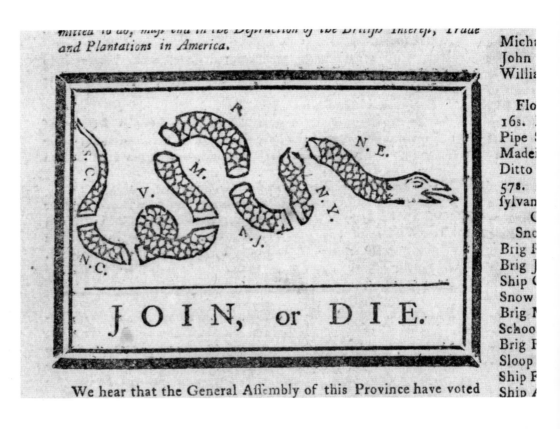

TO ALL BRAVE, HEALTHY, ABLE BODIED, AND WELL DISPOSED YOUNG MEN,
IN THIS NEIGHBOURHOOD, WHO HAVE ANY INCLINATION TO JOIN THE TROOPS,
NOW RAISING UNDER
GENERAL WASHINGTON,
FOR THE DEFENCE OF THE
LIBERTIES AND INDEPENDENCE
OF THE UNITED STATES,
Against the hostile designs of foreign enemies,

TAKE NOTICE,

THAT *tuesday, wednsday, thursday, friday and saturday at Spotswood in Middlesex* county, attendance will be given by *Lieutenant Recruiting* with his music and recruiting party *Battalion* of the 11th regiment of infantry, commanded by Lieutenant Colonel Aaron Ogden, for the purpose of receiving the enrollment of such youth of SPIRIT, as may be willing to enter into this HONOURABLE service.

The ENCOURAGEMENT at this time, to enlist, is truly liberal and generous, namely, a bounty of TWELVE dollars, an annual and fully sufficient supply of good and handsome cloathing, a daily allowance of a large and ample ration of provisions, together with SIXTY dollars a year in GOLD and SILVER money on account of pay, the whole of which the soldier may lay up for himself and friends, as all articles proper for his subsistance and comfort are provided by law, without any expence to him.

Those who may favour this recruiting party with their attendance as above, will have an opportunity of hearing and seeing in a more particular [...] the great advantages which these brave men will have, who shall embrace this opportunity of spending a few happy years in viewing the [...] of this beautiful continent, in the honourable and truly respectable character of a soldier, after which, he may, if he pleases return [...] with his pockets FULL of money and his head COVERED with laurels.

GOD SAVE THE UNITED STATES.

COMMON SENSE:

ADDRESSED TO THE

INHABITANTS

OF

A M E R I C A,

On the following interesting

S U B J E C T S.

I. Of the Origin and Design of Government in general,
with concise Remarks on the English Constitution.

II. Of Monarchy and Hereditary Succession.

III. Thoughts on the present State of American Affairs.

IV. Of the present Ability of America, with some miscellaneous
Reflections.

Written by an ENGLISHMAN.

Man knows no Master save creating HEAVEN,
Or those whom choice and common good ordain.
THOMSON.

PHILADELPHIA, Printed.
And Sold by R. BELL, in Third-Street, 1776.

1776
THOMAS PAINE

Common Sense was the first bestseller in American history. The pamphlet was published a few months after the king's proclamation, and its impassioned intellectual argument for independence pushed the formerly loyal subjects even further toward rebellion. Paine worked with what was available: typography. By changing letter spacing and type size, he transformed the text into an illustration unto itself.

RESS, JULY 4, 1776.

of the thirteen united States of Ame

ecessary for one people to dissolve the political bands which have connected them w
and of Nature's God entitle them, a decent respect to the opinions of mank
these truths to be self-evident, that *all men are created equal*, that they are en
ppiness.—— That to secure these rights, Governments are instituted among M
structive of these ends, it is the Right of the People to alter or to abolish it, a
rm, as to them shall seem most likely to effect their Safety and Happiness
auses; and accordingly all experience hath shewn, that mankind are more
med. But when a long train of abuses and usurpations, pursuing inva
throw off such Government, and to provide new Guards for their future se
m to alter their former Systems of Government. The history of the pre
ment of an absolute Tyranny over these States. To prove this, let Fac
sary for the public good.—— He has forbidden his Governors to p
ned; and when so suspended, he has utterly neglected to attend to them.
quish the right of Representation in the Legislature, a right inestimable to
ble, and distant from the depository of their Public Records, for the sole purp
opposing with manly firmness his invasions on the rights of the people.
incapable of Annihilation, have returned to the People at large for their
on.—— He has endeavoured to prevent the Population of these States;
hither, and raising the conditions of new Appropriations of Lands.
He has made Judges dependent on his Will alone, for the tenure of the
ther swarms of Officers to harrass our People, and eat out their substance.
jected to render the Military independent of and superior to the Civil Power
r laws; giving his Assent to their Acts of pretended Legislation:—— Fo
Murders which they should commit on the Inhabitants of these State

9

1776
THOMAS JEFFERSON

The first and most rebellious document of our country, the Declaration of Independence, includes the five most important words in the history of dissent: "All men are created equal." What's amazing here is how the country's most defining sentiment—one that would inspire and inform all the campaigns for equality in history, and certainly those included in this book—is seemingly buried in the middle of the third line, not called out in any way.

Immigrants
We Get the Job Done

Remember, remember always, that all of us, and you and I especially, are descended from immigrants and revolutionists.

FRANKLIN D. ROOSEVELT

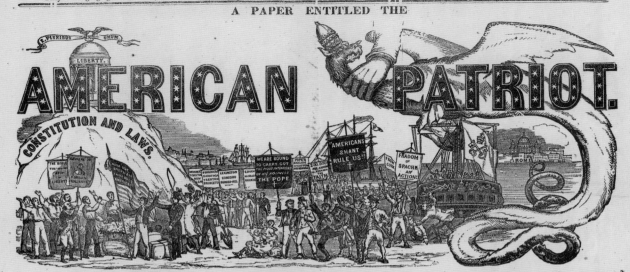

AMERICAN CITIZENS!

We appeal to you in all calmness. Is it not time to pause? Already the enemies of our dearest institutions, like the foreign spies in the Trojan horse of old, are within our gates. They are disgorging themselves upon us. at the rate of HUNDREDS OF THOUSANDS EVERY YEAR! They aim at nothing short of conquest and supremacy over us.

A PAPER ENTITLED THE

AMERICAN PATRIOT.

CONSTITUTION AND LAWS.

IN FAVOR OF

The protection of American Mechanics against Foreign Pauper Labor.

Foreigners having a residence in the country of 21 years before voting.

Our present Free School System.

Carrying out the laws of the State, as regards sending back Foreign Paupers and Criminals.

OPPOSED TO

Papal Aggression & Roman Catholicism.

Foreigners holding office.

Raising Foreign Military Companies in the United States.

Nunneries and the Jesuits.

To being taxed for the support of Foreign paupers millions of dollars yearly.

To secret Foreign Orders in the U. S.

We are burdened with enormous taxes by foreigners. We are corrupted in the morals of our youth. We are interfered with in our government. We are forced into collisions with other nations. We are tampered with in our religion. We are injured in our labor. We are assailed in our freedom of speech.

☞ The PATRIOT is Published by J. E. Farwell & Co., 32 Congress St., Boston,

And for Sale at the Periodical Depots in this place. Single copies 4 Cents.

1852

An advertisement promoting a Nativist newspaper shows a drawing that depicts "foreigners" as drunk and unkempt. In the illustration, Americans hold signs that say "Beware of Foreign Influence" and "None but Americans Shall Rule America."

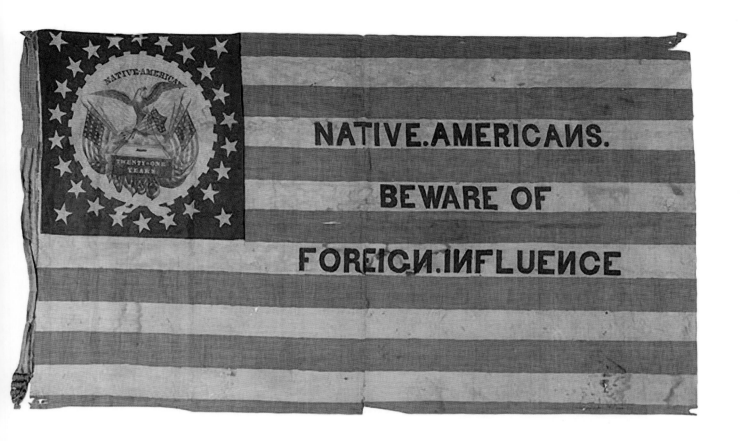

The flag depicts: NATIVE·AMERICAN / TWENTY·ONE YEARS / NATIVE.AMERICANS. BEWARE OF FOREIGN.INFLUENCE

There's nothing new about anti-immigrant sentiment; just decades after our country was born, offensive caricatures and stereotypes began appearing in national newspapers and political cartoons. Hardly any ethnic group was spared.

1853

In response to an influx of three million (mostly Catholic) immigrants, the Know-Nothing Party became a force in politics. (The party was named "Know Nothing" because if anyone asked about their activities, their response was supposed to be "I know nothing.") Similar to the Trump administration, they believed only those with proper qualifications were entitled to the full rights of Americans. Here, the group boldly emblazoned their fearmongering on a new version of the American flag, where, ironically, they referred to themselves as "Native Americans."

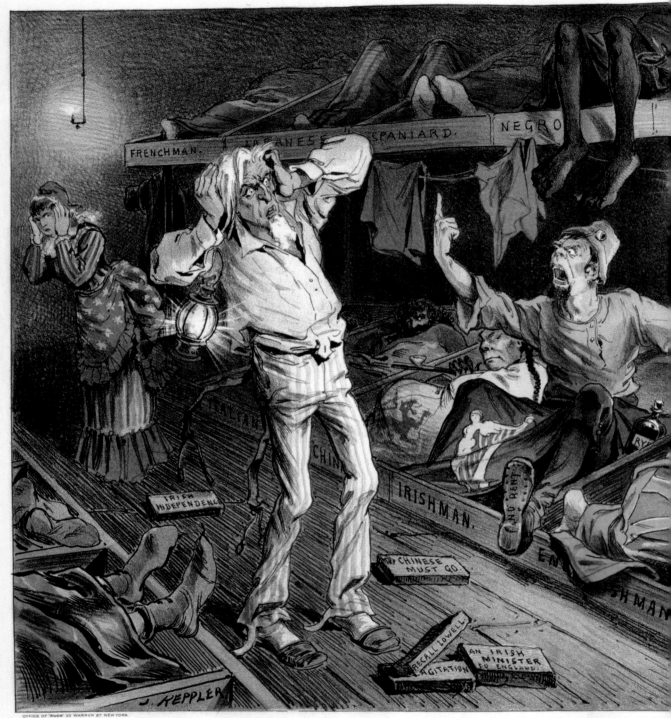

FRENCHMAN. JAPANESE SPANIARD. NEGRO

IRISH INDEPENDENCE

IRISHMAN.

NO RENT

CHINESE MUST GO.

RECALL LOWELL AGITATION

AN IRISH MINISTER TO ENGLAND.

J. KEPPLER

OFFICE OF "PUCK" 23 WARREN ST NEW YORK.

UNCLE SAM'S LODGING-H[O]

UNCLE SAM :—"Look here, you, everybody else is quiet and peaceable, and you'[r]

14

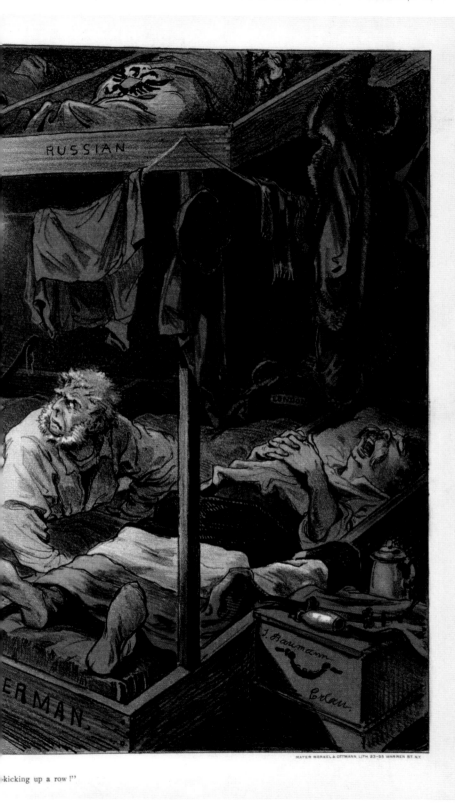

RUSSIAN

ERMAN

"kicking up a row!"

MAYER MERKEL & OTTMANN LITH 23-25 WARREN ST. N.Y.

A dark, frightening image of America: Uncle Sam is confused and Lady Liberty is scared.

1882
JOSEPH FERDINAND
KEPPLER

Cartoons were a staple of political discourse during this period, and often helped reinforce racial stereotypes and prejudices. The Irish, many of whom came to America during the Great Famine, were treated in an especially harsh manner. In this cartoon, Uncle Sam and Lady Liberty preside over a "lodging-house" (America) and though most of the boarders seem to be behaving, the whiskey-toting Irishman is throwing bricks and getting rowdy. Uncle Sam is clearly exasperated and Lady Liberty looks on in horror.

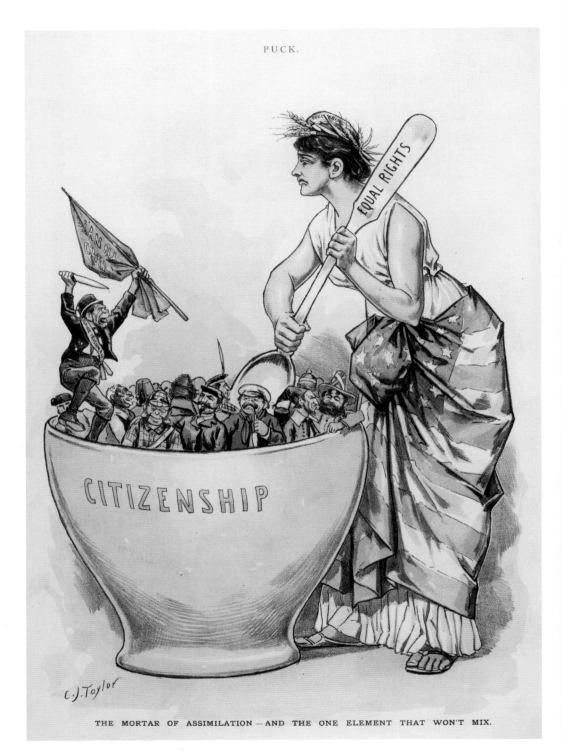

THE MORTAR OF ASSIMILATION — AND THE ONE ELEMENT THAT WON'T MIX.

1889
C.J. TAYLOR

Again, the Irish are targeted unfairly. In this melting pot (here, more of a soup bowl) the different ethnicities are mixing well together—all except for the Irish.

(OPPOSITE)
1919
BILLY IRELAND

Following World War I and the Russian Revolution, fear of Communists ran rampant. Americans began worrying about homegrown revolutionaries. Here, Uncle Sam is worried about those influences causing the melting pot to froth and boil over.

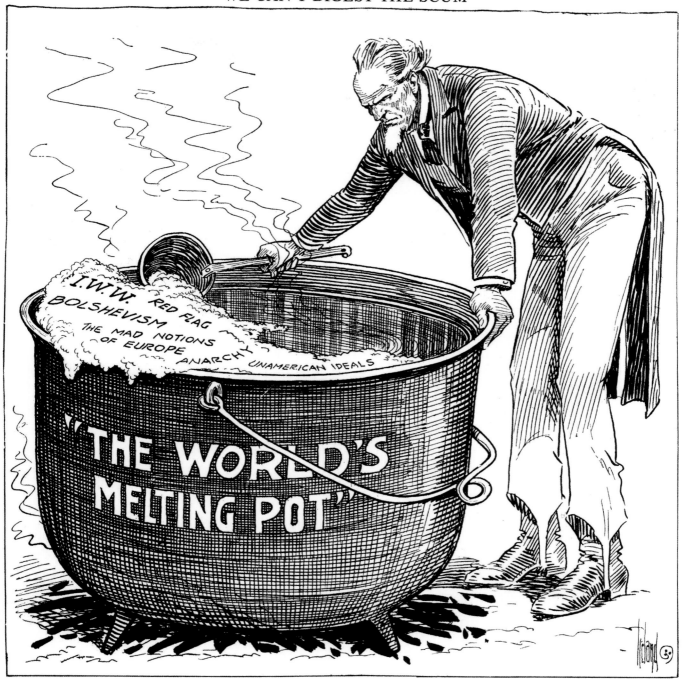

Limiting immigration began with the Chinese Exclusion Act 136 years ago.

1882

The Chinese Exclusion Act was passed in 1882, and was the first law restricting immigration in our country. Even Chinese immigrants who were already in America were required to get certifications to reenter if they left the country. This poster, which celebrated the passing of the act, is noticeable as much for its many different styles of wood type (nine by my count) as it is for its sad and shocking sentiment.

(OPPOSITE)
1882

The act was passed because the government believed Chinese laborers were taking jobs away from Americans. This cartoon points out how arbitrary and extreme it was, as communists, nihilists, and even "hoodlums" were deemed acceptable for entry, but the Chinese worker was not.

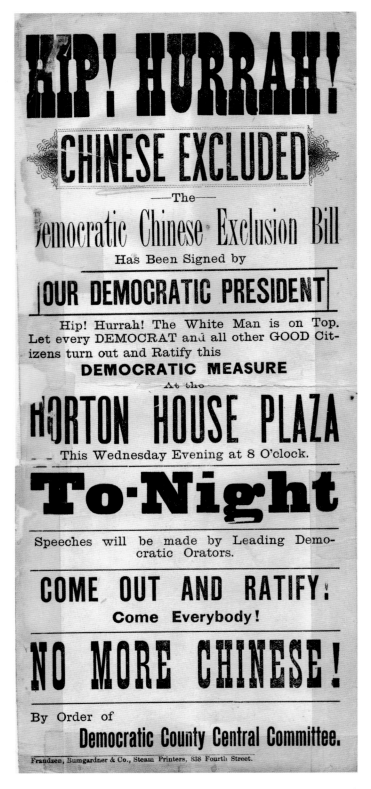

HIP! HURRAH!

CHINESE EXCLUDED

—The—
Democratic Chinese Exclusion Bill

Has Been Signed by

OUR DEMOCRATIC PRESIDENT

Hip! Hurrah! The White Man is on Top. Let every DEMOCRAT and all other GOOD Citizens turn out and Ratify this

DEMOCRATIC MEASURE

At the

HORTON HOUSE PLAZA

This Wednesday Evening at 8 O'clock.

To-Night

Speeches will be made by Leading Democratic Orators.

COME OUT AND RATIFY:
Come Everybody!

NO MORE CHINESE!

By Order of
Democratic County Central Committee.

Frandzen, Bumgardner & Co., Steam Printers, 838 Fourth Street.

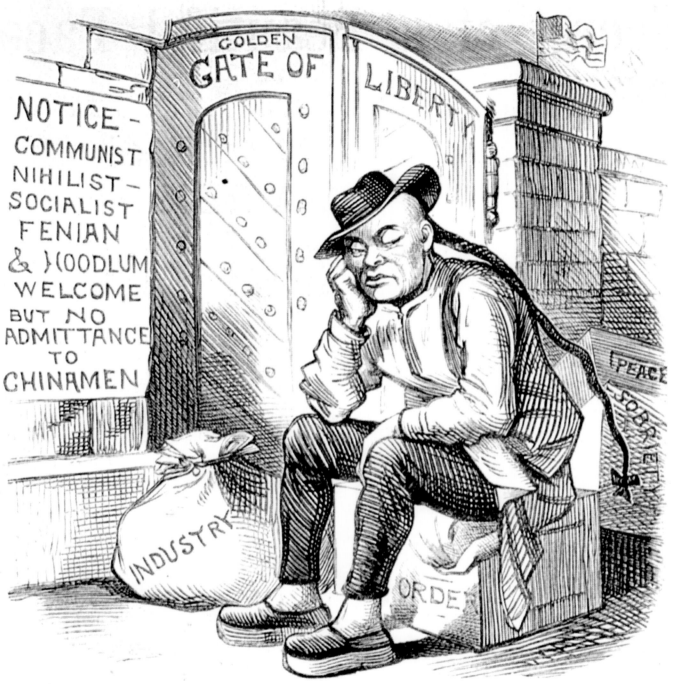

THE ONLY ONE BARRED OUT.

ENLIGHTENED AMERICAN STATESMAN.—"We must draw the line *somewhere*, you know."

The more things change,
the more they stay the same.

1916
RAYMOND O. EVANS

Even back then, people understood the absurdity and unjustness of issuing a literacy test for immigrants. This cartoon appeared in *Puck*, the first successful humor magazine of its day, and was drawn to protest the Immigration Act, which passed in 1917 anyway. The act required all immigrants to be able to read thirty to forty words.

(OPPOSITE)
1921
HALLHAN

The Immigration Act restricted immigration, as opposed to regulating it, and it essentially remained the law of the land until 1952. This cartoon shows a funnel bridging the Atlantic Ocean with European emigrants crowding into the top, as Uncle Sam selects just a few to trickle through.

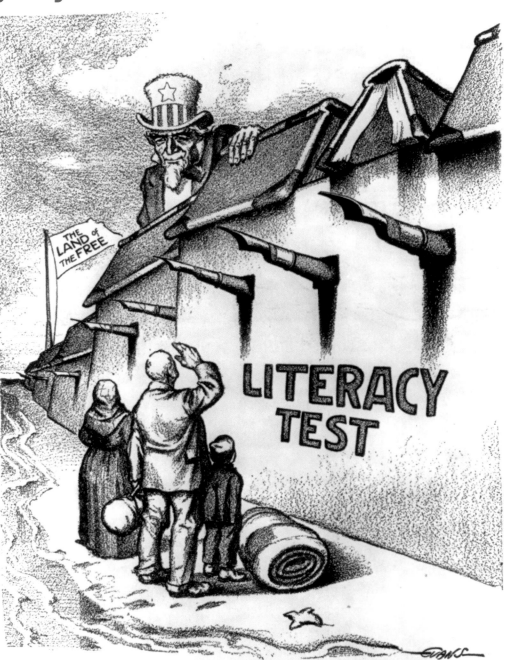

THE AMERICANESE WALL, AS CONGRESSMAN BURNETT WOULD BUILD IT.

UNCLE SAM: You're welcome in — if you can climb it!

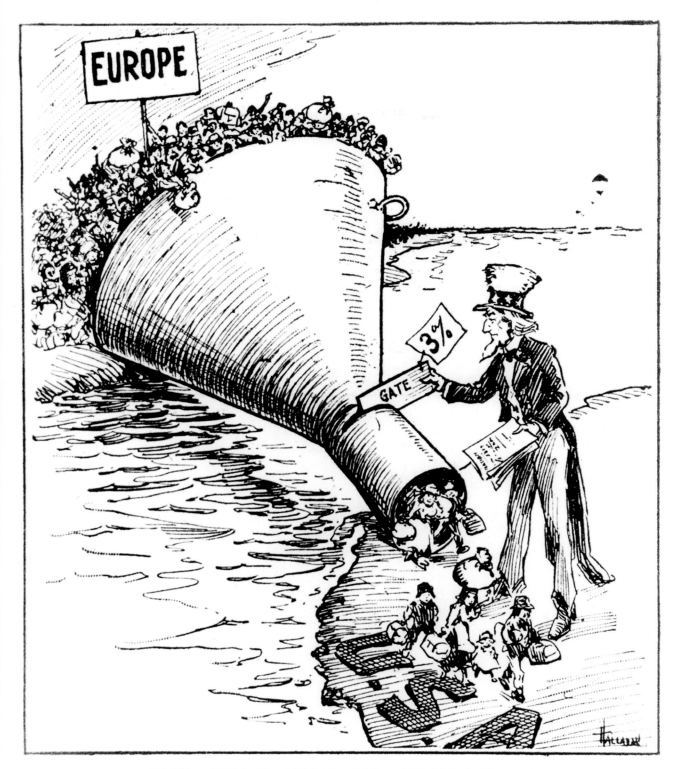

THE ONLY WAY TO HANDLE IT.

21

CHAPTER 3
Suffrage
And Yet She Persisted

It is downright mockery to talk to women of their enjoyment of the blessings of liberty while they are denied the use of the only means of securing them provided by this democratic-republican government: the ballot.

SUSAN B. ANTHONY

The suffragists liked to spell out absolutely every detail of their argument, in beautifully lettered signs, to ensure that they made their case.

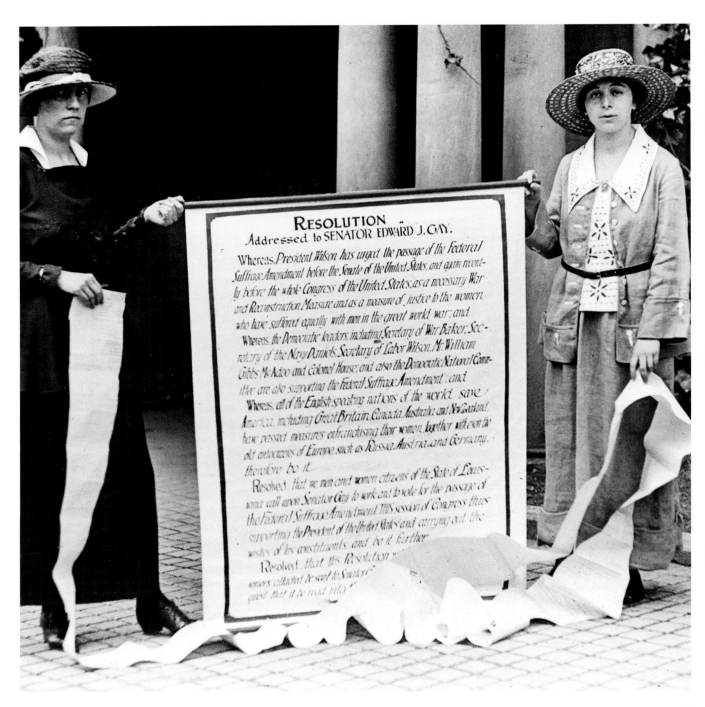

The resolution on the sign reads:

RESOLUTION

Addressed to SENATOR EDWARD J. GAY.

Whereas, President Wilson has urged the passage of the Federal Suffrage Amendment before the Senate of the United States, and again recently before the whole Congress of the United States, as a necessary War and Reconstruction Measure, and as a measure of Justice to the women who have suffered equally with men in the great world war; and

Whereas, the Democratic leaders including Secretary of War Baker, Secretary of the Navy Daniels, Secretary of Labor Wilson, Mr. William Gibbs McAdoo and Colonel House, and also the Democratic National Committee are also supporting the Federal Suffrage Amendment; and

Whereas, all of the English-speaking nations of the world save America, including Great Britain, Canada, Australia and New Zealand, have passed measures enfranchising their women, together with even the old autocracies of Europe such as Russia, Austria and Germany, therefore be it

Resolved, that we men and women citizens of the State of Louisiana call upon Senator Gay to work and to vote for the passage of the Federal Suffrage Amendment THIS session of Congress, thus supporting the President of the United States and carrying out the wishes of his constituents, and be it further

Resolved, that this Resolution [...]

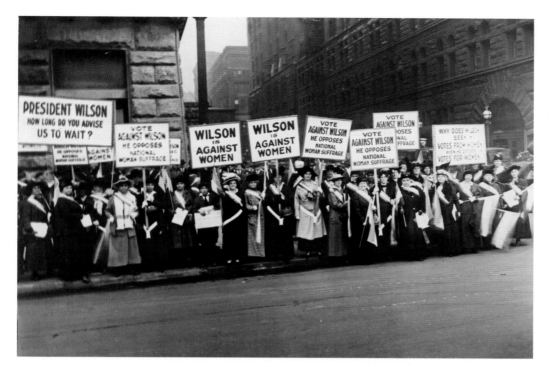

(OPPOSITE)
1919
HARRIS & EWING

Suffragists tried to convince the senator from Louisiana that it was time for him to support a woman's right to vote. Here, they outlined in full detail how the president and many other legislators already did. The very long roll of paper appears to be a petition.

(TOP)
1916
BURKE & ATWELL

Women march in Chicago to protest the reelection of President Wilson and his opposition to suffrage. Wilson eventually changed his stance and endorsed the movement. Suffragists were always identifiable thanks to their signature sashes. Their presentation was part of their protest—it was important for them to look unified if they were to be taken seriously.

(BOTTOM)
1920
INTERNATIONAL FILM SERVICE CO., INC.

Party members came from around the country to picket the Republican Convention in Chicago and share their anger through beautiful calligraphic signs.

Suffragists also used straightforward headlines, bold type, and minimal graphics to make their point as clear as possible.

(TOP)
1910

Published as a supplement to *Votes for Women* magazine, this quote came from a letter Abraham Lincoln wrote to the Illinois General Assembly while running for reelection in 1836.

(BOTTOM)
1917

Don't dodge the question, New York! What was taking you so long? The six states listed here, plus five others—none of them original colonies—all gave women the vote before New York did.

(OPPOSITE, TOP)
1913

As suffrage swept the nation, state by state, there was no more effective way to show its momentum than by charting it on an official map. The best part about this? "Imitation is the sincerest flattery!," a humorous, human spin on the trend.

(OPPOSITE, BOTTOM)
1914

Again, nothing quite so effective as the facts, presented clearly. It's also interesting to see how much more progressive Western states were compared to Eastern states.

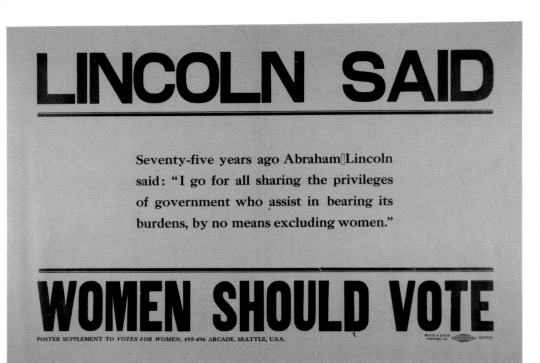

LINCOLN SAID

Seventy-five years ago Abraham Lincoln said: "I go for all sharing the privileges of government who assist in bearing its burdens, by no means excluding women."

WOMEN SHOULD VOTE

POSTER SUPPLEMENT TO *VOTES FOR WOMEN*, 495-496 ARCADE, SEATTLE, U.S.A.

WOMEN VOTE

IN WYOMING, IDAHO, COLORADO, UTAH, WASHINGTON AND CALIFORNIA

WHY NOT IN NEW YORK?

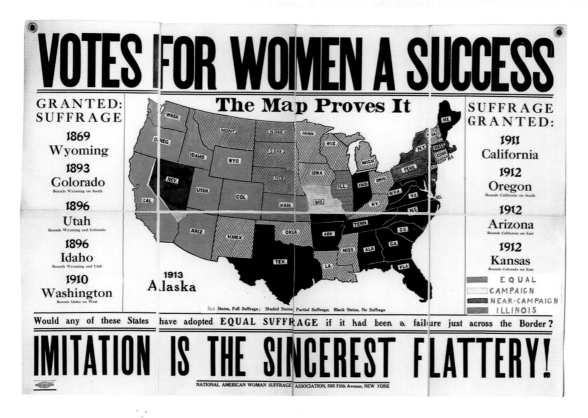

VOTES FOR WOMEN A SUCCESS

The Map Proves It

GRANTED: SUFFRAGE

1869
Wyoming

1893
Colorado
Bounds Wyoming on South

1896
Utah
Bounds Wyoming and Colorado

1896
Idaho
Bounds Wyoming and Utah

1910
Washington
Bounds Idaho on West

1913
Alaska

SUFFRAGE GRANTED:

1911
California

1912
Oregon
Bounds California on South

1912
Arizona
Bounds California on East

1912
Kansas
Bounds Colorado on East

EQUAL
CAMPAIGN
NEAR-CAMPAIGN
ILLINOIS

Red States, Full Suffrage; Shaded States, Partial Suffrage; Black States, No Suffrage

Would any of these States have adopted EQUAL SUFFRAGE if it had been a failure just across the Border?

IMITATION IS THE SINCEREST FLATTERY!

NATIONAL AMERICAN WOMAN SUFFRAGE ASSOCIATION, 505 Fifth Avenue, NEW YORK

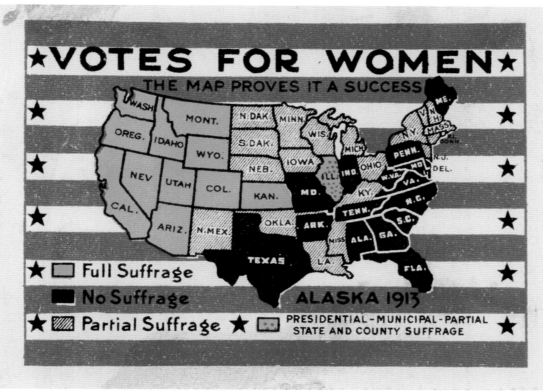

★VOTES FOR WOMEN★
THE MAP PROVES IT A SUCCESS

★ ☐ Full Suffrage
■ No Suffrage
★ ▨ Partial Suffrage ★ ☐ PRESIDENTIAL-MUNICIPAL-PARTIAL STATE AND COUNTY SUFFRAGE

ALASKA 1913

Of course, not everyone was on board, and they made their case, too.

THE HOME LOVING WOMEN
DO NOT WANT THE BALLOT
VOTE NO
TO AMENDMENT 8
FOURTH PLACE ON BALLOT

LOUIS ROESCH CO. LITH. AND PRINT. S. F.

1911

There were people fighting against suffrage as well. Here, the more traditionalist women in California protested the reform, but their state was the sixth state to adopt it. The mix of condensed type and extended type, serif and sans serif, lends an extra touch of nuttiness.

(OPPOSITE)
1920

Efforts to oppose suffrage began in earnest in 1912, and some posters betrayed more sexism than others.

MEN

You are making "The World Safe for Democracy."
And also safe for women.
That your Mothers, Sisters and Wives may
never have to suffer as the women of
Belgium and France have suffered.

ALL WOMEN THANK YOU

Men manage most of our business.
Our Government is a very big business.
Most women want men to manage our Government.

Only a few women want suffrage.
Shall these few women force all women
into politics?

Women can do their bit best outside of Politics.
Our hands are full already with work
which only women can do.

Women are free from the duty of fighting.
Protect us in our right to be free
from political duties.

Virginia
Association **OPPOSED TO** Woman
Suffrage

There was no stopping suffrage—here are twelve excellent reasons why.

1917

After nearly 72 years of fighting for suffrage, women finally felt optimistic about their momentum and progress. In this handout, they are literally rolling over the opposition.

(OPPOSITE)
1916

Who doesn't love a list? This document was used during the referendum in New York, the first Eastern state to fully enfranchise women. No gimmicks, no metaphors, no clever cartoons or turns of phrase—just good old-fashioned logic.

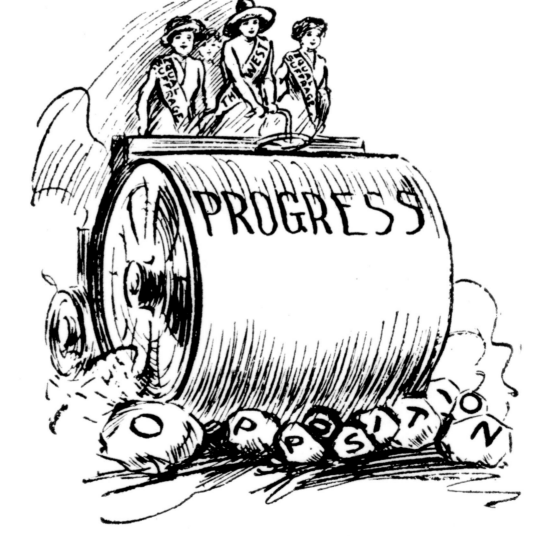

THE STEAM ROLLER

Twelve Reasons
Why Women Should Vote

1. **BECAUSE** those who obey the laws should help to choose those who make the laws.

2. **BECAUSE** laws affect women as much as men.

3. **BECAUSE** laws which affect WOMEN are now passed without consulting them.

4. **BECAUSE** laws affecting CHILDREN should include the woman's point of view as well as the man's.

5. **BECAUSE** laws affecting the HOME are voted on in every session of the Legislature.

6. **BECAUSE** women have experience which would be helpful to legislation.

7. **BECAUSE** to deprive women of the vote is to lower their position in common estimation.

8. **BECAUSE** having the vote would increase the sense of responsibility among women toward questions of public importance.

9. **BECAUSE** public spirited mothers make public spirited sons.

10. **BECAUSE** about 8,000,000 women in the United States are wage workers, and the conditions under which they work are controlled by law.

11. **BECAUSE** the objections against their having the vote are based on prejudice, not on reason.

12. **BECAUSE** to sum up all reasons in one—IT IS FOR THE COMMON GOOD OF ALL.

VOTES FOR WOMEN

NATIONAL WOMAN SUFFRAGE PUBLISHING CO., INC.
171 Madison Avenue, 154 New York City

1917
JAMES MONTGOMERY
FLAGG

The artist who drew the famous Uncle Sam poster created this cover. The hope was that there would be power in showing women not just as women, but as the mothers of all voters. It was a gentle, nonthreatening way to prod the men who could change the law.

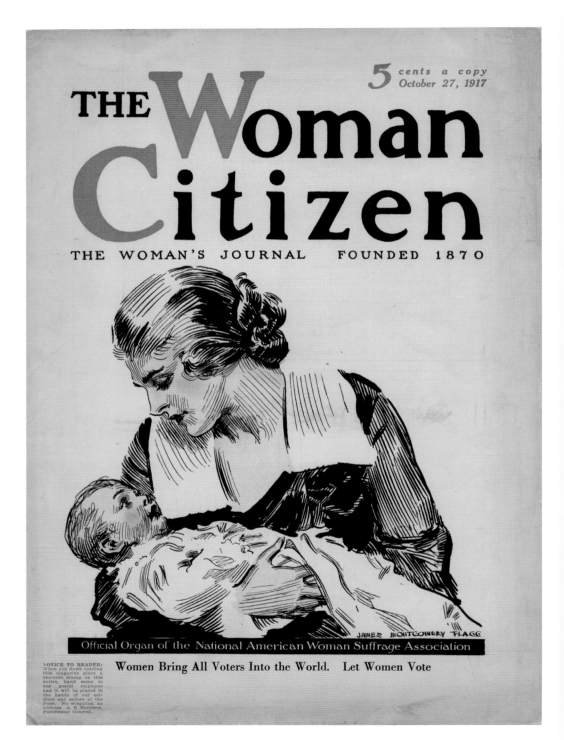

5 cents a copy
October 27, 1917

THE Woman Citizen

THE WOMAN'S JOURNAL FOUNDED 1870

JAMES MONTGOMERY FLAGG

Official Organ of the National American Woman Suffrage Association

NOTICE TO READER:
When you finish reading this magazine place a one-cent stamp on this notice, hand same to any postal employee and it will be placed in the hands of our soldiers and sailors at the front. No wrapping, no address. A. S. Burleson, Postmaster General.

Women Bring All Voters Into the World. Let Women Vote

Hang one of these in your window for each woman registered. Cut this off before displaying.

A WOMAN
LIVING HERE
HAS
REGISTERED
TO VOTE
THEREBY ASSUMING
RESPONSIBILITY OF
CITIZENSHIP

Seventy years of hard work paid off. The Nineteenth Amendment passed in 1920, and who wouldn't be proud to display this in their window?

1920

This sign, given to women to display for all to see, is a sophisticated, fully designed piece of art, as joyful and celebratory as a circus poster.

CHAPTER 4
American Icons
Uncle Sam &
Rosie the Riveter

Of all of our inventions
for mass communication,
pictures still speak the
most universally
understood language.

WALT DISNEY

1914
ALFRED LEETE

This British magazine cover featuring Lord Kitchener, the Secretary of State for War, was designed to convince men to enlist in World War I. Published a month after the outbreak of World War I, when the British military was in need of fresh troops, the image was transformed into the more famous recruiting poster with a new headline: "Britons!" When paired with the finger-pointing, it communicated a direct, unavoidable call to action and was so effective, America decided to follow suit with its own version.

(OPPOSITE)
1917
JAMES MONTGOMERY FLAGG

Though Uncle Sam had appeared in various cartoons dating back to the mid-eighteenth century, this rendering of an old white man (Flagg used himself as the model) clad in red, white, and blue was the face and figure that would endure. Like the Lord Kitchener poster, the U.S. take on "I Want You" was created to encourage men to enlist, and it quickly became one of the most beloved (and parodied) images in history.

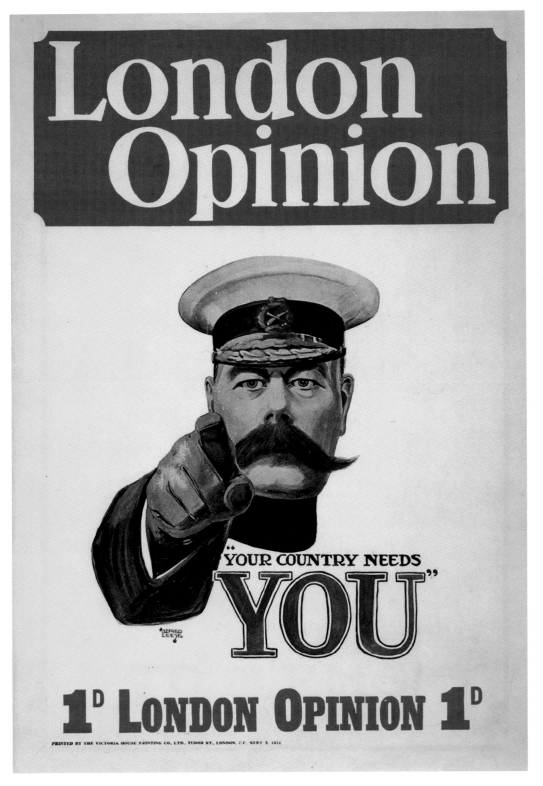

Yes, the personification of America is a patriotic old white man.

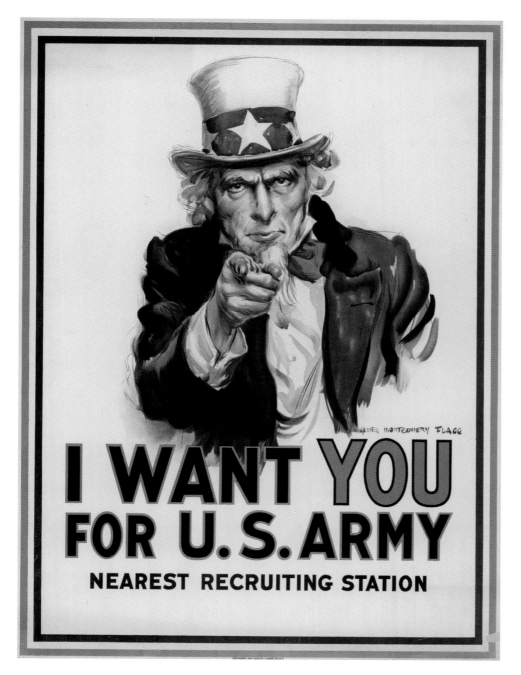

These posters take a beloved image, essentially a marketing device associated with military patriotism, and use it to market the opposite message.

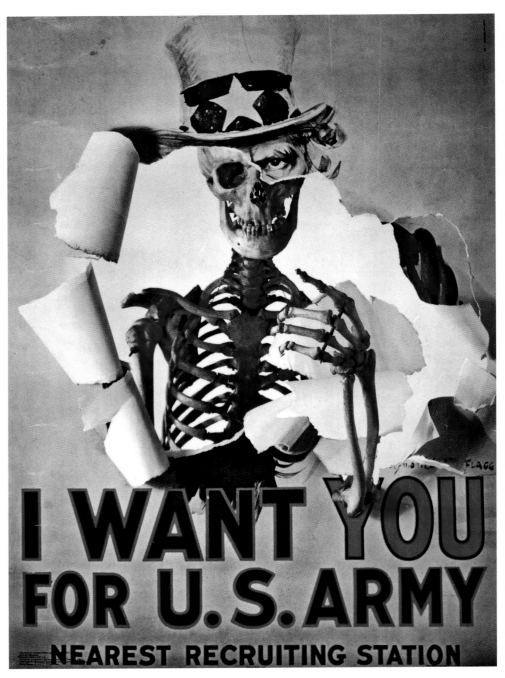

1972

Death, not-so-subtly represented here with a skeleton, literally breaks through the original Uncle Sam poster with only the hat and a single eye remaining. The result is a powerful piece of antiwar propaganda.

(OPPOSITE)
1971
STEVE HORN, photo
LARRY DUNST, design

This was one of the most popular anti-Vietnam posters of the era. In stark contrast to the confident, authoritative original, it reimagines Uncle Sam as a battered, vulnerable soldier, and rewords his famous quote to telegraph a shocking message of desperation.

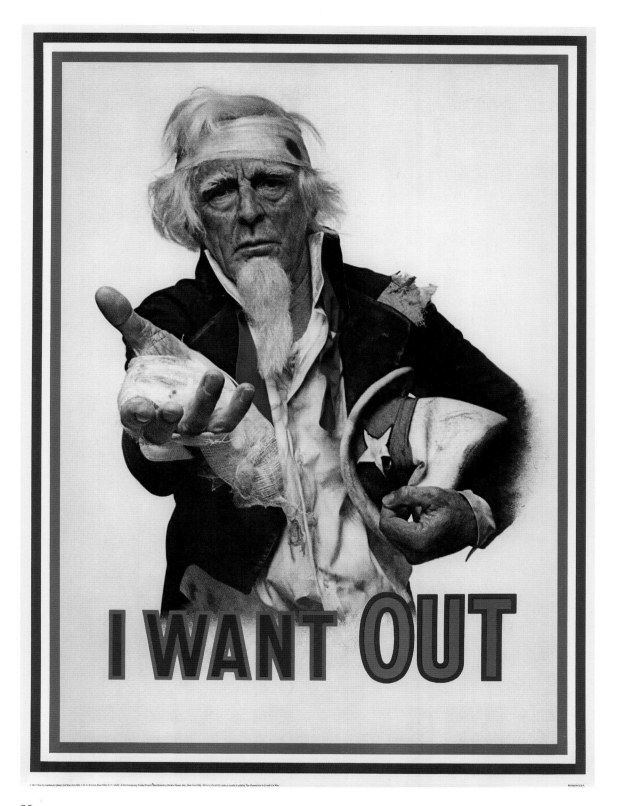

Keeping the image but changing the words or swapping in a less patriotic face is a common way to subvert the message— and also to add a little humor.

2016
SAGO DESIGN

Enduring icons endure for a reason: There is usually one strong visual (in this case a face staring right at us) and minimal words. This makes the image easily reproducible and easily recognizable in any iteration, like this sophomoric parody, which always gets a chuckle.

(OPPOSITE)
2016

Similarly, this legitimate magazine cover, preelection, used the Uncle Sam template to question the possibility of a Trump presidency.

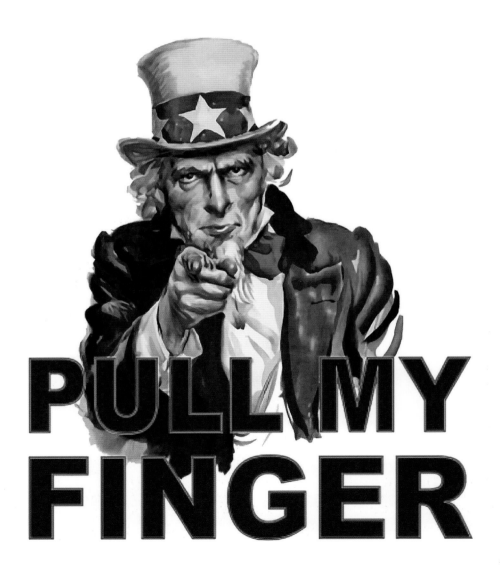

PULL MY FINGER

The Economist

FEBRUARY 27TH–MARCH 4TH 2016

INDONESIA: A SPECIAL REPORT

Brexit: a threat to the West

Unjamming megacities

Why Apple is right

Hieronymus Bosch, painter of fear

Really?

Australia........A$11(inc.GST) Hong Kong............HK$80 Korea..............Won 11,000 New ZealandNZ$13.00 Sri Lanka...............Rs1,000
Bangladesh............TK470 India₹300 Malaysia...RM25.50 (inc.GST) Pakistan................Rs640 Taiwan.................NT$275
Cambodia.............US$8.00 Indonesia.........Rp77,000 Myanmar............US$8.00 Philippines........Pesos385 Thailand.............Baht 300
China................RMB 75 Japan.............¥1,143+Tax Nepal..................NR490 Singapore .. S$12.50 (inc.GST) Vietnam............US$8.00

2017
WOKE GIANT

This group makes, in their words, "Political Art for Third Century America" and has created posters for the Climate March, the Science March, DAPL, and Flint, encouraging citizens to take an active role in their democracy.

(OPPOSITE)
2017
DOUGLAS CHRISTIAN

This wonderful sign at the Women's March transforms Uncle Sam into a woman (rarely done) fighting for diversity instead of an enticement to join the army.

I am telling you that Transphobia is UN-AMERICAN and if you disagree, then please tell me how you define the word "FREEDOM."

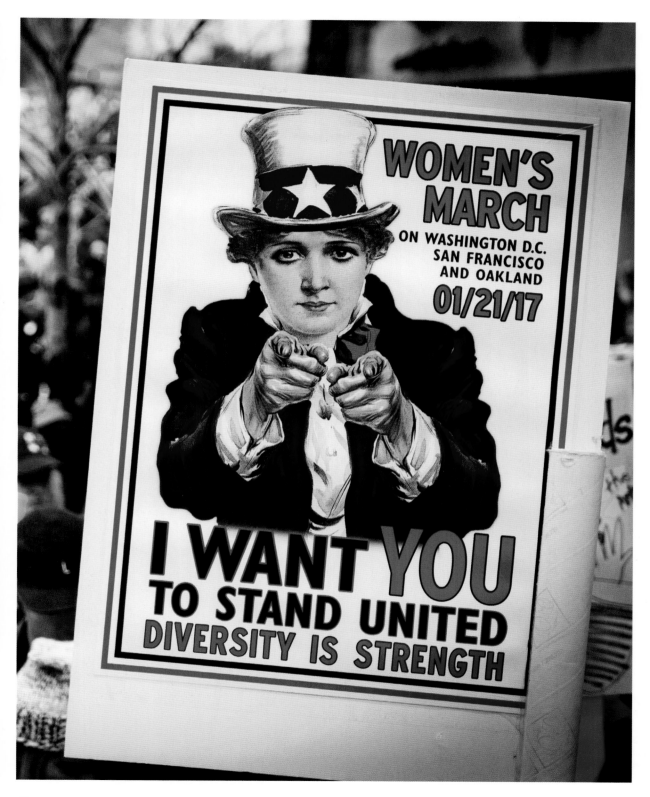

1942

Before Rosie was a famous poster girl, she was the subject of a hugely popular song, performed by the biggest artists (including the Four Vagabonds) and band-leaders of the day. It was the height of World War II and the song was written about a real woman named Rosalind P. Walter who worked on the night shift building F4U Corsair fighters.

(OPPOSITE)
1943
NORMAN ROCKWELL

Six months later, Rockwell painted his version of Rosie (from the song) for the cover of the *Saturday Evening Post*. Here, Rosie, resting her foot on a copy of *Mein Kampf*, is seen as the all-American girl trampling Hitler in her penny loafers. Rockwell's Rosie did encourage women to fill World War II production jobs, though it wasn't created specifically for that purpose.

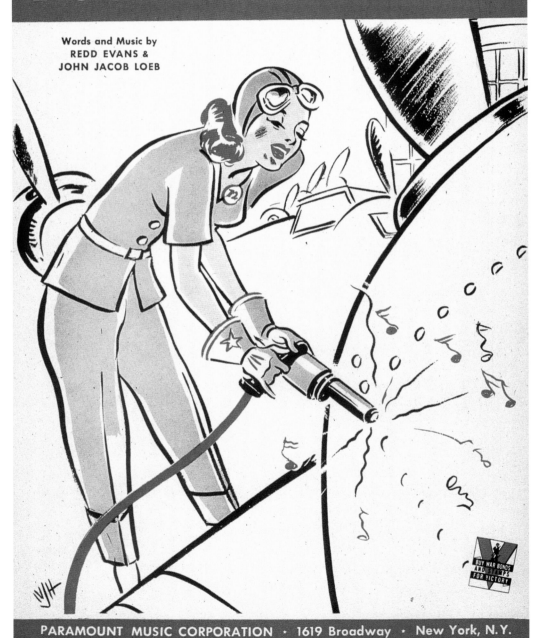

ROSIE THE RIVETER

Words and Music by
REDD EVANS &
JOHN JACOB LOEB

PARAMOUNT MUSIC CORPORATION · 1619 Broadway · New York, N.Y.

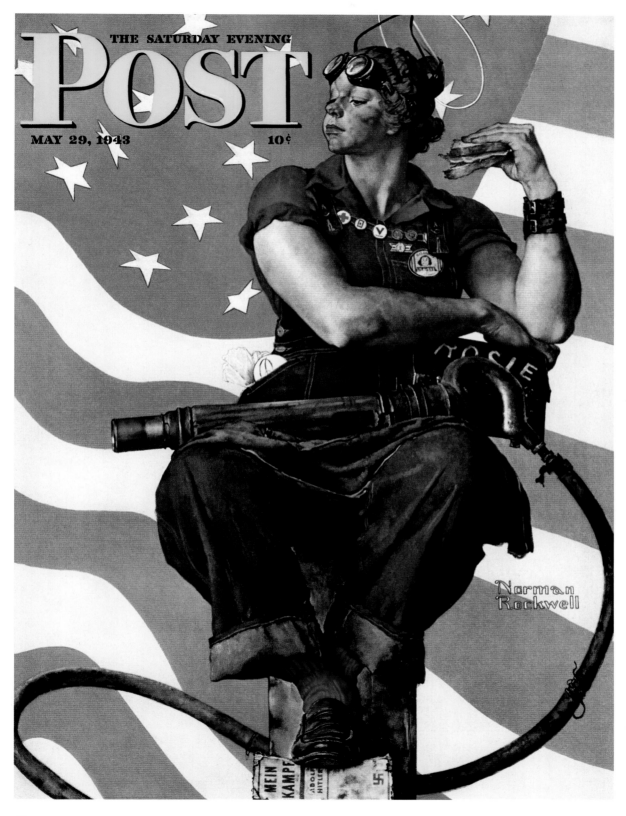

THE SATURDAY EVENING
POST

MAY 29, 1943 10¢

Norman
Rockwell

45

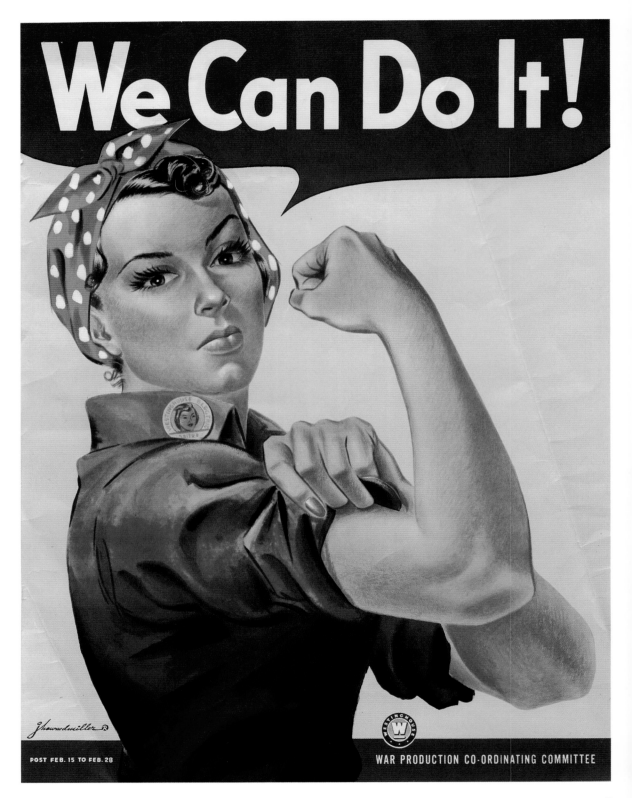

Sometimes the best cultural icons happen by accident and take on a life of their own.

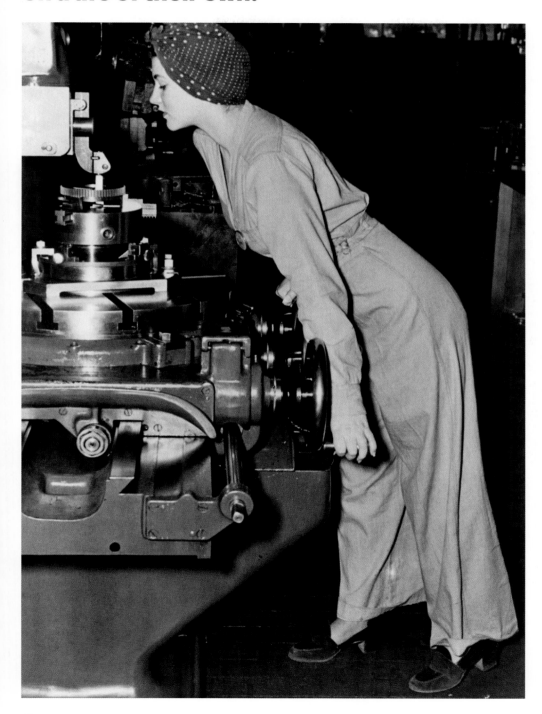

(OPPOSITE)
1943
J. HOWARD MILLER

The iconic Rosie poster was actually created for internal use at Westinghouse as an inspirational image to boost employee morale, and for decades the only people who saw it were Westinghouse workers during a two-week period in 1943. Then it disappeared for nearly forty years. It was rediscovered in 1982, mistakenly called Rosie the Riveter, and mistakenly described as a poster created to recruit women for factory jobs during the war. Thus began its life as a symbol of women's empowerment.

1942

This newspaper photograph was taken at the Alameda Naval Air Station, where Naomi Parker Fraley, the inspiration for the famous poster, worked the lathe. Amazingly, Parker Fraley had no idea she was the inspiration for it until she was eighty-eight and discovered the photo displayed (with another woman's name) at the Rosie the Riveter National Park. She corrected the museum and explained she wore the famous red-and-white polka-dot scarf to keep her hair out of the way.

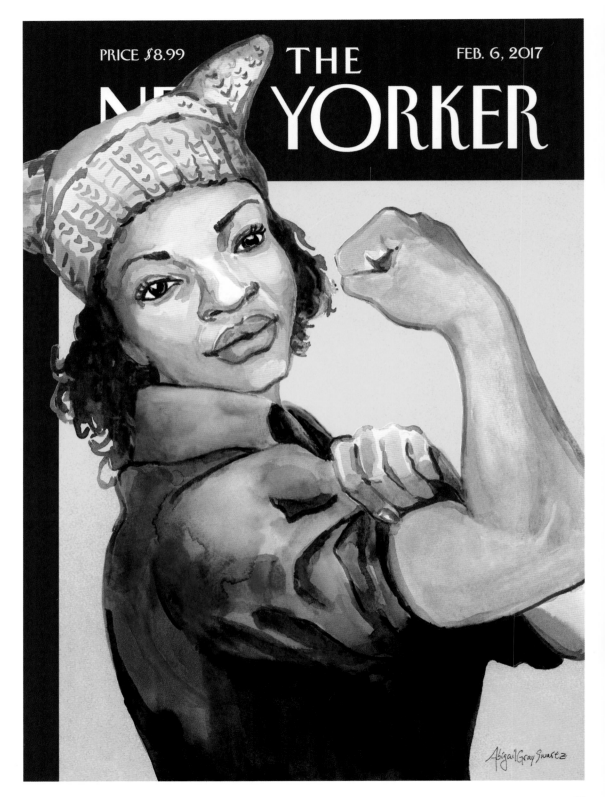

PRICE $8.99

THE NEW YORKER

FEB. 6, 2017

Abigail Gray Swartz

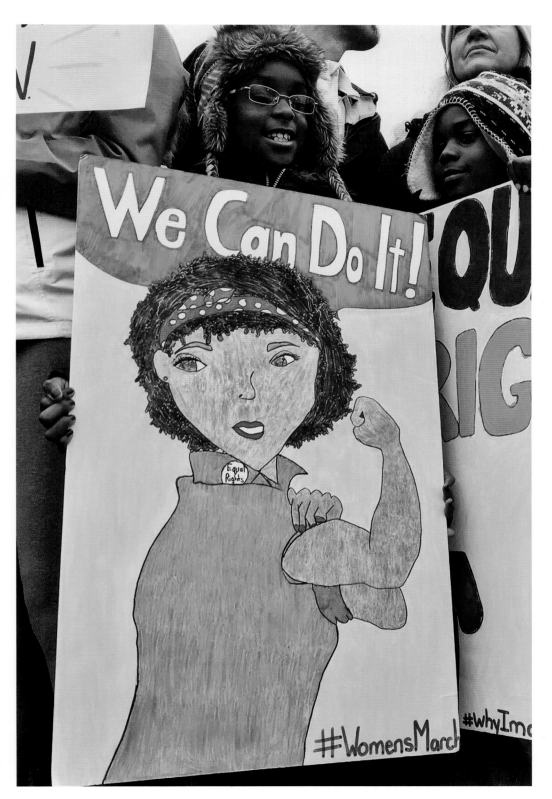

(OPPOSITE)
2017, *The March*
ABIGAIL GRAY SWARTZ

One of the more celebrated *New Yorker* covers in recent history, Swartz's drawing depicted an African American Rosie wearing not the famous scarf but the iconic pink pussy hat that has come to symbolize women's resistance in the Trump era. With her nod to equality and diversity, this Rosie represented the new wave of American feminism.

2017
KIARA NELSON

A true labor of love, this intensely colored magic-marker version of Rosie was so precise and personal, you just know that the marcher truly felt she could do it.

This version brought attention to a different reading of Rosie's gesture of strength.

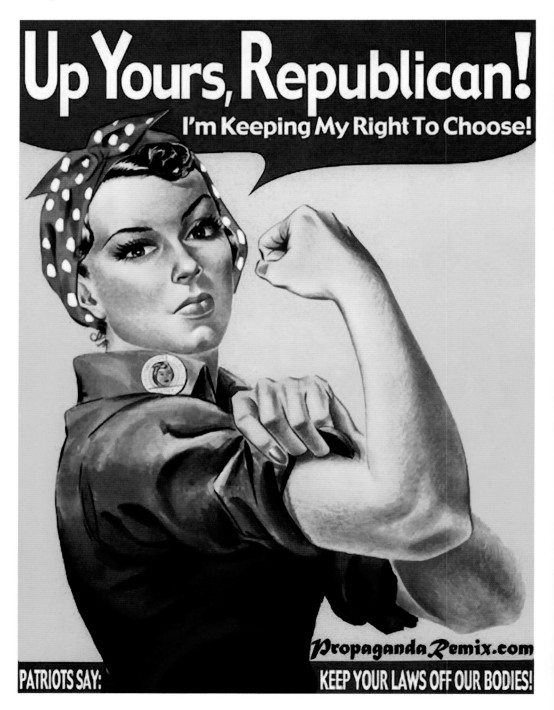

Up Yours, Republican!
I'm Keeping My Right To Choose!

PropagandaRemix.com

PATRIOTS SAY: **KEEP YOUR LAWS OFF OUR BODIES!**

2012
MICAH WRIGHT

This was originally created in 2002 with "Up Yours Bush!" to protest the Bush administration's attempt to diminish a woman's right to choose. It was remade when it was clear how "virulently anti-choice the main-stream of the Republican Party" had become.

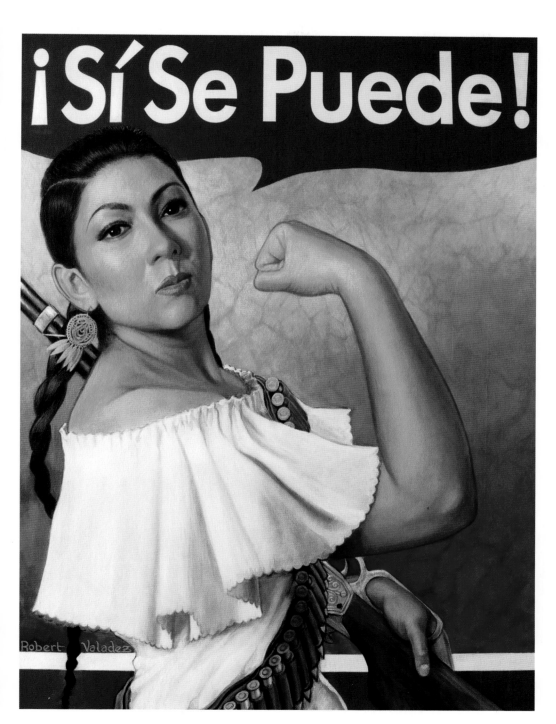

¡Sí Se Puede!

2009
ROBERT VALADEZ

Here, Rosita is combined with another fictional pre-feminist archetype named La Adelita, who represents all the women who participated in the Mexican Revolution. The power of this image is its ability to be adapted and still instantly communicate a woman's strength and ability to "do it."

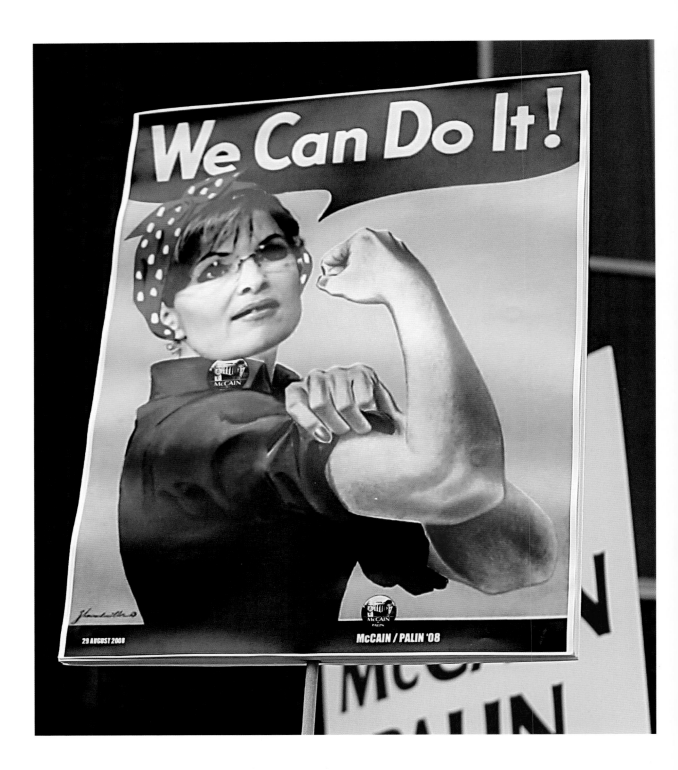

Things get frightening when inclusive cultural touchstones are used to divide us.

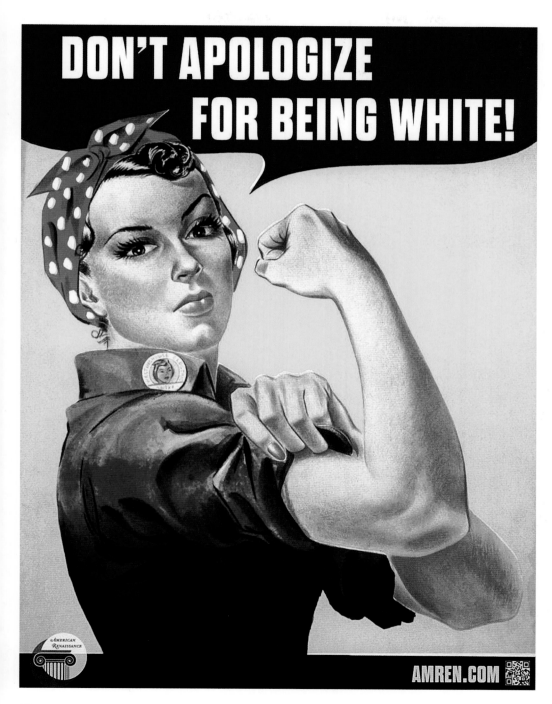

Civil Rights
I Have a Dream

The question is not whether we will be extremist but what kind of extremist will we be. . . . The South, the nation and the world are in dire need of creative extremists.

MARTIN LUTHER KING JR.

A man on his knees, in chains, begging to be recognized for his dignity. The image was so powerful and iconic, it endured for centuries.

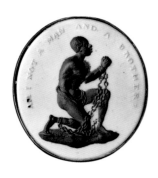

1787
JOSIAH WEDGWOOD

A Quaker organization, the Society for Effecting the Abolition of the Slave Trade, enlisted Wedgwood to design the symbol as a jasperware cameo; its image was adopted (and reproduced in many forms, like this etching—RIGHT—from 1791) by abolitionists, and its words were revived by civil rights activists nearly 150 years later.

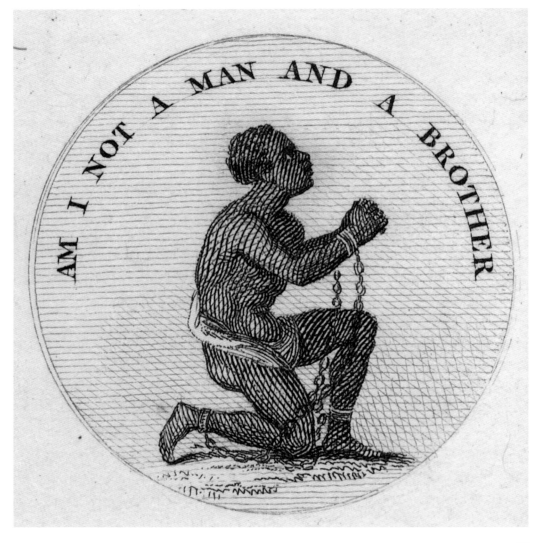

AM I NOT A MAN AND A BROTHER

THE MAN IS NOT BOUGHT!

HE IS STILL IN THE

SLAVE PEN
IN THE COURT HOUSE!

THE KIDNAPPER AGREED
Both Publicly, and in writing, to SELL HIM
FOR $1200!
The sum was raised by eminent citizens of Boston, and offered him. He then claimed more. The BARGAIN WAS BROKEN. THE

KIDNAPPER BREAKS HIS AGREEMENT!
Though even the UNITED STATES COMMISSIONER advised him to keep it.

BE ON YOUR GUARD AGAINST ALL LIES!
WATCH THE SLAVE PEN
Let Every Man attend the Trial!

1854

This broadside, which uses multiple typefaces to illustrative effect, publicized the arrest of Anthony Burns, a fugitive slave who made his way from Richmond, Virginia, to Boston, Massachusetts. While he was awaiting trial for extradition, large groups of abolitionists stormed the jail to free him. Federal troops arrived to support the extradition forcing him back to Richmond. He was later ransomed and eventually attended Oberlin College and became a Baptist minister.

1922
WALTER WHITE
HERBERT SELIGMANN

Designed essentially as what we would now call an infographic, this full-page ad let the numbers speak for themselves. The ad was placed in ten major national papers, and the NAACP sent copies to every senator, urging them to pass the Dyer Anti-Lynching Bill. The bill passed in the House but was ultimately defeated in the Senate, so lynching was not outlawed.

(OPPOSITE)
1936
NAACP

Throughout the 1930s, the NAACP would unfurl a flag outside its Fifth Avenue headquarters in New York every time they received news of a lynching. They had only a moment to capture the attention of drivers or walkers, so the design needed to be as big, bold, and simple as possible.

THE SHAME OF AMERICA

Do you know that the United States is the Only Land on Earth where human beings are BURNED AT THE STAKE?

In Four Years, 1918-1921, Twenty-Eight People Were Publicly BURNED BY AMERICAN MOBS

3436 People Lynched 1889 to 1922

For What Crimes Have Mobs Nullified Government and Inflicted the Death Penalty?

The Alleged Crimes	The Victims	Why Some Mob Victims Died:
Murder	1288	Not turning out of road for white boy in auto
Rape	571	Being a relative of a person who was lynched
Crimes against the Person	615	Jumping a labor contract
Crimes against Property	333	Being a member of the Non-Partisan League
Miscellaneous Crimes	453	"Talking back" to a white man
Absence of Crime	176	"Insulting" white man.
	3436	

Is Rape the "Cause" of Lynching?

Of 3,436 people murdered by mobs in our country, only 571, or less than 17 per cent., were even accused of the crime of rape.

83 WOMEN HAVE BEEN LYNCHED IN THE UNITED STATES

Do lynchers maintain that they were lynched for "the usual crime"?

AND THE LYNCHERS GO UNPUNISHED

THE REMEDY

The Dyer Anti-Lynching Bill Is Now Before the United States Senate

The Dyer Anti-Lynching Bill was passed on January 26, 1922, by a vote of 230 to 119 in the House of Representatives.

The Dyer Anti-Lynching Bill Provides:
That culpable State officers and mobbists shall be tried in Federal Courts on failure of State courts to act, and that a county in which a lynching occurs shall be fined $10,000, recoverable in a Federal Court.

The Principal Question Raised Against the Bill is upon the Ground of Constitutionality.

The Constitutionality of the Dyer Bill Has Been Affirmed by—
The Judiciary Committee of the House of Representatives
The Judiciary Committee of the Senate
The United States Attorney General, legal adviser of Congress
Judge Guy D. Goff, of the Department of Justice

The Senate has been petitioned to pass the Dyer Bill by—
79 Lawyers and Jurists, including two former Attorneys General of the United States
19 State Supreme Court Justices
24 State Governors
3 Archbishops, 85 bishops and prominent churchmen
39 Mayors of large cities, north and south.

The American Bar Association at its meeting in San Francisco, August 9, 1922, adopted a resolution asking for further legislation by Congress to punish and prevent lynching and mob violence.

Fifteen State Conventions of 1922 (3 of them Democratic) have inserted in their party platforms a demand for national action to stamp out lynchings.

The Dyer Anti-Lynching Bill is not intended to protect the guilty, but to assure to every person accused of crime trial by due process of law.

THE DYER ANTI-LYNCHING BILL IS NOW BEFORE THE SENATE
TELEGRAPH YOUR SENATORS TODAY YOU WANT IT ENACTED

If you want to help the organization which has brought to light the facts about lynching, the organization which is fighting for 100 per cent. Americanism, not for some of the people some of the time, but for all of the people, white or black, all of the time

Send your check to J. E. SPINGARN, Treasurer of the

NATIONAL ASSOCIATION FOR THE ADVANCEMENT OF COLORED PEOPLE
70 FIFTH AVENUE, NEW YORK CITY

THIS ADVERTISEMENT IS PAID FOR IN PART BY THE ANTI-LYNCHING CRUSADERS.

58

The NAACP's strategy: change hearts and minds by delivering the cold, hard facts in as straightforward a manner as possible.

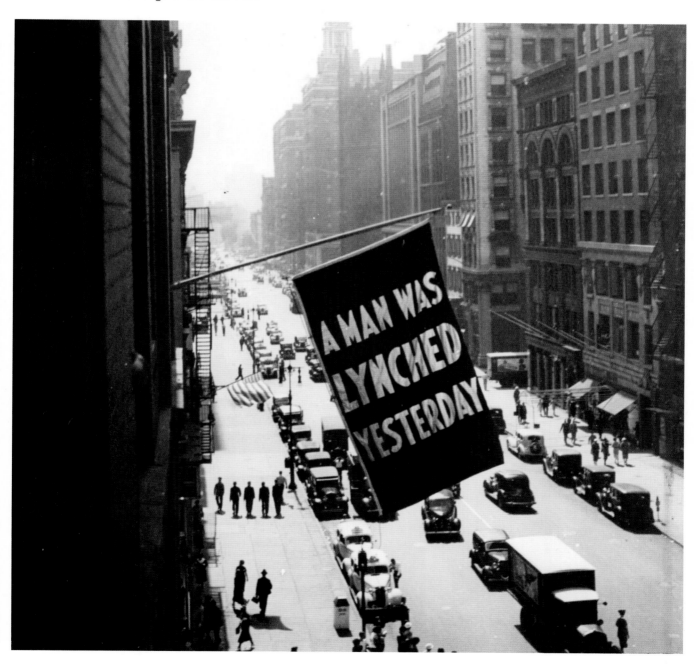

The anger and outrage over Emmett Till's murder was one of the catalysts that sparked the civil rights movement. And it was all because of a photo.

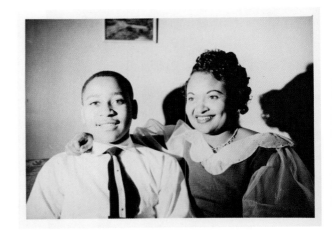

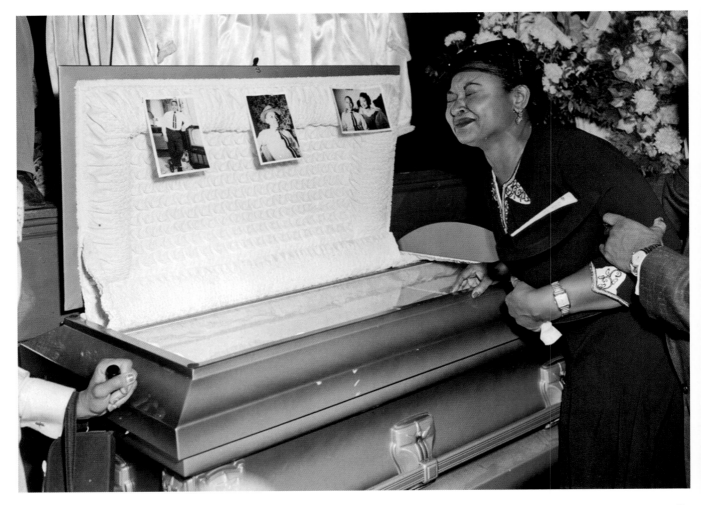

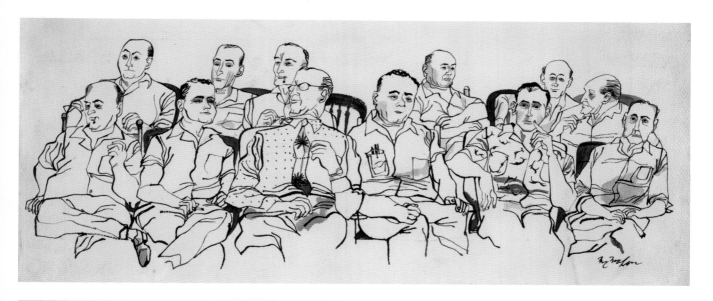

"I thought about Emmett Till and I could not go back." –ROSA PARKS

1955

Emmett Till (WITH HIS MOTHER, OPPOSITE, TOP) was a fourteen-year-old boy from Chicago, visiting cousins in Mississippi. While there, he was brutally beaten, shot in the head, and dumped in a river; murdered for allegedly flirting with and whistling at a white woman. Emmett Till's mother (OPPOSITE, BOTTOM) defied norms and insisted that the coffin be open at his funeral to show the world the brutal horror of racial violence. The photo of his disfigured face (not pictured) was seen around the world. (TOP) An ink-and-wash illustration of the all-white, all-male jury that acquitted the murderers despite eyewitness identification and their admission to kidnapping. In 2007, the woman who had accused Till confessed that she had lied. (BOTTOM) The protest in New York City after the publication of the photos and the acquittal.

I AM
A MAN

MEMPHIS

A perfect example of the starkness of the message supported and amplified by the starkness of the design.

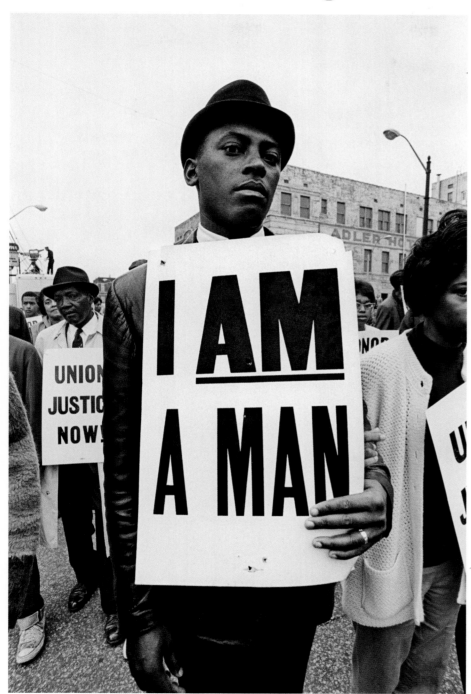

(OPPOSITE)
1968

African American workers carried these signs during the Memphis sanitation strike, when they were fighting for the right to unionize. Appropriating the abolitionists' "Am I not a man . . . ?" slogan, they changed the question to a statement, in the form of this striking, simple poster. The message? We are no longer asking you, we are telling you.

1968
BOB ADELMAN

The strike began after two sanitation workers were killed by a malfunctioning garbage truck and the workers tried to unionize. When the mayor of Memphis refused to negotiate, the workers took to the streets to protest. Photographs like this one put a face on the struggle—which garnered national attention as it dragged on for months—and communicated the spirit and dignity of the workers in their push for fair and proper treatment.

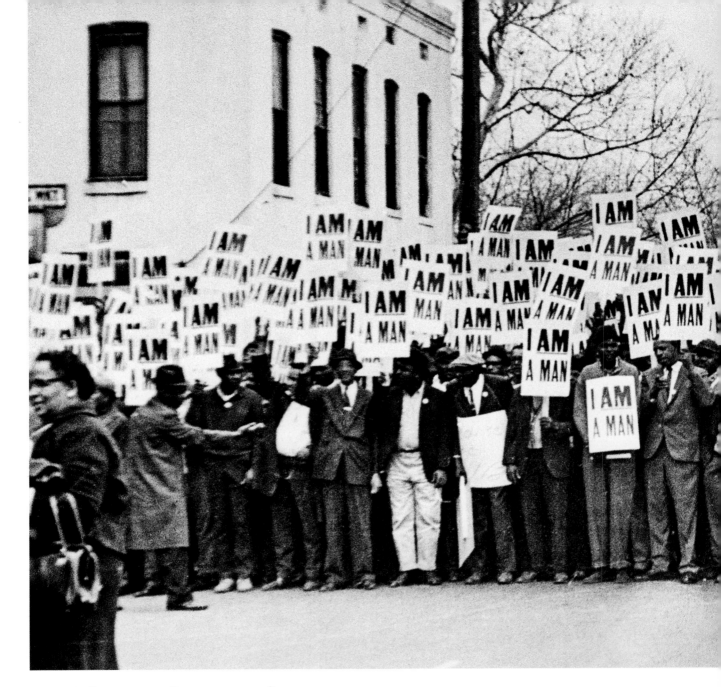

**The sign achieved a singular,
extraordinary power when it was
hoisted up in multiples.**

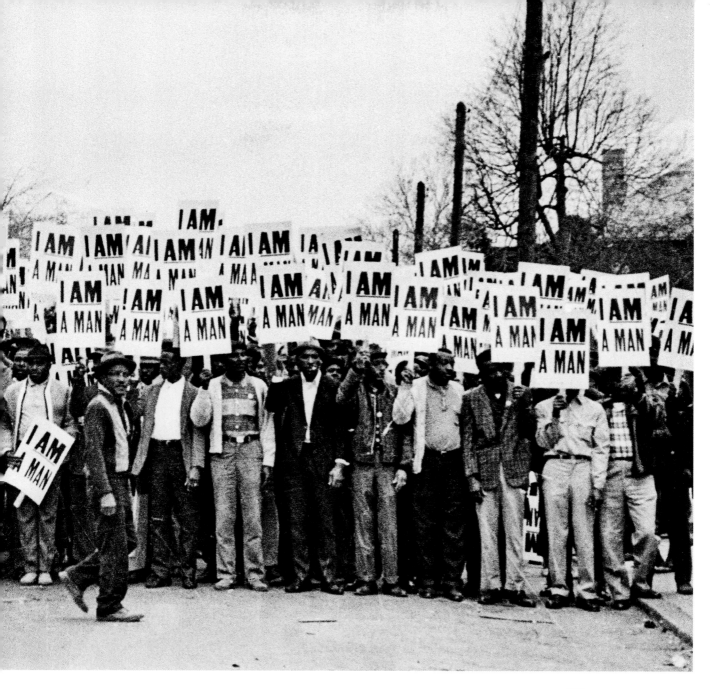

1968
ERNEST C. WITHERS

This was taken on the forty-fourth day of the strike. More than 5,000 strikers picked up their signs at Clayborn Temple in Memphis and lined up to begin marching.

Simple message, bold type, strength in numbers.

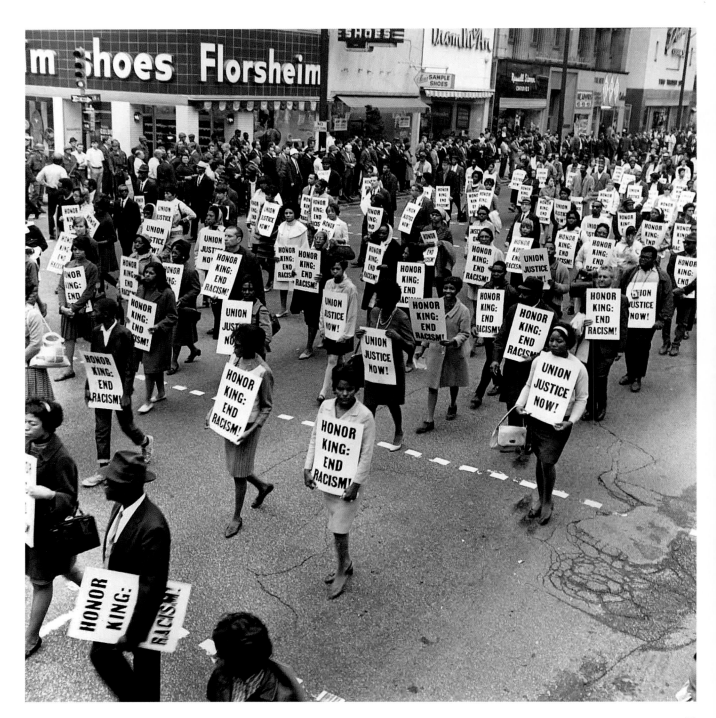

HONOR KING: END RACISM!

(OPPOSITE)
1968
ERNEST WITHERS

Martin Luther King Jr. was assassinated seven days after the march. Four days after that, Mrs. King and other national figures led another march in honor of Dr. King and in support of the strike in Memphis.

1968

Following the simplicity of the I Am a Man posters, this sign was given out to marchers, along with one that read "Union Justice Now!"

SNCC used photography to show hard evidence of crimes against humanity so the uncomfortable, brutal truth couldn't be disputed or ignored.

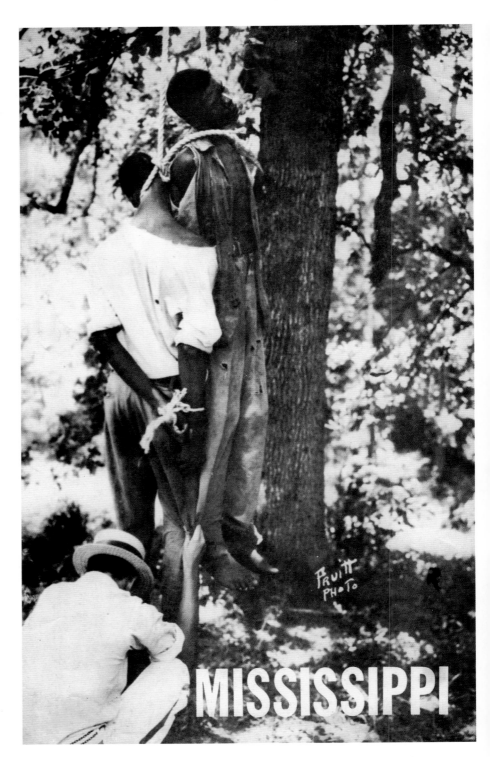

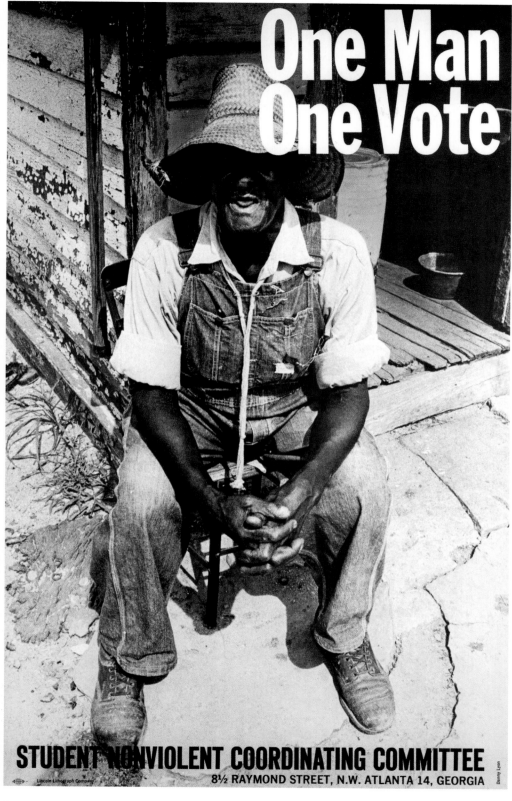

One Man One Vote

STUDENT NONVIOLENT COORDINATING COMMITTEE
8½ RAYMOND STREET, N.W. ATLANTA 14, GEORGIA

Lincoln Lithograph Company

Danny Lyon

(OPPOSITE)
1965

The Student Non-Violent Coordinating Committee (SNCC; pronounced "snick") was formed in 1960 to help young black Americans gain a voice in the civil rights movement. Their posters combined shocking photography with minimal words to great effect. They used a photo by Otis Noel Pruitt documenting the 1935 lynching of Bert Moore and Dooley Morton and needed only one word on the image—Mississippi—to give it the necessary context and impact. They were saying, For African Americans THIS is the real Mississippi. The photograph is dark, terrifying, and difficult to look at, and that's the point.

1963
DANNY LYON

This was the slogan of the SNCC voter registration drives in Mississippi, and when paired with the image of a hardworking local farmer, meant to represent "everyman," it sent an important message: Every American, no matter who you are or where you come from, has a right to be heard.

(TOP)
1963

A SNCC button, with their logo suggesting/ hoping/working toward equality.

(BOTTOM)
1963
DANNY LYON

These young protesters at the March on Washington seem to be reaching for the word NOW. Freedom must be grasped, fought for, and demanded. John Lewis, the twenty-three-year-old national chairman of SNCC, ended his speech that day by saying, "We must say wake up, America. Wake up! For we cannot stop, and we will not and cannot be patient."

(OPPOSITE)
1965

The cry for justice and the right to vote is communicated through the eyes of this girl, innocently waving the flag of her country while her country throws every possible obstacle in her path.

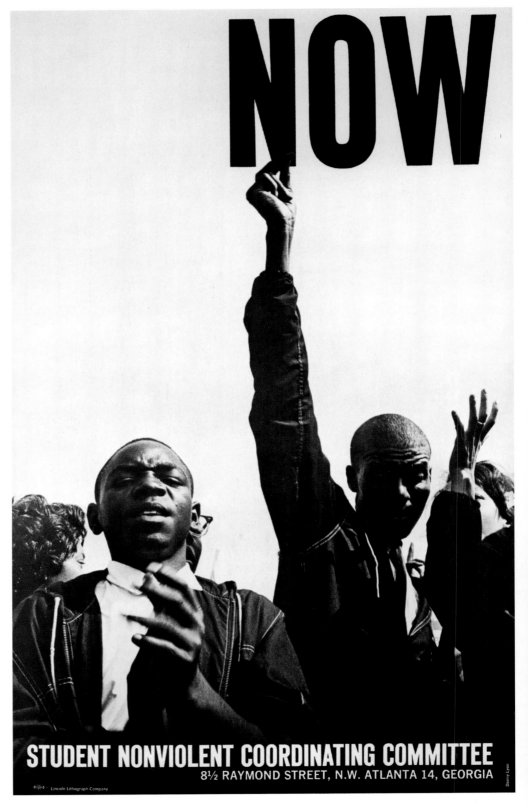

NOW

STUDENT NONVIOLENT COORDINATING COMMITTEE
8½ RAYMOND STREET, N.W. ATLANTA 14, GEORGIA

Lincoln Lithograph Company

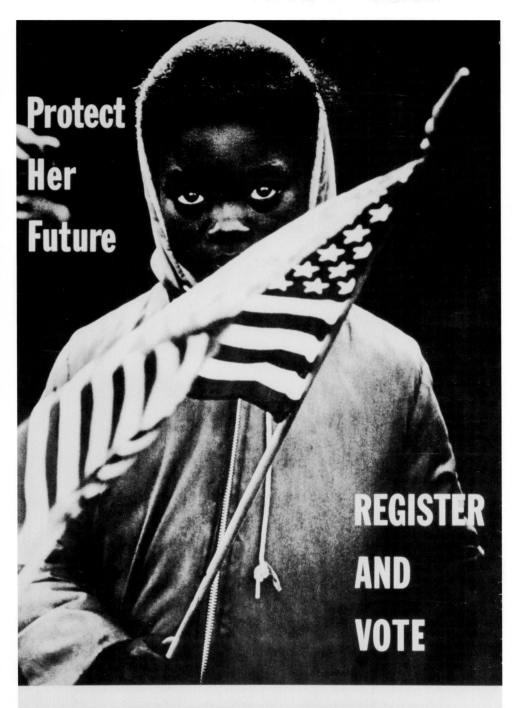

Protect
Her
Future

REGISTER
AND
VOTE

BLACK IS BEAUTIFUL - BUT YOU LOOK
PRETTIER WHEN YOU ARE REGISTERED

NATIONAL ASSOCIATION FOR THE ADVANCEMENT OF COLORED PEOPLE

Sadly, as relevant today as it was then.

1962
DANNY LYON

In September 1962, James Meredith, a Vietnam War veteran and civil rights activist, enrolled at the University of Mississippi. Though it was eight years after *Brown vs. Board of Ed*, "Ole Miss" was still segregated and Meredith's admission instigated riots on campus, eventually forcing the federal government to intervene with protective troops. The violent protesters shot and killed two civilians execution style, burned cars, and threw rocks and bricks at U.S. Marshals sent to protect Meredith when state officials, like this Mississippi highway patrolman, essentially stood by and watched. It is the patrolman's stubborn indifference captured here that makes the message of SNCC's poster so frightening.

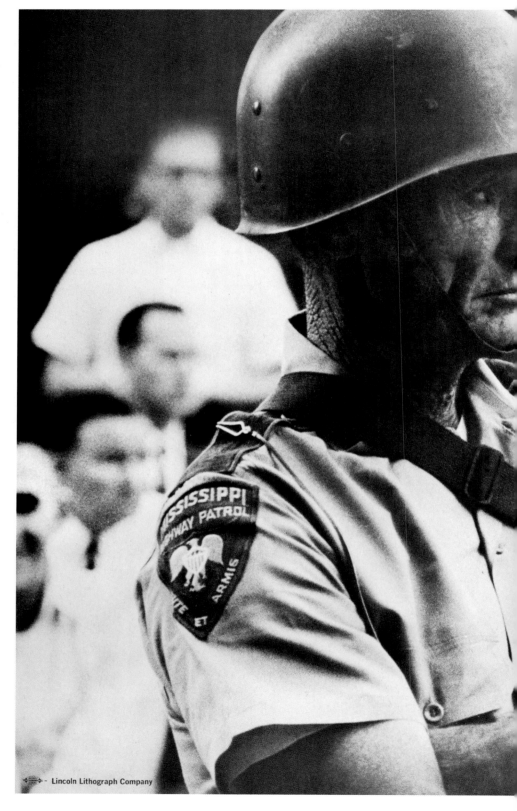

Lincoln Lithograph Company

S HE PROTECTING YOU?

STUDENT NONVIOLENT COORDINATING COMMITTEE
8½ RAYMOND STREET, N.W. ATLANTA 14, GEORGIA

Danny Lyon

1971
FAITH RINGGOLD

Angela Davis was a UCLA professor, a civil rights activist, and a member of the Black Panthers. She was charged with aiding in the botched escape attempt of an imprisoned radical but was acquitted after serving eighteen months in jail. During the time Davis was in prison, Ringgold made this in an act of solidarity. The visual style was inspired by the motifs of Central Africa's Kuba tribe.

(OPPOSITE)
1970
BLACK PANTHER PARTY

Simple and clear, and really, sadly, the same message as that of Black Lives Matter today.

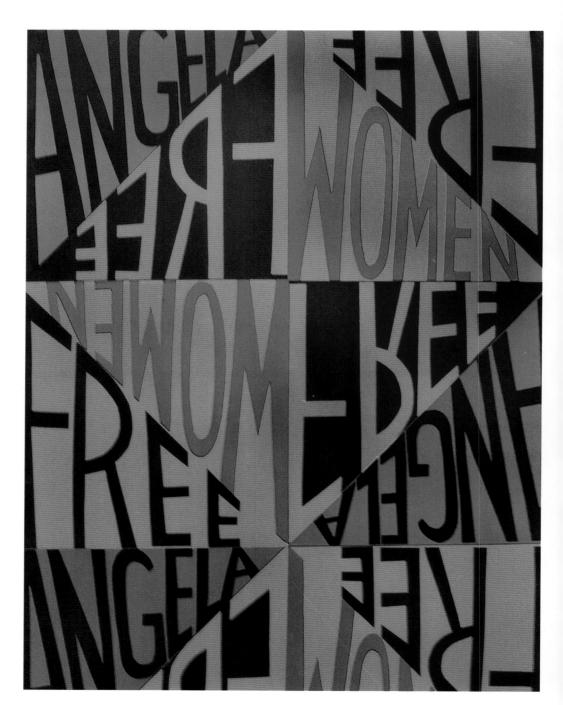

According to civil rights leader Stokely Carmichael, a black panther was chosen as the symbol for the party because it "symbolizes the strength and dignity of black people, an animal that never strikes back until he's back so far into the wall, he's got nothing to do but spring out."

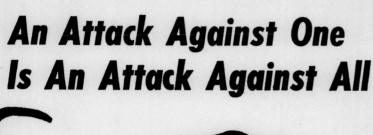

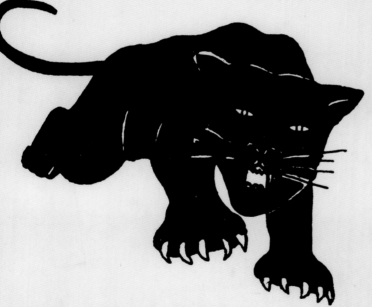

An Attack Against One
Is An Attack Against All

The Slaughter of Black
People Must Be Stopped!
By Any Means Necessary!

Emory Douglas defined the visual identity
of the Black Panthers and was considered the
"Norman Rockwell of the ghetto."

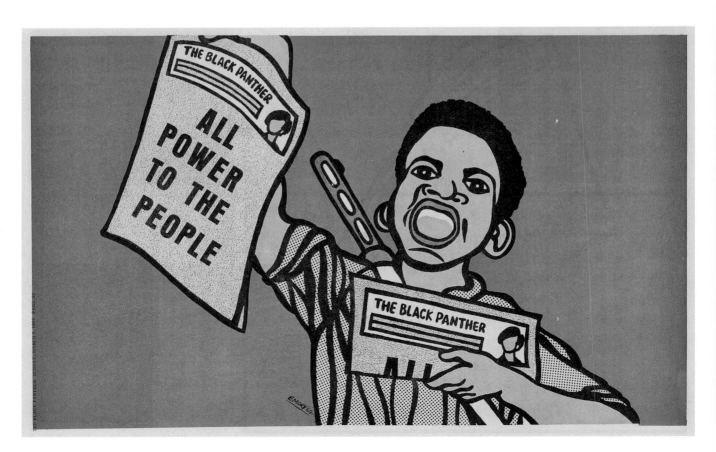

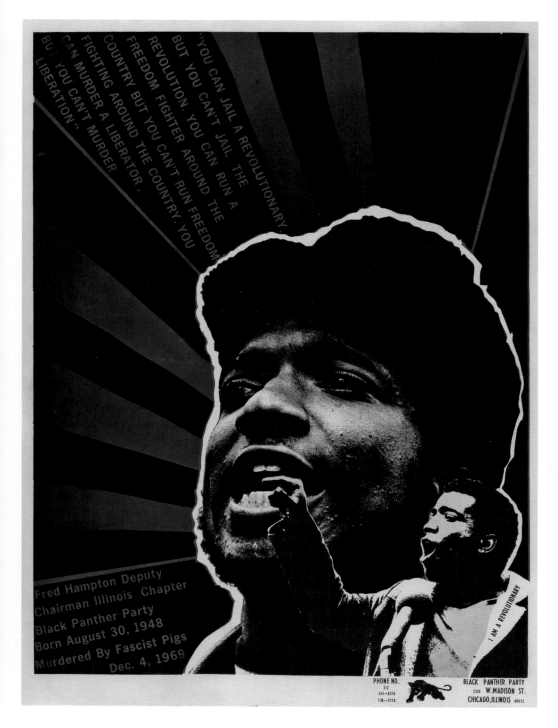

"YOU CAN JAIL A REVOLUTIONARY BUT YOU CAN'T JAIL THE REVOLUTION. YOU CAN RUN A FREEDOM FIGHTER AROUND THE COUNTRY BUT YOU CAN'T RUN FREEDOM FIGHTING AROUND THE COUNTRY. YOU CAN MURDER A LIBERATOR. BUT YOU CAN'T MURDER LIBERATION".

Fred Hampton Deputy
Chairman Illinois Chapter
Black Panther Party
Born August 30, 1948
Murdered By Fascist Pigs
Dec. 4, 1969

I AM A REVOLUTIONARY

PHONE NO.
312
243-4276
738-0778

BLACK PANTHER PARTY
2350 W. MADISON ST.
CHICAGO, ILLINOIS 60612

(OPPOSITE)
1970
EMORY DOUGLAS

Douglas understood the strength of a straight-forward graphic image for people who felt powerless. This was a poster for the party's weekly newspaper, the *Black Panther*, which he also designed.

1970
EMORY DOUGLAS

Douglas was the Minister of Culture for the Black Panther Party and the most prolific artist in the Black Power movement. His artwork depicted African Americans as outraged and ready to fight, rather than as victims of society. In this graphic poster, Douglas channels the rage over the murder of Fred Hampton, a Panther revolutionary killed in his apartment by the Chicago Police Department during a predawn raid.

CHAPTER 6
Vietnam
Hell No, We Won't Go

Each time a man stands up for an ideal, or acts to improve the lot of others, or strikes out against injustice, he sends forth a tiny ripple of hope, and crossing each other from a million different centers of energy and daring, those ripples build a current which can sweep down the mightiest walls of oppression and resistance.

ROBERT KENNEDY

Antiwar protesters were young and antiestablishment, and they banked on humor and irreverence to shock their leaders (and the public) into action.

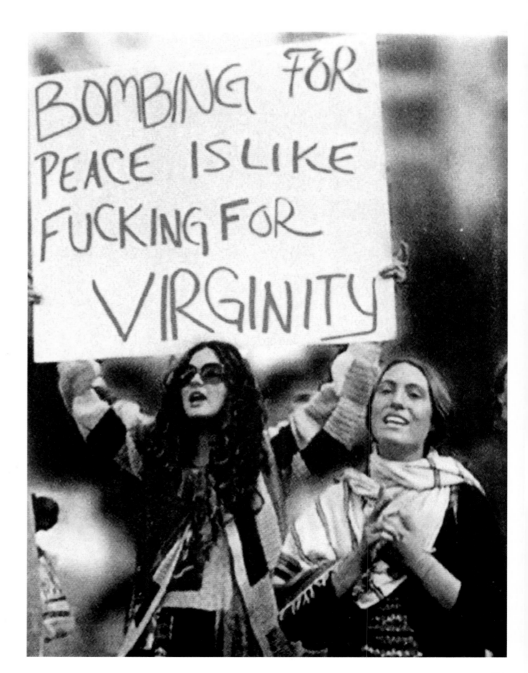

1968

This was a popular slogan, responding directly to the government's own questionable logic—i.e., that war saves lives.

(OPPOSITE)
1969
ROBERT ALTMAN

Another favorite rallying cry, this time held up at a moratorium to end the war, in San Francisco.

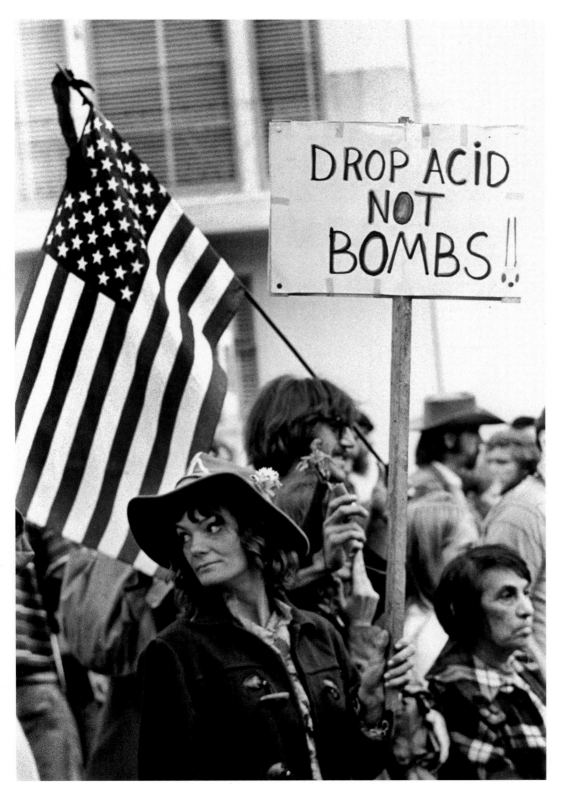

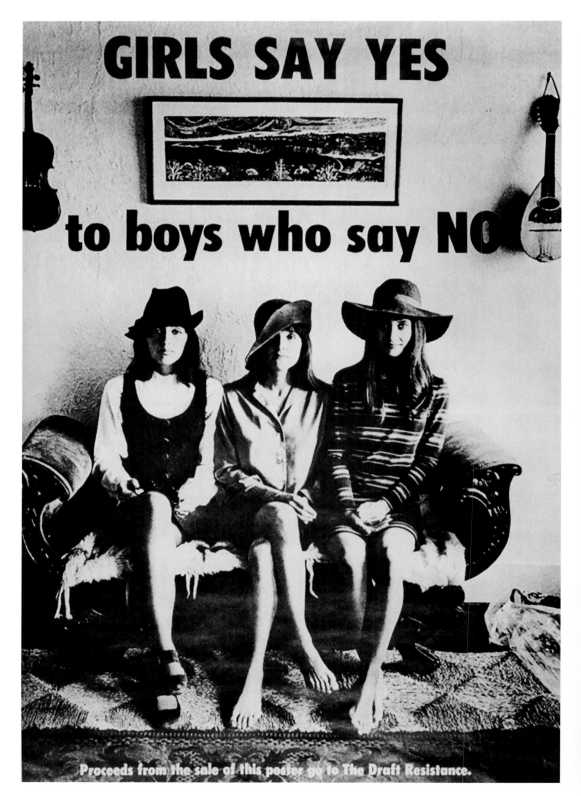

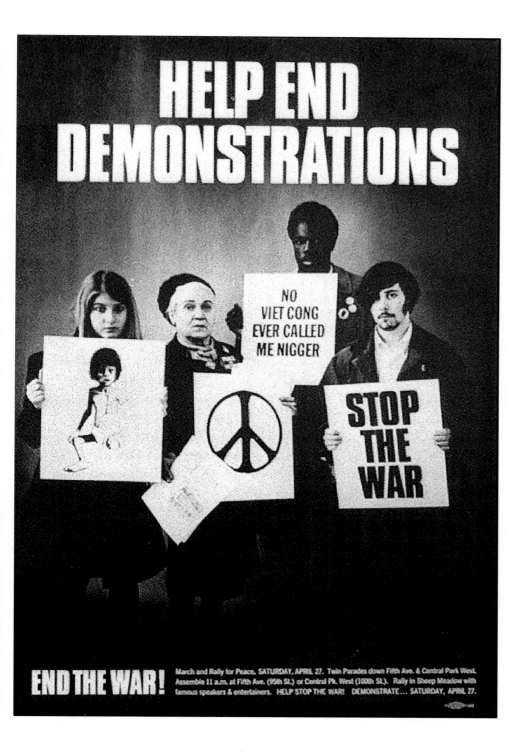

HELP END DEMONSTRATIONS

NO VIET CONG EVER CALLED ME NIGGER

STOP THE WAR

END THE WAR! March and Rally for Peace, SATURDAY, APRIL 27. Twin Parades down Fifth Ave. & Central Park West. Assemble 11 a.m. at Fifth Ave. (95th St.) or Central Pk. West (100th St.). Rally in Sheep Meadow with famous speakers & entertainers. HELP STOP THE WAR! DEMONSTRATE... SATURDAY, APRIL 27.

(OPPOSITE)
1968
JIM MARSHALL, photo
LARRY GATES, design

It wasn't all shock and anger. Celebrity and antiwar activist Joan Baez, (left) and her sisters, Pauline and Mimi, posed for this poster all girlish and innocent, effectively saying that resisting the draft was sexy.

1968

A call to action to convince people to attend a peace rally, this poster deliberately shows a cross section of generations and ethnicities. "No Viet Cong Ever Called Me Nigger" was a popular antiwar rallying cry in the African American community, first inspired by Mohammad Ali's famous declaration "I don't have no personal quarrel with those Viet Cong." By using it here, the protester seems to be asking "Who is the real enemy?"

Artists truly became the alarm system for society.

1968
STUDENTS FOR A
DEMOCRATIC SOCIETY

The SDS was the largest
and most influential
radical student organi-
zation of the 1960s.
Inspired by the civil
rights movement and
initially concerned with
equality, economic
justice, peace, and
participatory democracy,
the SDS grew with the
escalation of the
Vietnam War.

(OPPOSITE)
1967
ROBERT ROSS

Two incredibly aggres-
sive words, combined
with a crude, almost
childlike drawing of an
atomic cloud, created a
simple, stunning image
that resonated with angry
protesters.

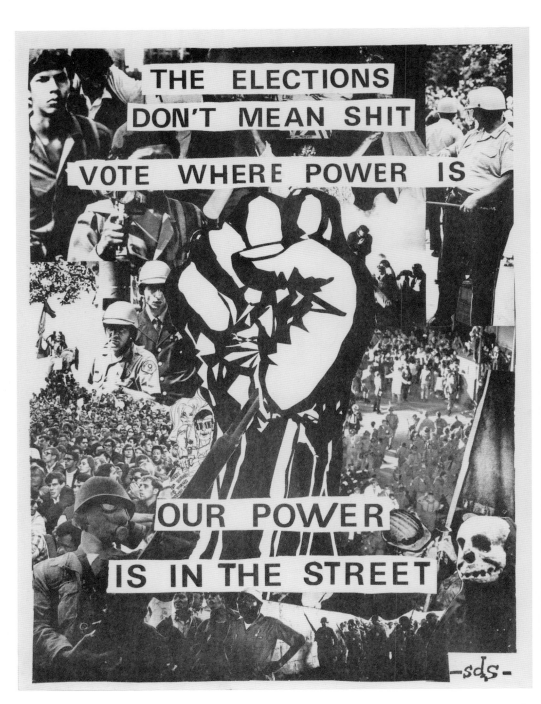

THE ELECTIONS
DON'T MEAN SHIT

VOTE WHERE POWER IS

OUR POWER
IS IN THE STREET

-sds-

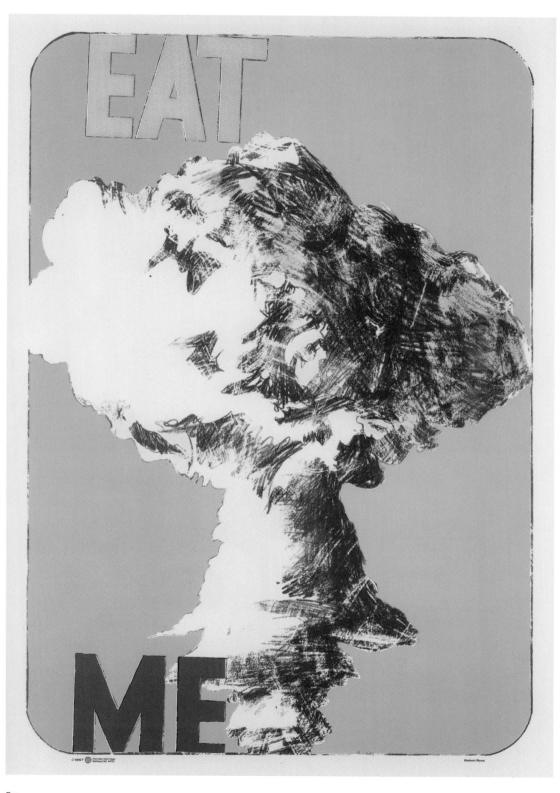

1968
KIYOSHI KUROMIYA

Kuromiya was a prominent civil rights leader and gay rights activist who was born in a Japanese internment camp in Wyoming during World War II. His iconic poster followed a tried-and-true persuasive design formula: one simple image, very few words, and a sprinkle of shock value. (It was unusual to see the word "fuck" in print, especially when combined with such a bold rejection of authority.) The FBI looked for Bill Greenshields, the man in the photo, but did not find him. Kuromiya went on to be one of the founders of ACT UP, and became a powerful advocate for AIDS patients. He himself died of the disease in 2000.

(OPPOSITE)
1968
KIYOSHI KUROMIYA

This ad, appearing in an underground newspaper called the *Berkeley Barb*, took the protest one step further. You could buy five posters and have the sixth sent to the "mother" of your choice—i.e., men and women who might not necessarily welcome the gesture. The Secret Service arrested Kuromiya, charging him with using the U.S. Mail to incite with lewd and indecent materials.

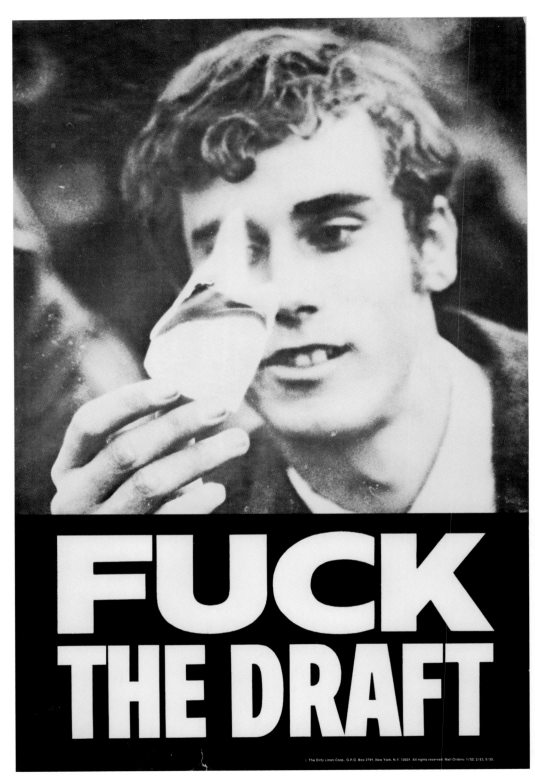

FUCK THE DRAFT

: The Dirty Linen Corp., G.P.O. Box 2791, New York, N.Y. 10001. All rights reserved. Mail Orders: 1/$2, 2/$3, 5/$5.

HERE'S A LITTLE SOMETHING ❀ FOR ❀ MOTHER'S ❀ DAY ❀ ☞

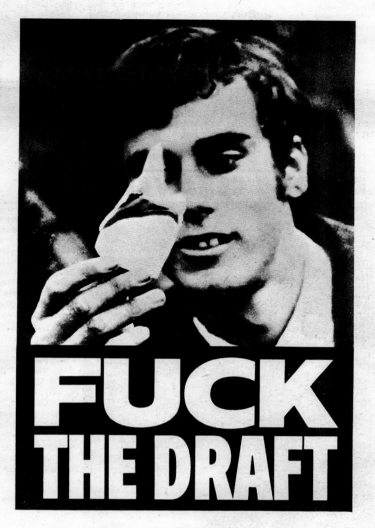

FUCK THE DRAFT

Send for five posters ($5) and we'll send a sixth one free to the mother of your choice. Please send my sixth (free) poster to:

- ☐ Mrs. Lady Bird Johnson
- ☐ Mrs. Shirley Temple Black
- ☐ Lieutenant General Lewis B. Hershey
- ☐ General William Westmoreland
- ☐ Madame Ngo Dinh Nhu
- ☐ Mr. J. Edgar Hoover
- ☐ Mrs. Richard Hughes
- (other specify)_____

Single poster $2, two for $3, five for $5. Send cash, check or money order.

The Dirty Linen Corp.
Dept. B
G.P.O. Box 2791
New York, N.Y. 10001

NAME_____

ADDRESS_____

CITY_____ STATE_____ ZIP_____

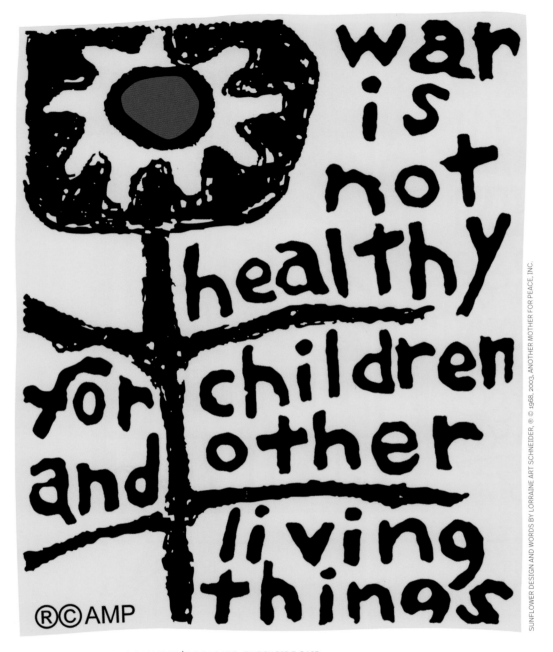

war is not healthy for children and other living things

®©AMP

ORIGINALLY CREATED AS A MOTHER'S DAY CARD, THE INSIDE SAID:

For my Mother's Day gift this year,
I don't want candy or flowers.
I want an end to killing.
We who have given life must
be dedicated to preserving it.
Please talk peace.

The antiwar movement was launched by the younger generation, the ones being asked to risk their lives. Naturally, the mothers of the younger generation soon followed suit.

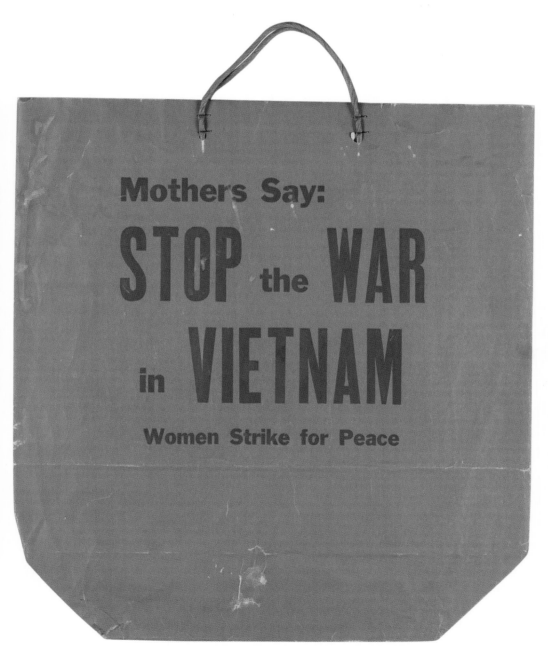

Mothers Say:
STOP the WAR in VIETNAM
Women Strike for Peace

(OPPOSITE)
1968
LORRAINE SCHNEIDER,
ANOTHER MOTHER FOR
PEACE

Another Mother for Peace was a grassroots antiwar group created to encourage women to become activists. Schneider, who was worried about her oldest son being drafted, made this picket sign and it became one of the most ubiquitous antiwar icons of all time. "It had to say something, something logical," she said, "something irrefutable and so true that no one in the world could say it was not so." Before it was a poster, it was a Mother's Day card, and the group sent 200,000 of them to members of Congress.

1968
A shopping bag for mothers who wanted to wear their cause every day.

The Berkeley political posters were raw and crude and immediately communicated the rage and frustration of the artists.

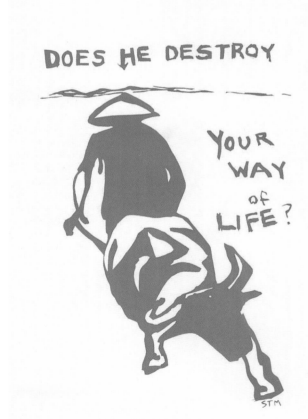

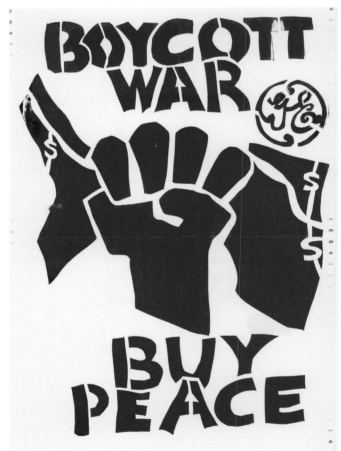

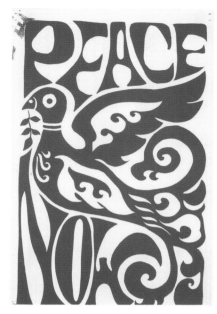

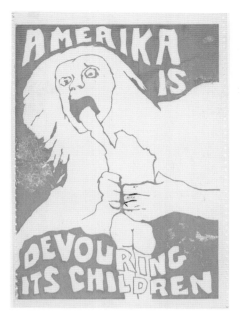

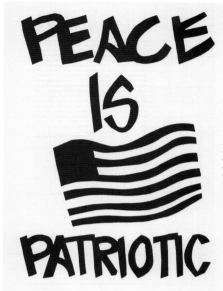

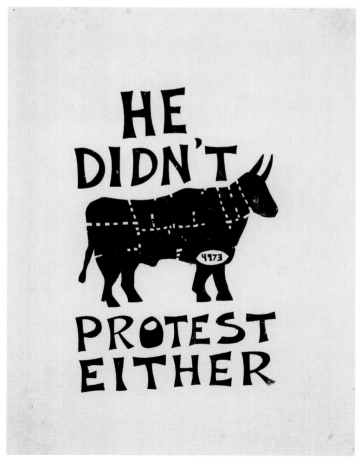

1970
BERKELEY POLITICAL
POSTER WORKSHOP

After the Ohio National Guard shot and killed four students at Kent State University, student activists got together in Berkeley with a mission to use art as a protest weapon. The Berkeley Political Poster workshop was formed and in just a few months, they silkscreened an estimated 50,000 prints of nearly 600 different posters protesting everything from the escalation of war into Cambodia to the reinstatement of the draft. The posters were meant to be seen as a group, "as a melody, not as single notes." For the same reason, no individual artist gave him- or herself personal credit on any one image.

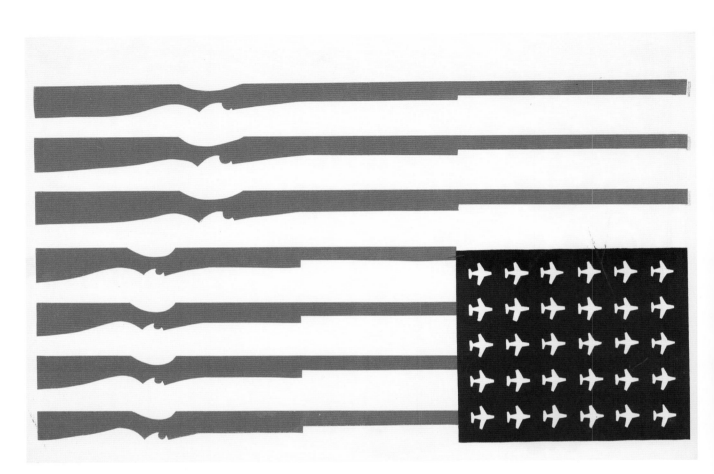

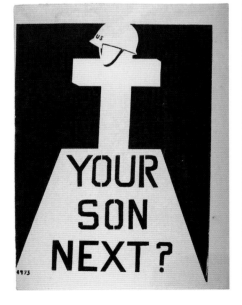

YOUR
SON
NEXT?

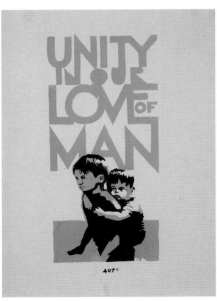

UNITY
IN OUR
LOVE OF
MAN

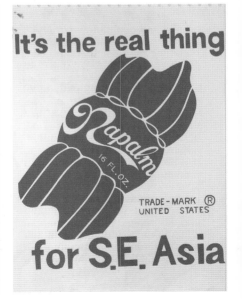

It's the real thing

Napalm
16 FL. OZ.

TRADE-MARK ®
UNITED STATES

for S.E. Asia

"We came in peace for all mankind" were the words written on a plaque that was left on the moon by the Apollo 11 astronauts (while we were fighting in Vietnam). Here, a Berkeley artist co-opted those same words to devastating effect.

1970
BERKELEY
POLITICAL POSTER
WORKSHOP

It was art by any means necessary: The artists silkscreened on cardboard, computer printer paper, poster board, and scrap paper with printing on the other side. The posters were displayed all over the campus, Berkeley, and Oakland.

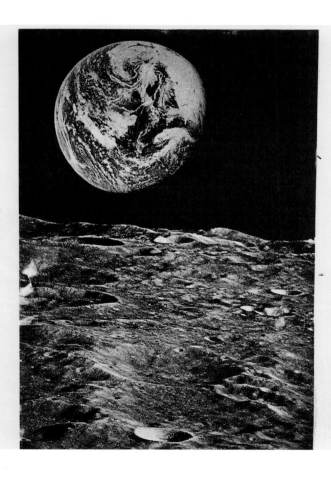

DID WE REALLY COME IN PEACE FOR ALL MANKIND?

Artists used the colors of the flag for what might be called "antipatriotic" messages. Here, rendering the images and the messages in red, white, and blue was very intentional.

1969

"You Can't Jail the Revolution" was a Black Panther slogan and here refers to the Chicago 8, antiwar activists who were charged with conspiracy to cross state lines with intent to incite a riot during the 1968 Democratic Convention. The eight included members of SDS, the Black Panthers, and the Yippies. The illustration references the American sprinters who famously gave the Black Power salute on the medal stand at the 1968 Olympics.

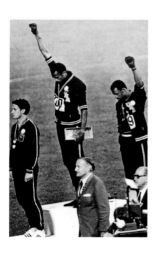

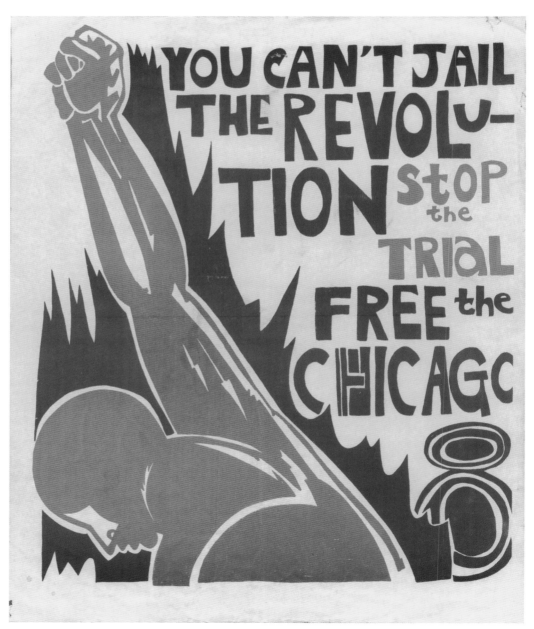

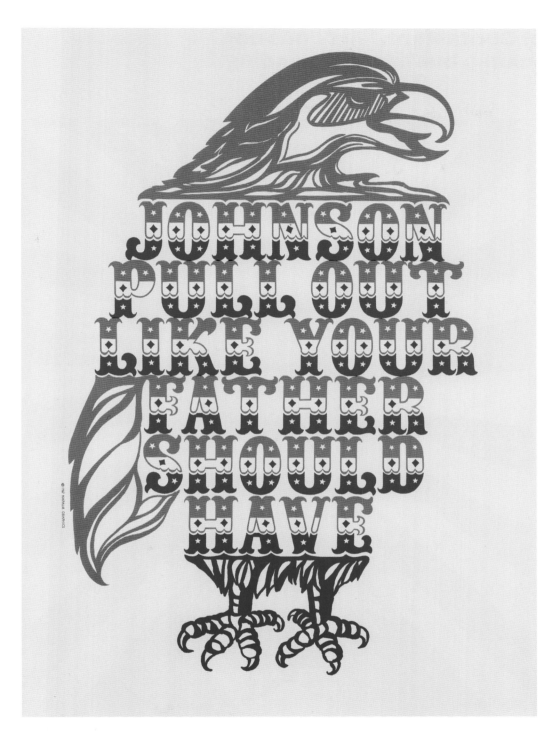

JOHNSON PULL OUT LIKE YOUR FATHER SHOULD HAVE

1967
NAPALM GRAPHICS

At first glance, you see the American eagle, symbol of our country, resplendent in stars and stripes. On closer inspection, you get a pretty insulting message to the president reflecting the anger about his promises of withdrawal.

In the words of Corita Kent, "Art does not come from thinking, but from responding."

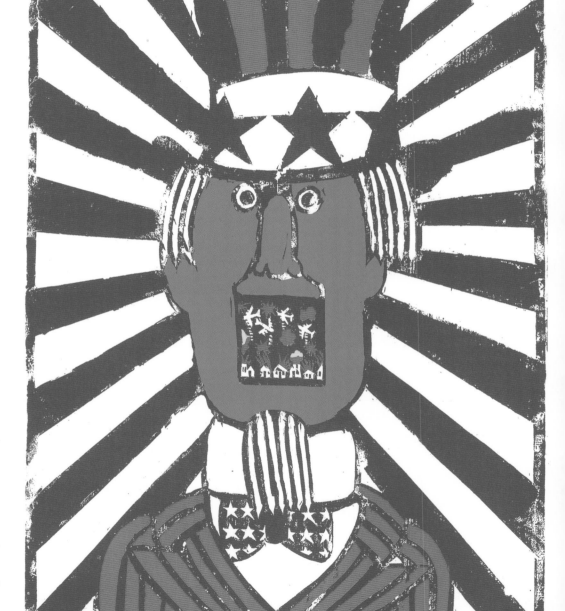

1967
SEYMOUR CHWAST

Chwast created this poster using a green-faced Uncle Sam to protest the bombing of Hanoi. Witty, dark, and wry, with an ironically patriotic image, it was one of the most memorable posters of the era.

(OPPOSITE)
1967
CORITA KENT

Kent was an artist, educator, advocate for social justice, and nun. She channeled her rebellious spirit into inventive works using graphic type and color to promote social change.

End Bad Breath.

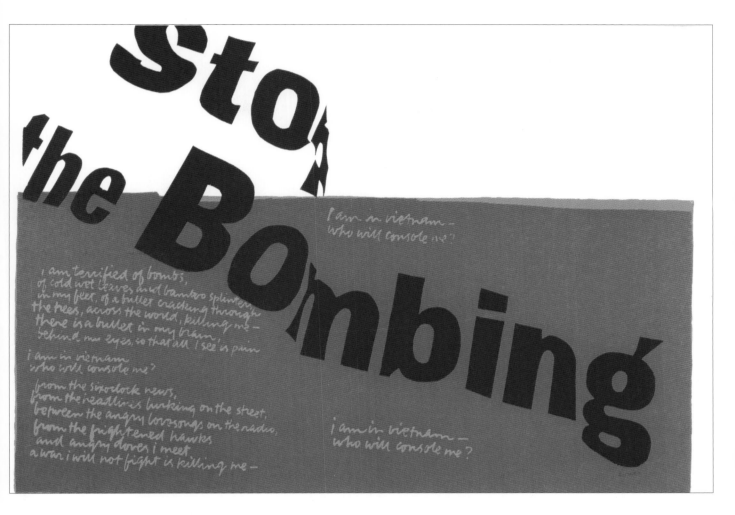

THE TEXT READS:

I am in Vietnam–who will console me?
I am terrified of bombs, of cold wet leaves and
bamboo splinters in my feet, of a bullet cracking
through the trees, across the world, killing me–
there is a bullet in my brain, behind my eyes,
so that all I see is pain
I am in Vietnam–who will console me?
from the six o'clock news, from the headlines lurking on
the street, between the angry love songs on the radio,
from the frightened hawks and angry doves I meet
a war I will not fight is killing me–I am in Vietnam–
who will console me? Stop the Bombing

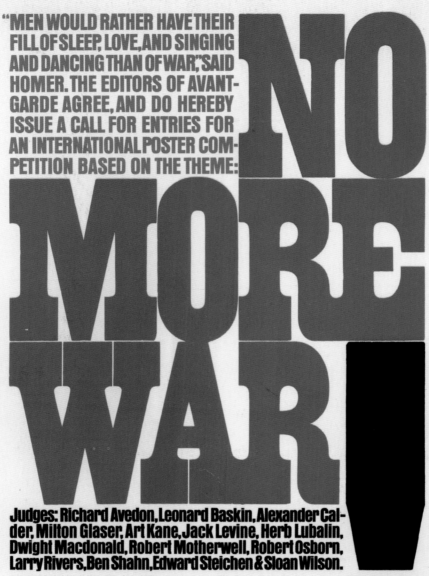

"MEN WOULD RATHER HAVE THEIR FILL OF SLEEP, LOVE, AND SINGING AND DANCING THAN OF WAR," SAID HOMER. THE EDITORS OF AVANT-GARDE AGREE, AND DO HEREBY ISSUE A CALL FOR ENTRIES FOR AN INTERNATIONAL POSTER COMPETITION BASED ON THE THEME:

NO MORE WAR!

Judges: Richard Avedon, Leonard Baskin, Alexander Calder, Milton Glaser, Art Kane, Jack Levine, Herb Lubalin, Dwight Macdonald, Robert Motherwell, Robert Osborn, Larry Rivers, Ben Shahn, Edward Steichen & Sloan Wilson.

THE RULES OF THE CONTEST ARE AS FOLLOWS: All professional painters, designers, illustrators, cartoonists, and other graphic artists are eligible. Amateurs may enter, too, but only after elimination contests at colleges, art and photography schools, museums, and similar institutions.

Ten winners will be selected. All winning posters will be reproduced and sold for $1 each through bookstores, art supply shops, coffeehouses, boutiques, and similar retail outlets. Sales will be promoted by vigorous advertising and publicity campaigns. Profits will be donated to peace causes as designated by the judges.

Artists will receive a 10% royalty on sales. Advances totaling $1,400 will be presented as follows: $500 to a grand prize-winner and $100 to each of the other nine winners.

All winning posters will be featured in an issue of Avant-Garde Magazine. Fifty of the best entries will be exhibited at a New York museum or gallery and sent on tour of the United States.

Choice of subject matter is at the discretion of individual artists (though posters must bear some relationship to the theme of the contest, world peace). Posters may carry any related slogan, caption, or title—or none at all—and may relate to specific conflicts, such as the war in Vietnam. Entries will be judged on the basis of artistic merit and impact of anti-war message.

Judging will take place in New York on May 30, 1968, Memorial Day. Winners will be announced at a press conference held immediately thereafter.

Deadline is 5 p.m., Monday, May 27, 1968. Entries may not exceed 19" x 25" in size and must be accompanied by artist's name and address.

The address of Avant-Garde, both for entries and inquiries, is 110 W. 40th St., New York, N.Y. 10018, U.S.A.

LEGAL STIPULATIONS: This contest is a non-profit undertaking. All revenues remaining from sales of posters after payment of royalties and out-of-pocket expenses will be donated to peace causes as designated by the judges. Financial records will be audited by certified public accountants. Avant-Garde will exercise all possible care in the handling of entries but assumes no responsibility for loss or damage. Avant-Garde reserves the right to change contest rules or cancel the contest entirely for any reason whatsoever. © 1967 by Avant-Garde. PRINTED IN U.S.A.

AVANT GARDE

Avant Garde magazine sponsored an international poster contest, with design and art world luminaries as judges, and printed the standout winners in the next issue.

BILLY APPLE, ENGLAND, AND ROBERT COBURN, U.S.A.

(OPPOSITE)
1968
HERB LUBALIN

An advertisement for the antiwar poster compe-tition appeared in the magazine, and ironically, the image announcing the contest became better known than any of the winning entries.

1968
BILLY APPLE
ROBERT COBURN

One of the winners of the competition, this poster was interactive, encouraging protesters to invite people to join the movement.

1968
RON AND KAREN BOWEN

Another contest winner used an iconic World War II image, depicting the soldiers raising a flower (i.e., peace) instead of the American flag at Iwo Jima. No words necessary.

(OPPOSITE)
1968
SEYMOUR CHWAST

Chwast reimagined a popular slogan as an ironic recruitment poster from another era.

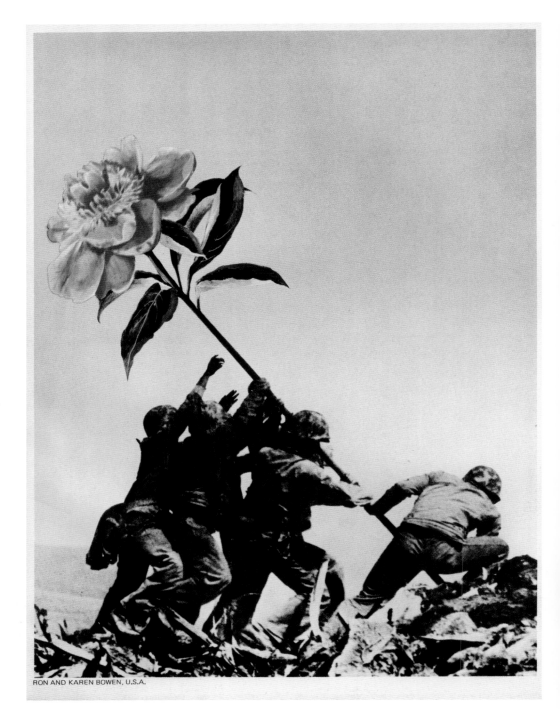

RON AND KAREN BOWEN, U.S.A.

THE NEXT WAR WILL DETERMINE NOT WHAT IS RIGHT BUT WHAT IS LEFT.

(OPPOSITE)
1972
HERB LUBALIN

Lubalin is considered one of the greatest typographers and art directors ever, and managed to imbue meaning clearly and elegantly through type wordplay and some tiny, well-placed imagery. He designed this famous poster for a competition called "Survival."

1967
TOMI UNGERER

Ungerer's antiwar posters were often deemed too radical for the movement, so he printed and distributed them himself. This one, a woodcut, is a violent visualization of America forcing its ideals on the Vietnamese people.

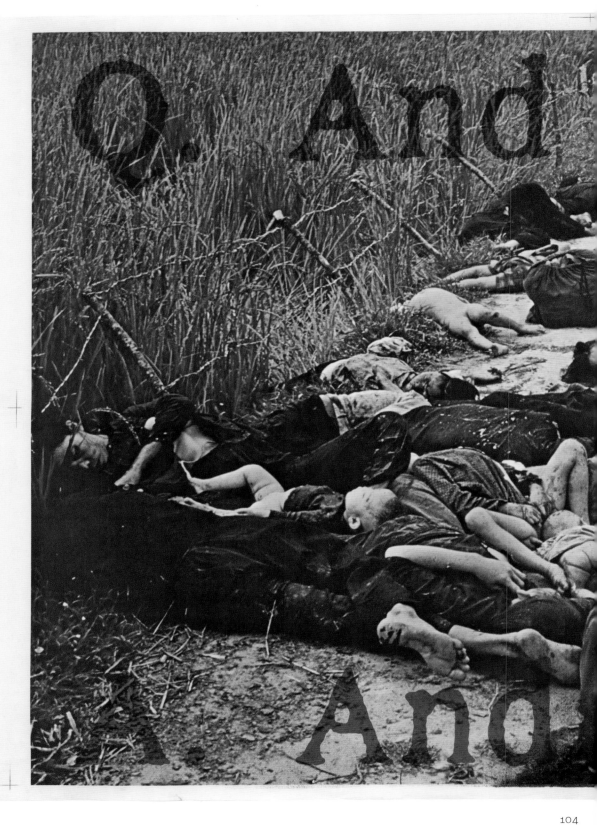

104

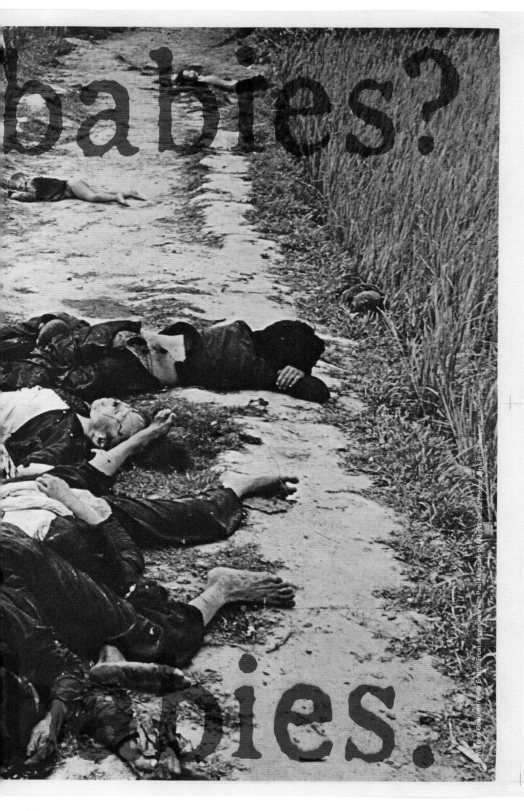

The type on the poster within the image reads: **babies?** ... **bies.**

Image caption (vertical text along right edge of photo): Art Workers Coalition/Peter Brandt/From an interview with Paul Meadlow by Mike Wallace/Photograph © R. L. Haeberle

1969
ARTISTS POSTER
COMMITTEE OF THE ART
WORKERS COALITION
RON L. HAEBERLE, photo

After the My Lai Massacre, Mike Wallace interviewed a soldier who had participated in it, asking if he had killed men, women, and children. The soldier confirmed, "Men, women, and children." Wallace added, "And babies?" The soldier answered, infamously, "And babies." The type on this horrifying photograph came directly from a *New York Times* printing of the transcript; the words were blown up and changed from black to blood-red. The resulting poster shocked the world and successfully generated fresh outrage against the war, in a way that words alone had not.

1972
CLERGY AND LAYMEN
CONCERNED

Showing dead American soldiers challenged the way the public thought of Vietnam. Combined with the sarcastic headline, mocking the government's explanation, it was an important step toward forcing Americans to contemplate the horrors of war.

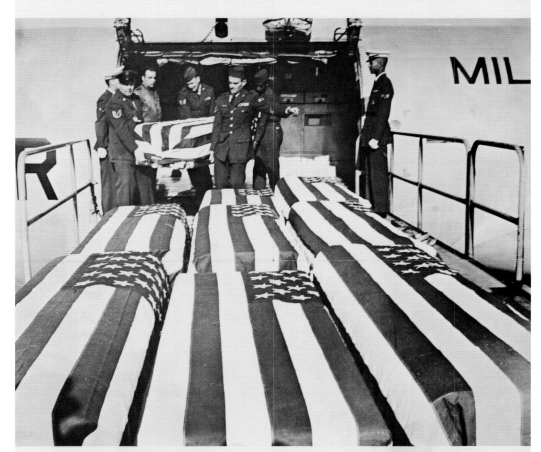

Is this what you'd call "PHASED WITHDRAWAL?"

CLERGY AND LAYMEN CONCERNED, 475 Riverside Drive, New York, New York 10027

price: 1 for $1.25—5 for $4.00—10 for $6.50—100 for $30.00

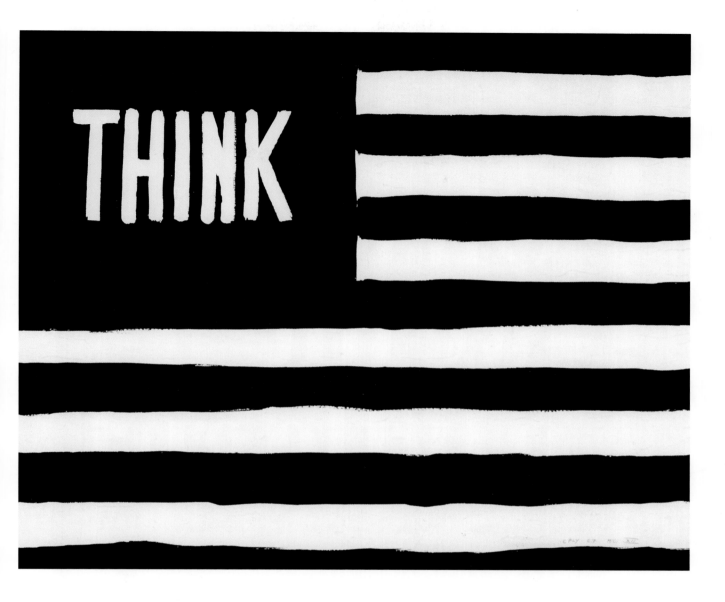

If either of these had been done in color, they wouldn't have been as powerful.

1967
WILLIAM N. COPLEY

A reimagined flag is always an arresting design strategy. This was one of the works included in a portfolio released by Artists and Writers Protest, Inc. In stark black and white, it implores Americans to really think about the war and, of course, what it means to be American.

AUGUST 1966
PRICE 75c

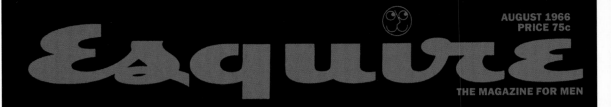

Esquire

THE MAGAZINE FOR MEN

"Oh my God –we hit a little girl."

The true story of M Company. From Fort Dix to Vietnam.

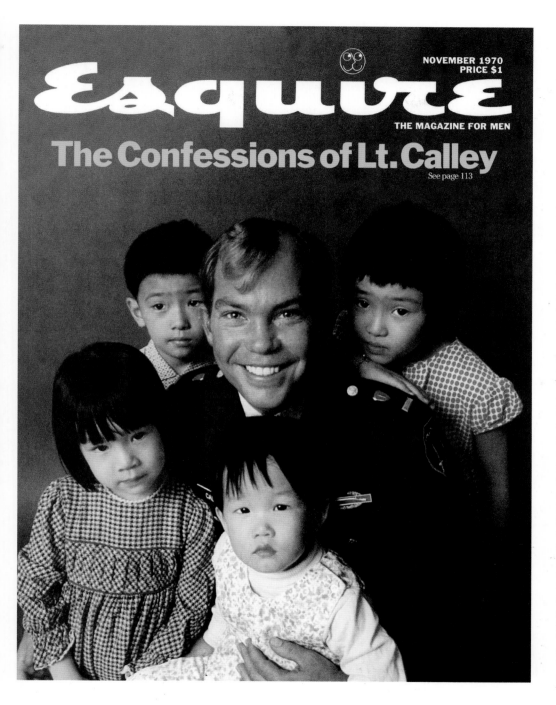

NOVEMBER 1970
PRICE $1

Esquire

THE MAGAZINE FOR MEN

The Confessions of Lt. Calley

See page 113

(OPPOSITE)
1966
GEORGE LOIS

The mainstream media stepped up as well. Specifically, *Esquire*'s art director George Lois created countless powerful pieces of propaganda that stared at readers from newsstands and coffee tables where they could not be ignored. On this famous cover, quoting a GI's horrified reaction as he came upon the body of a dead Vietnamese girl, he knew that no illustration was necessary. The quote was enough.

1970
GEORGE LOIS
CARL FISCHER, photo

Lieutenant William L. Calley Jr. was charged as a war criminal for killing 102 civilians in the My Lai Massacre, and Lois shot this cover while Calley was awaiting trial. To many, Calley was the face of evil, personifying all that was senseless and horrifying about Vietnam; still others defended him, saying he was merely a scapegoat. Lois later explained the motive behind the cover, showing Calley in an eerily cheery pose surrounded by Vietnamese children: "Those who think he's innocent will say that proves it. Those who think he's guilty will say that proves it."

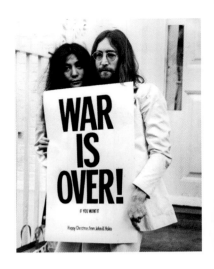

When John Lennon was asked how much the billboards cost, he replied, "I don't know— but it is cheaper than someone's life."

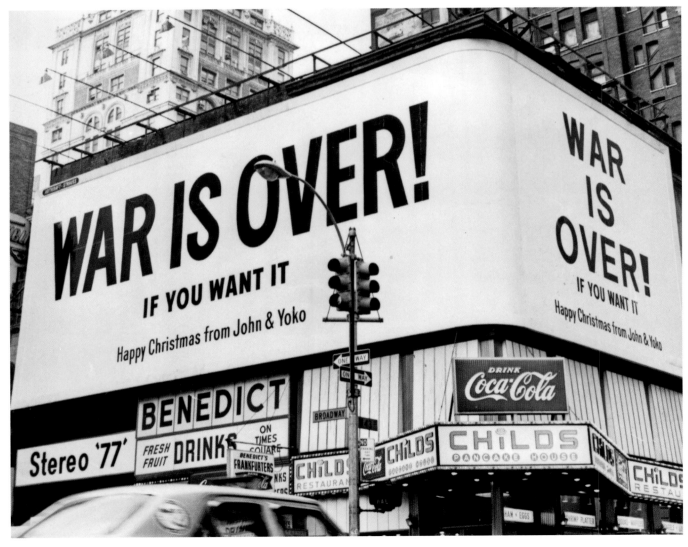

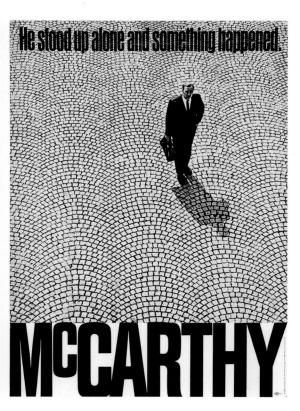

There was also power in imagining peace.

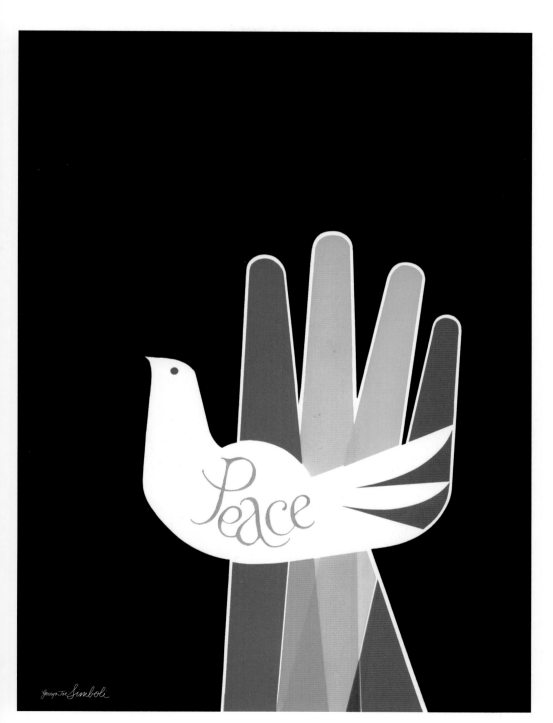

(OPPOSITE)
1968

The posters calling for peace were abundant and beautiful as well. Their goal was to inspire people to reconsider their hopes and dreams for America.

1968
SIMBOLI DESIGN

Another entry in *Avant Garde*'s No More War poster contest, by Joe Simboli (who was at the liberation of the Ohrdruf concentration camp during World War II), combined the dove of peace with a multiracial open hand.

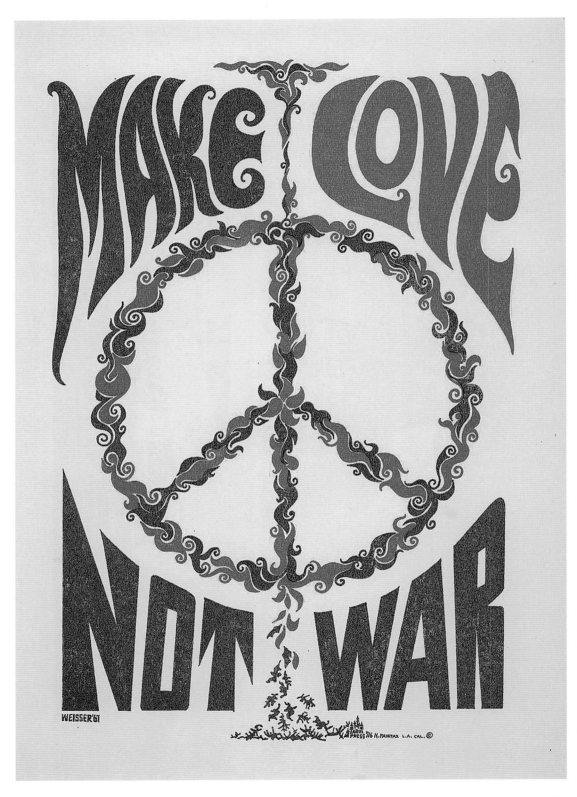

WEISSER'61

114

YOU ARE ALREADY INVOLVED.

The myth of the "silent majority" is dead. We are all involved. It is no longer possible to avoid our responsibilities and to seek refuge in silence and apathy. Name calling, blind patriotism, and simplistic political cliches cannot negate 40,000 American war dead and the destruction of Southeast Asia and its people; nor can they negate the toll which this war and its consequences have inflicted upon American society. No escape can be found in the abdication of political responsibility. Each of us must examine the situation and recognize his position.

In the past few weeks, students and faculty from the nation's universities have taken positive measures to end U.S. military involvement in S.E. Asia. In an unprecedented effort to educate ourselves and the general public to the issues of the war and the implications within our society, the campus community has demonstrated the need for active participation. Writing, speaking, and lobbying have prevailed across the country. Such legitimate and necessary dissent must be reinforced by public support.

Personal action in a country as complex as ours often seems futile. But personal commitment is crucial for our society to face its problems and overcome them. Our form of government is based upon our legislators' representing our convictions. We must make these convictions known to them. Let us move together to bring to the attention of our fellow men their obligation to act and to support those who have made a commitment to ending the war. We must each recognize our personal responsibility to act, and move accordingly. We are already involved.

This statement has been sponsored by the students and faculties of University of California: at Berkeley, Davis, Irvine, Los Angeles, Riverside, Santa Barbara, Santa Cruz, San Diego, San Francisco; University of the Pacific; Claremont Mens College; Pitzer College; Pomona College; Stanford University; University of Southern California; San Jose State College; San Francisco State College; San Diego State College; San Fernando Valley State College; Hastings Law School; Boalt Law School; Mills College; Long Beach State College and their professional counterparts.

1.
TAKE PERSONAL ACTION:
Write; Campaign

Make a personal commitment to write 20 postcards to legislators expressing your opposition to the war—OR—pledge 20 hours of campaign time to a peace candidate of your choice.

2.
SUPPORT STATE LEGISLATION:
Vasconcellos Bill

This bill in Sacramento protects California residents from fighting in wars that have not received Congress' explicit approval and are thus unconstitutional. Write to Speaker of the Assembly Robert Monagan, State Capitol, Sacramento, and your local assemblyman.

3.
SUPPORT FEDERAL LEGISLATION:
McGovern-Hatfield Amendment

This amendment exercises Congress' power to control funds calling for a stoppage of funds for Cambodia 30 days after the passage of the amendment, stoppage of funds for military operations in S.E. Asia after June 30, 1971.

4.
CONTRIBUTE FUNDS:

Help the universities continue their peace efforts.

CONSTRUCTIVE ALTERNATIVES, R. Remer, Chmn. 1124 F Street, Apt. 21 Davis, California 95616

[] I pledge to write 20 postcards to legislators expressing my opposition to the war.
[] I pledge to work 20 hours in the next congressional campaign for a candidate who is against the war.

Name _____
Address _____
City, State _____

HON. CARL BRITSCHGI State Capitol Sacramento, Calif.

I endorse & urge the passage of the Vasconcellos bill, 1974.

Name _____
Address _____
City, State _____

SENATOR ALAN CRANSTON U.S. Senate Washington, D.C.

I endorse & urge the passage of the McGovern-Hatfield amendment.

Name _____
Address _____
City, State _____

CONSTRUCTIVE ALTERNATIVES, R. Remer, Chmn. 1124 F Street, Apt. 21 Davis, California 95616

I have enclosed $ _____
in [] Cash
[] Money Order
[] Check
To further peace efforts such as this ad.

Name _____
Address _____
City, State _____

BERKELEY GRAPHIC ARTS

These artists made their poster interactive—because if you weren't speaking out, you were part of the problem.

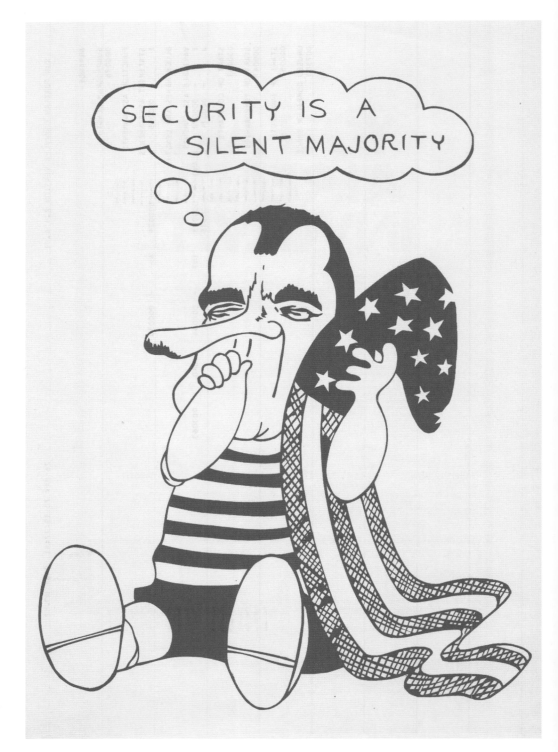

1970

In a brutally sarcastic dig, a Linus-inspired Nixon comforts himself by clinging to the myth of the Silent Majority.

THE SILENT MAJORITY

Honoring a great tradition in protest, artists took words that came right out of the president's mouth—"the Silent Majority"— and turned them back on him.

THE WHITE HOUSE
WASHINGTON

May 7, 1970

PERSONAL

Dear Friends:

I want to thank you for your thoughtfulness in sending me the framed award you received from the Los Angeles Art Directors Club for your poster entitled, "Silent Majority." It was very kind of you to share this honor with me, and I was pleased to learn that your entry won such high distinction.

With my best wishes to you and your colleagues,

Sincerely,

Richard Nixon

Women's Equality
Reclaiming Our Time

Feminism has never been about getting a job for one woman. It's about making life more fair for women everywhere. It's not about a piece of the existing pie; there are too many of us for that. It's about baking a new pie.

GLORIA STEINEM

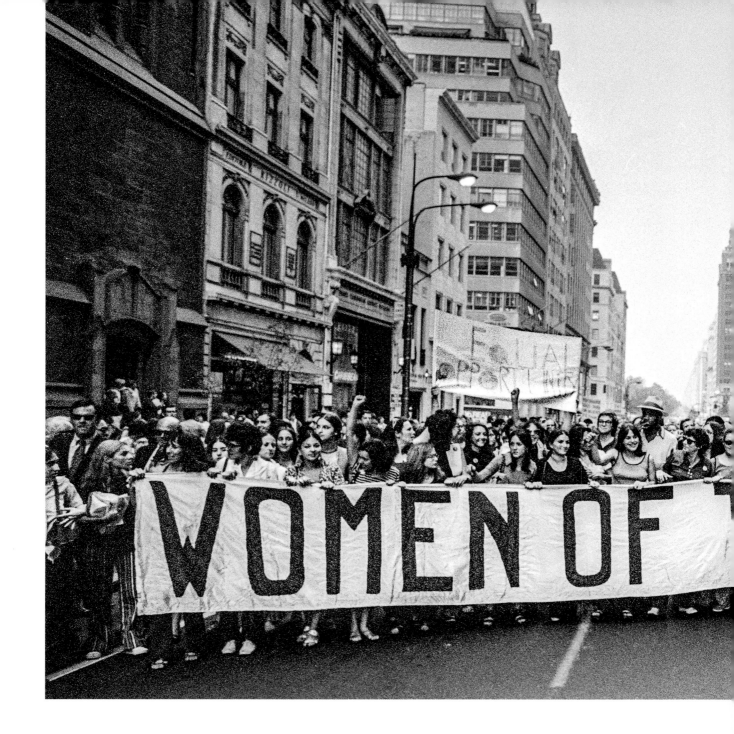

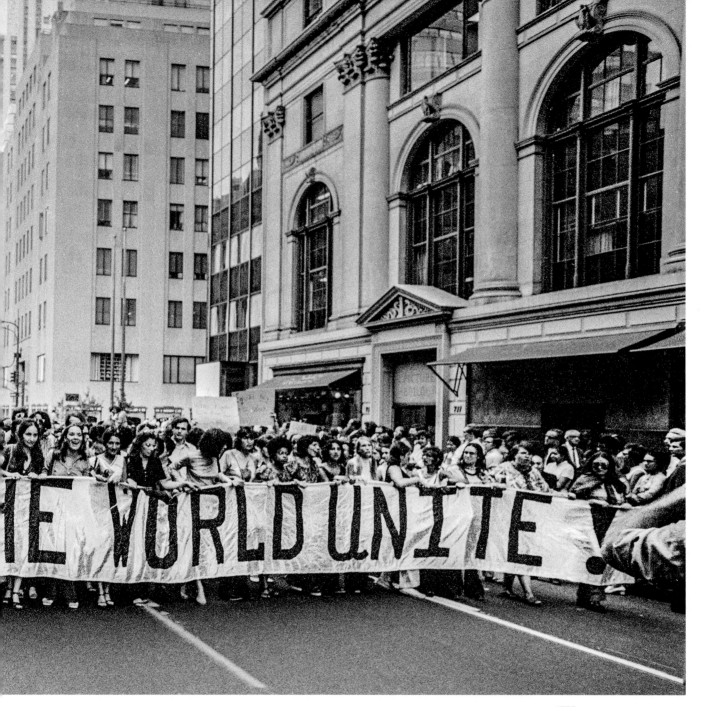

1970
BOB ADELMAN

Fifty thousand marched in New York City during the Women's Strike for Equality and to celebrate the fiftieth anniversary of the Nineteenth Amendment.

No one designer put her name on these, because it wasn't about their individual egos, it was about the common cause.

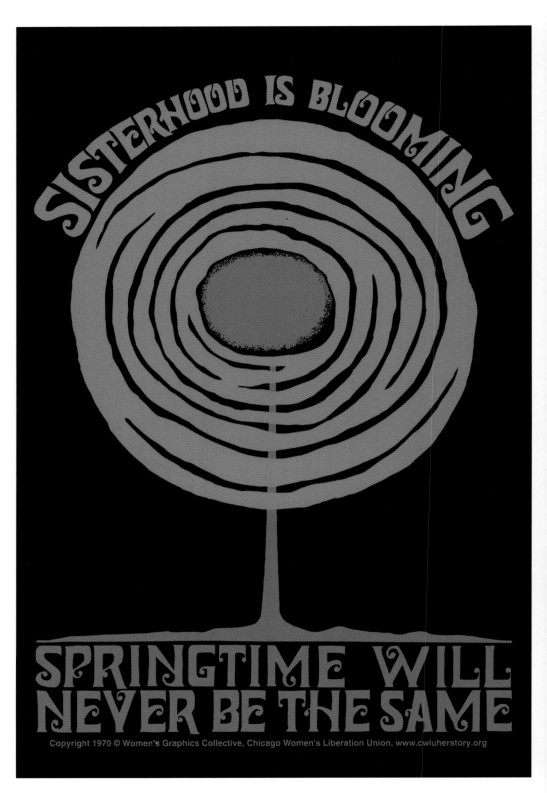

SISTERHOOD IS BLOOMING

SPRINGTIME WILL NEVER BE THE SAME

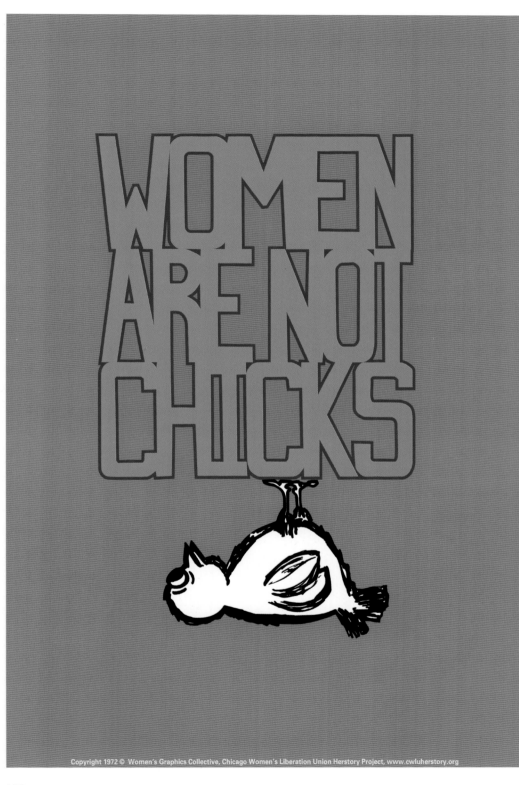

(OPPOSITE)
1970
THE CHICAGO WOMEN'S
GRAPHICS COLLECTIVE

The Collective held workshops about women's leadership, health, education, and safety—a radical concept at the time. They also designed beautiful posters, using bright, bold colors and borrowing imagery from Mother Nature.

1972
THE CHICAGO WOMEN'S
GRAPHICS COLLECTIVE

The Collective understood that changing women's positions in society required (and still requires) changes in expectations, jobs, childcare, and education.

1978
SEE RED WOMEN'S
WORKSHOP

The Workshop was
founded in 1974 to combat
the negative images of
women in the media. This
quote was pulled from a
magazine interview with
Mme. Phan Thi Minh,
a former resistance
fighter in South Vietnam
and an advisor to the
provisional Revolutionary
Government.

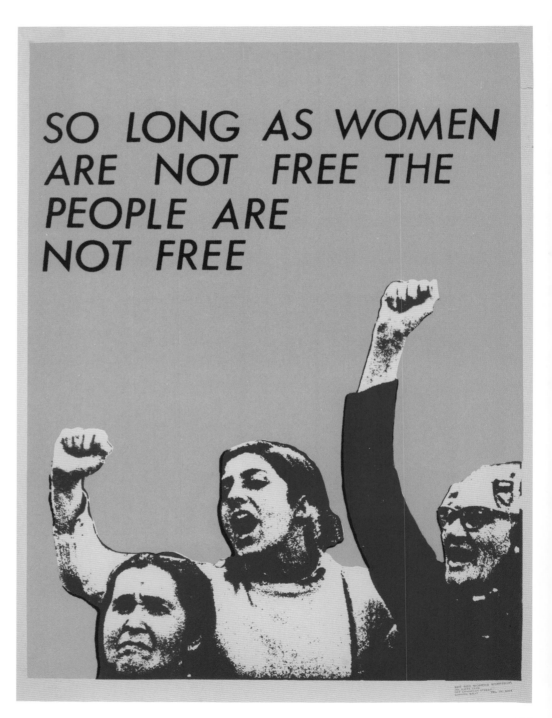

The homespun look gave it built-in trust. It sent a silent message that *Our Bodies Ourselves* was indeed by women, for women.

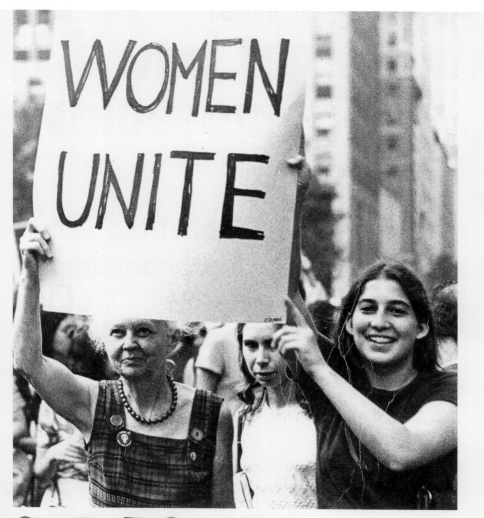

WOMEN UNITE

OUR BODIES OURSELVES

A BOOK BY AND FOR WOMEN

BY THE BOSTON WOMEN'S HEALTH BOOK COLLECTIVE $2.95

1973

In 1969, twelve women met during a women's liberation conference in Boston and found discussions about their health and sexuality so fulfilling, they decided to share them, first in a stapled 193-page booklet (BELOW) titled *Women and Their Bodies*, then later published as *Our Bodies Ourselves*, emphasizing women's ownership of their bodies. It quickly became the bible for women, selling millions of copies around the world.

WOMEN and THEIR BODIES a course

WOMEN UNITE

by BOSTON WOMEN'S HEALTH COLLECTIVE

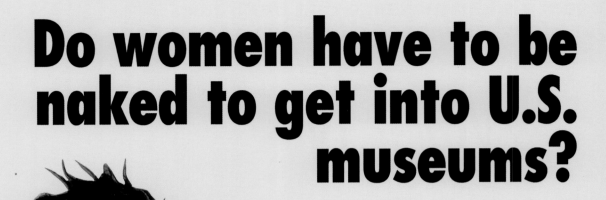

Do women have to be naked to get into U.S. museums?

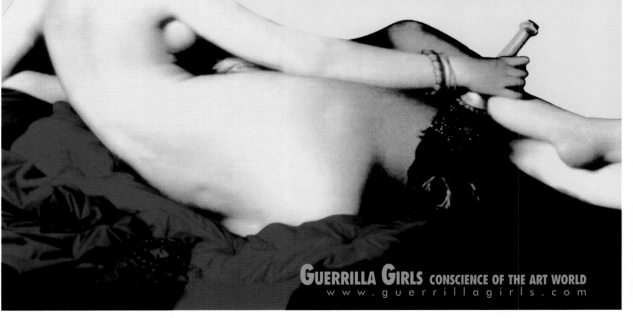

Less than **3%** of the **artists** in the Met. Museum are women, but **83%** of the **nudes** are female.

Statistics from modern and contemporary galleries, Metropolitan Museum of Art, New York, 2004

GUERRILLA GIRLS CONSCIENCE OF THE ART WORLD
www.guerrillagirls.com

GUERRILLA GIRLS' POP QUIZ

Q. If February is Black History Month and March is Women's History Month, what happens the rest of the year?

A. discrimination

A PUBLIC SERVICE MESSAGE FROM **GUERRILLA GIRLS** CONSCIENCE OF THE ART WORLD

GUERRILLA GIRLS' DEFINITION OF A HYPOCRITE.

(hip' o-crit) An art collector who buys white male art at benefits for liberal causes, but never buys art by women or artists of color.

Box 1056 Cooper Sta., NY, NY 10276 **GUERRILLA GIRLS** CONSCIENCE OF THE ART WORLD

(OPPOSITE)
2005
GUERRILLA GIRLS

The Guerrilla Girls is a group of anonymous, feminist art activists. They use facts, humor, and outrageous visuals to expose gender and ethnic bias in contemporary culture. Initially, they paid special attention to the art world, but eventually they broadened their focus.

(TOP AND BOTTOM)
1990
GUERRILLA GIRLS

These are two images from Guerrilla Girls Talk Back, a portfolio of thirty images that called out what they felt was blatant sexism and racism in Hollywood, government, and mass media.

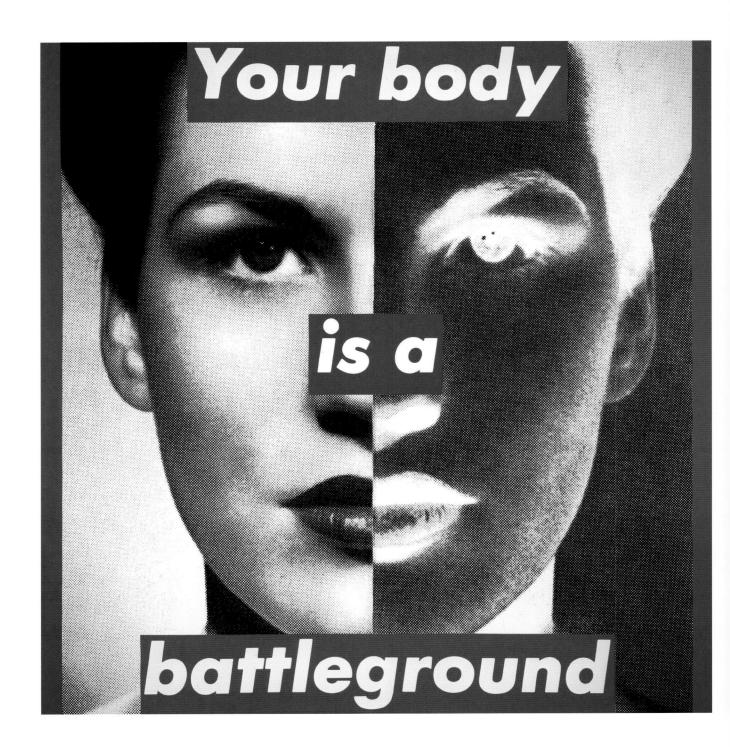

128

When art is protest and protest is art.

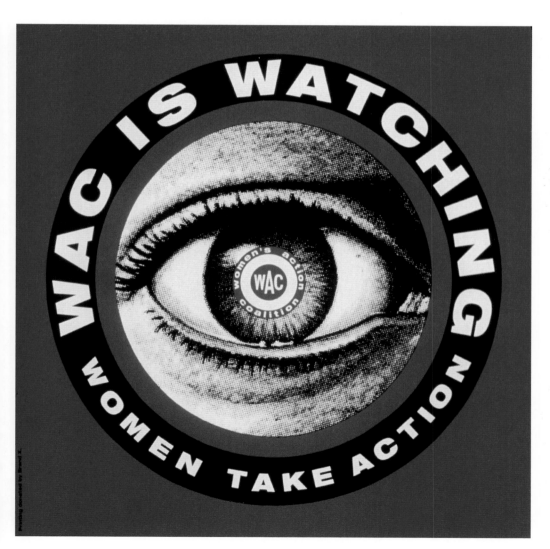

WAC IS WATCHING
WOMEN TAKE ACTION
women's action coalition
WAC

(OPPOSITE)
1989
BARBARA KRUGER

Seventeen years after *Roe v. Wade* legalized abortion, a new wave of antiabortion laws started chipping away at the rights granted by the Supreme Court. Though Kruger created this poster specifically for the Women's March on Washington in support of reproductive freedom, its message, unfortunately, never lost its relevance.

1992
MARLENE MCCARTY
BETHANY JOHNS

Women's Action Coalition (WAC) was an organization that staged public demonstrations or "actions" to raise the visibility of women in art, culture, and society. Their eyes-wide-open logo signaled that WAC's members were always watching.

CHAPTER 8
AIDS
Silence = Death

You'd think one day we'd learn. You don't get anything unless you fight for it, united and with visible numbers. If ACT UP taught us anything, it taught us that.

LARRY KRAMER

ACT UP took a symbol created by Nazis to identify gays and literally turned it upside down.

1986
ACT UP

One of the most successful awareness campaigns in American history, Silence = Death was created by six activists in New York who would eventually join ACT UP (AIDS Coalition to Unleash Power). The pink triangle is an inverted version of the symbol used to identify homosexuals in Nazi concentration camps, and Silence = Death refers to the consequences of not speaking out against the spread of AIDS. It became the signature icon and headline of the movement, empowering the AIDS community and raising awareness of the disease around the world.

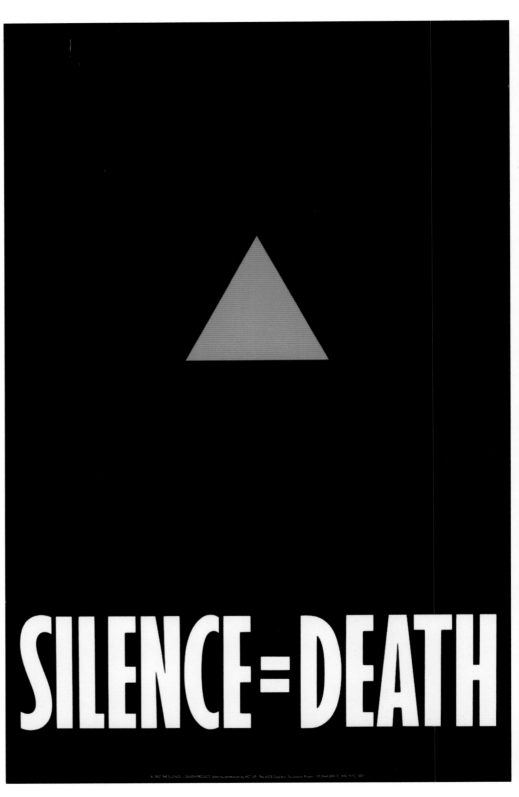

132

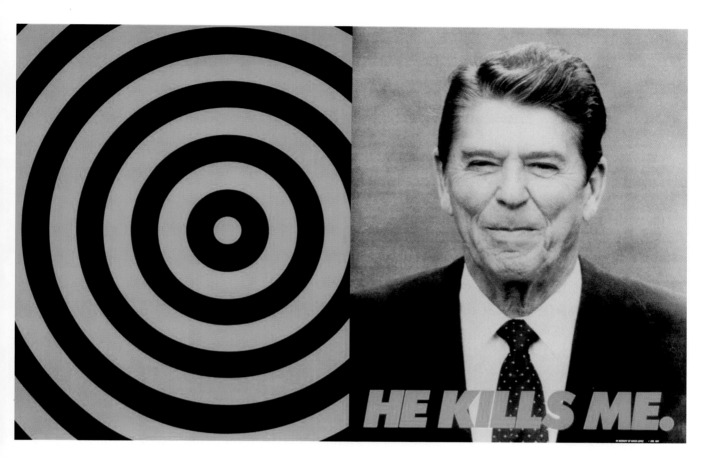

1987
DONALD MOFFETT

A founding member of Gran Fury created this poster for the same reason so many had created protest posters before him: out of frustration, rage, and the unrelenting urge to *do something*. The multiples pasted on the street made it even more powerful.

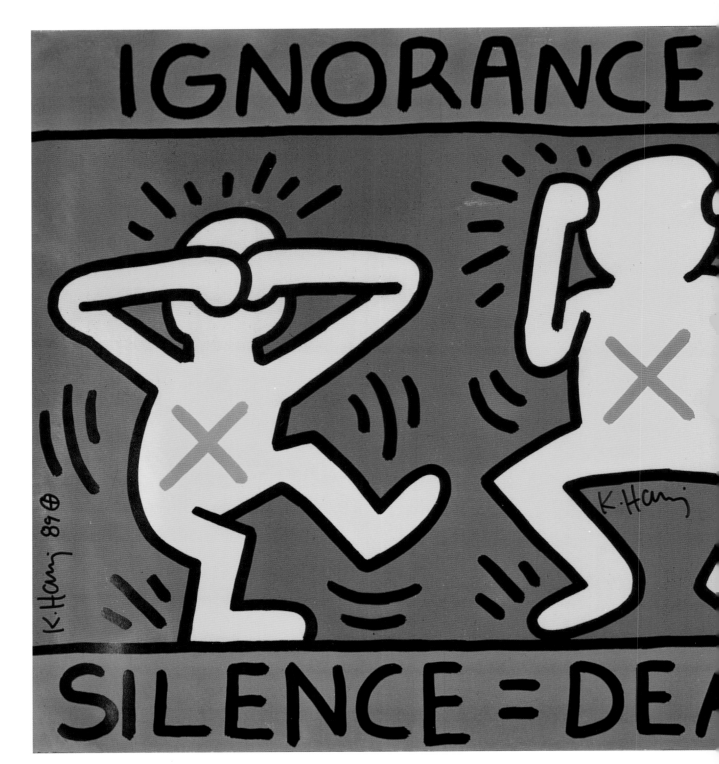

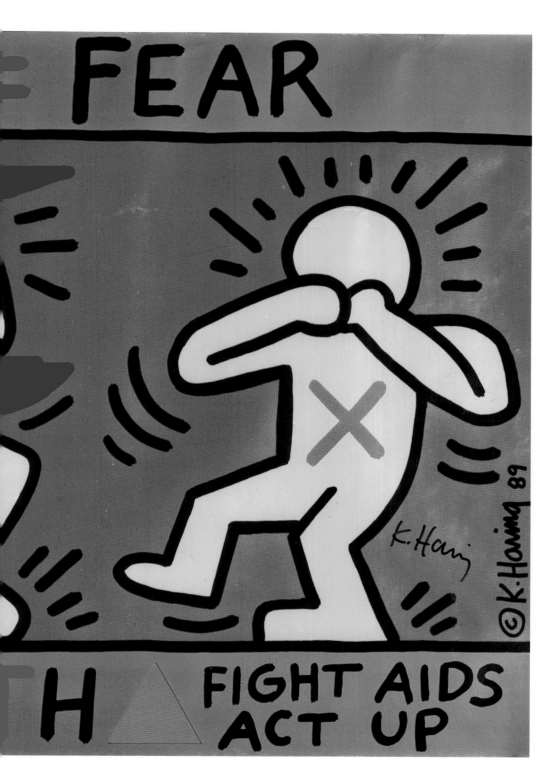

1989
KEITH HARING
ACT UP

Haring was already a world-renowned artist when he was diagnosed with AIDS in 1988. He soon switched his focus to helping others with the disease, through ACT UP and through his own foundation, which supported other AIDS organizations and children suffering from the disease.

ACT UP educated America about AIDS when the government was ignoring it, and forced a response; it was the best kind of art.

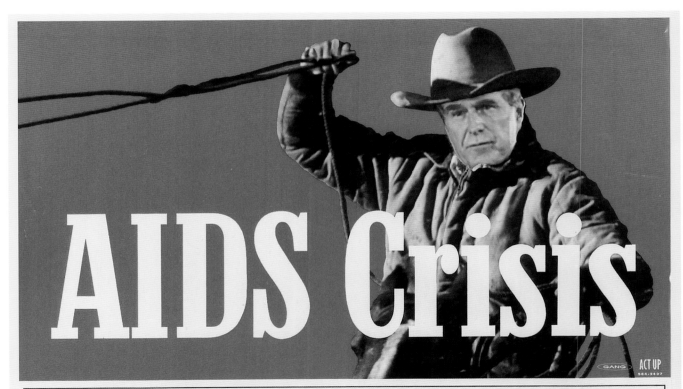

AIDS Crisis

WARNING: While Bush spends billions playing cowboy, 37 million Americans have no health insurance. One American dies of AIDS every eight minutes.

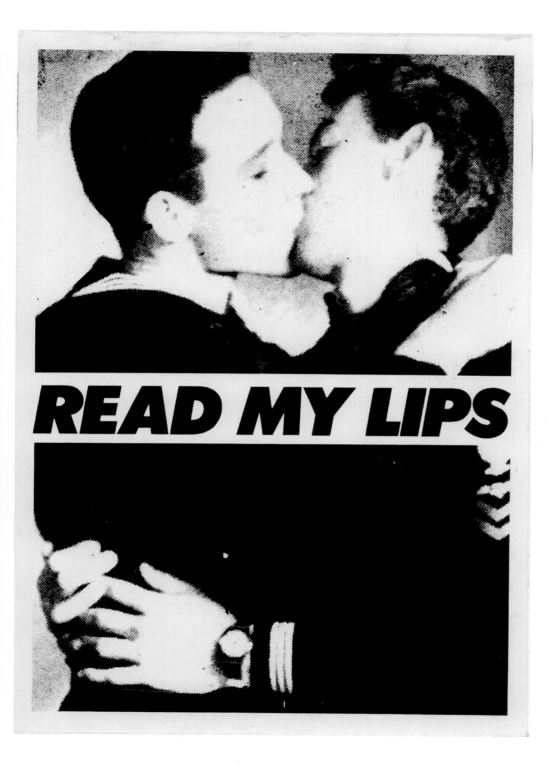

READ MY LIPS

Enjoy

AZT

Trade-mark ®

The U.S. government has spent one billion dollars over the past 10 years to research new AIDS drugs. The result. 1 drug—AZT. It makes half the people who try it sick and for the other half it stops working after a year. Is AZT the last, best hope for people with AIDS, or is it a short-cut to the killing Burroughs Wellcome is making in the AIDS marketplace? Scores of drugs languish in government pipelines, while fortunes are made on this monopoly.

IS THIS HEALTH CARE OR WEALTH CARE?

BULLET

THE GOVERNMENT HAS BLOOD ON ITS HANDS

ONE AIDS DEATH EVERY HALF HOUR

(OPPOSITE)
1989
VINCENT GAGLIOSTRO
AVRAM FINKELSTEIN
ACT UP

The Food and Drug Administration approved the use of AZT for the treatment of AIDS in 1987, but it was dangerous and toxic, and its effectiveness was questionable. Activists demanded safer, healthier alternatives, and here they compared AZT to Coca-Cola, accusing drug companies of designing AZT like a consumer product, existing solely to make a profit.

1988
GRAN FURY, ACT UP

A simple image and a strong statistic make a powerful, unforgettable impact.

When activists weren't fighting for awareness, they were busy spreading the word about AIDS prevention, often using humor to their advantage.

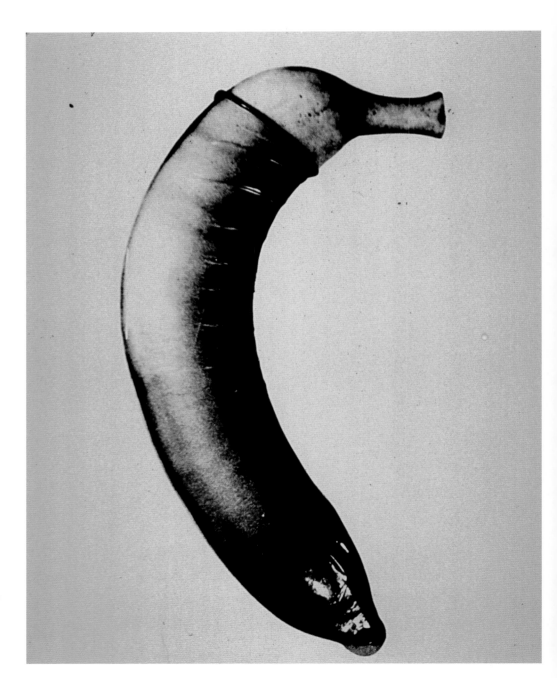

1982
TRILLIUM HEALTH
LEGACY AIDS
ROCHESTER, INC.

Sometimes you just need a visual reminder of what to do.

(OPPOSITE)
1994, *Penis Cop*
ART CHANTRY

This poster was made for the Washington State Department of Social and Health Services to encourage people to use condoms regularly. Not only was it wildly popular, the poster was also remarkably successful in spreading the word because everyone wanted to hang it up.

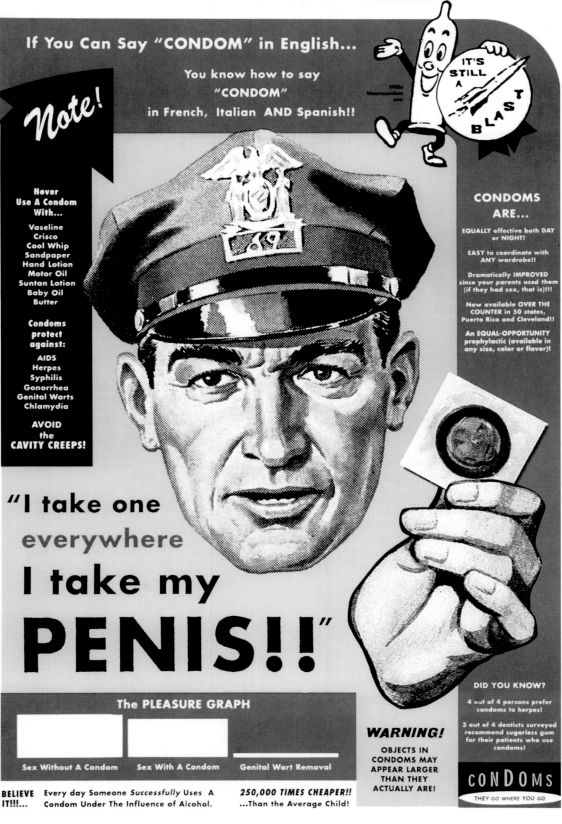

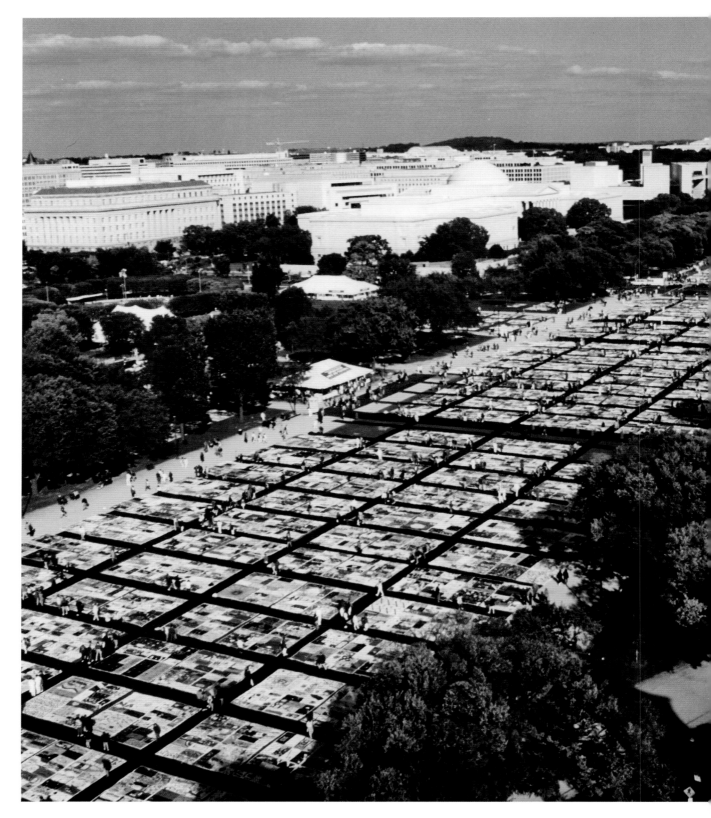

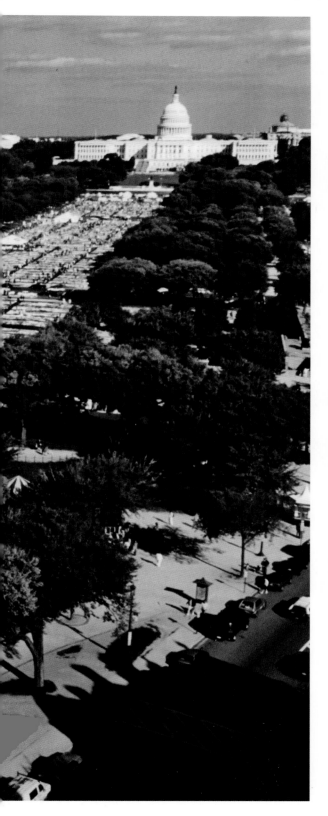

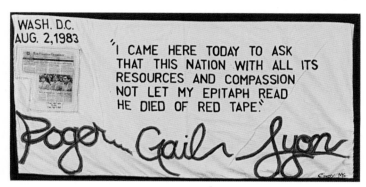

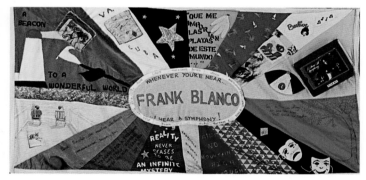

1996
AIDS MEMORIAL QUILT

Conceived by Cleve Jones in 1985 and nominated for a Nobel Peace Prize, the AIDS Quilt is the largest piece of community folk art in the world. It was created to both memorial-ize those who died and to communicate the massive impact of the disease.

CHAPTER 9
The Bushes
Oil Wars

In the United States,
anybody can be president.
That is the problem.

GEORGE CARLIN

"It was the all-American greeting falling on deaf ears," the designer explained. Juxtaposed with the grim news photo, it's a devastating piece of protest art.

1989
JOHN YATES
STEALWORKS

Yates created this as a response to what he saw as America's seemingly endless search for conflicts. It recalls the protest imagery of the Vietnam War, using coffins—not government propaganda—to communicate the actual result of war.

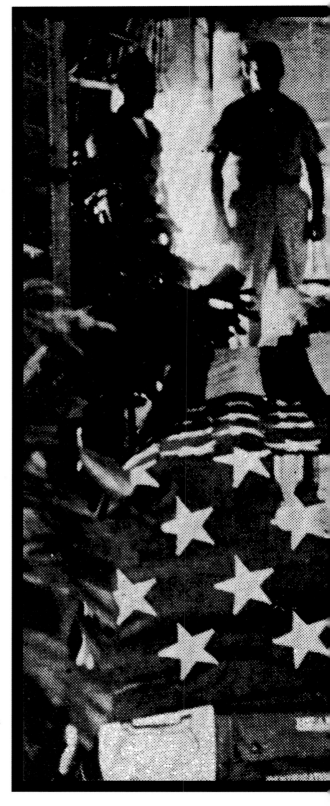

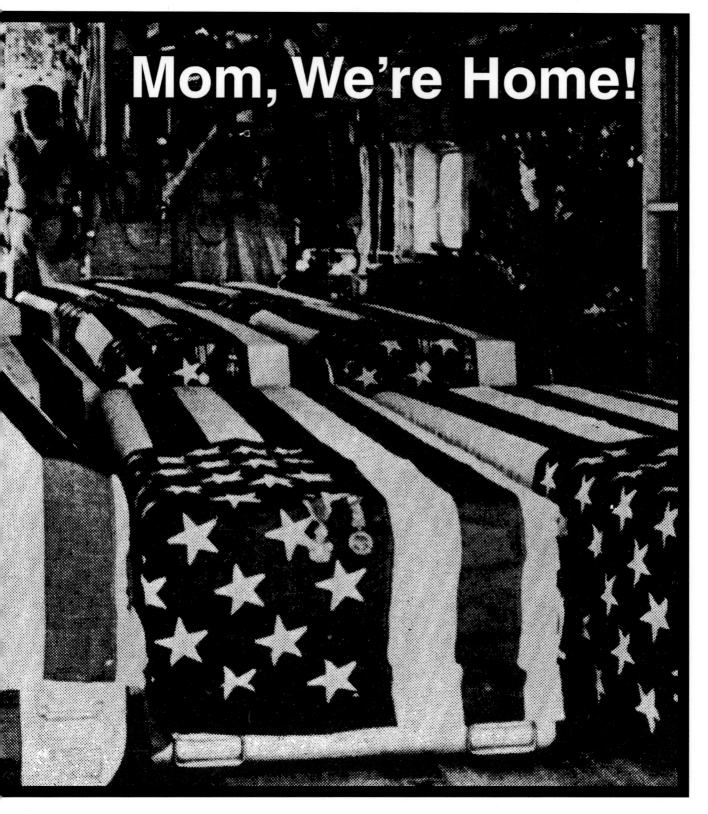

Mom, We're Home!

WHAT IS IT GOOD FOR?

2004
MARTY NEUMEIER

The words come from a Vietnam-era Edwin Starr song, but what makes this work so effective is the not-so-subtle double read.

Red and black, which tend to represent anger and death, are traditional colors of protest.

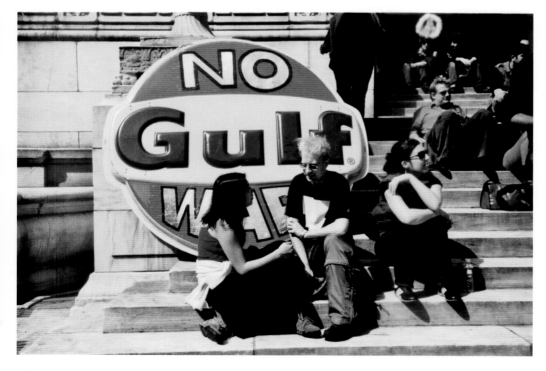

(TOP)
2003
JOHN EMERSON

Many protesters focused on the idea that we were sacrificing lives for a war that was ultimately about oil and money, a concept this icon communicates graphically and power-fully. It was printed on stickers and flyers, and was available for free download on the internet.

(BOTTOM)
2003
JEFF JACKSON

By doctoring a real Gulf sign (which shared its name with the senior Bush's first war in the region), marchers came up with a way to protest the conflict on multiple levels.

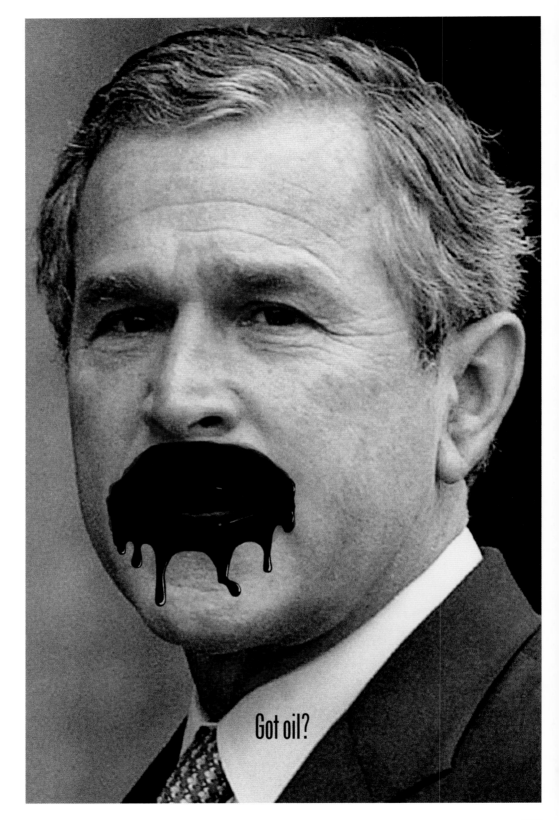

Got oil?

2004
NENAD CIZL
TONI TOMASEK
STEPHAN SAVOIA, photo

Take a beloved campaign (Got Milk?) and turn it on its head to generate an image that is both creepy and repulsive.

(OPPOSITE)
2005
WORSTPRESIDENT.ORG

Graffiti-style spray paint leaks through this stencil art, resulting in an aggressive, angry portrait.

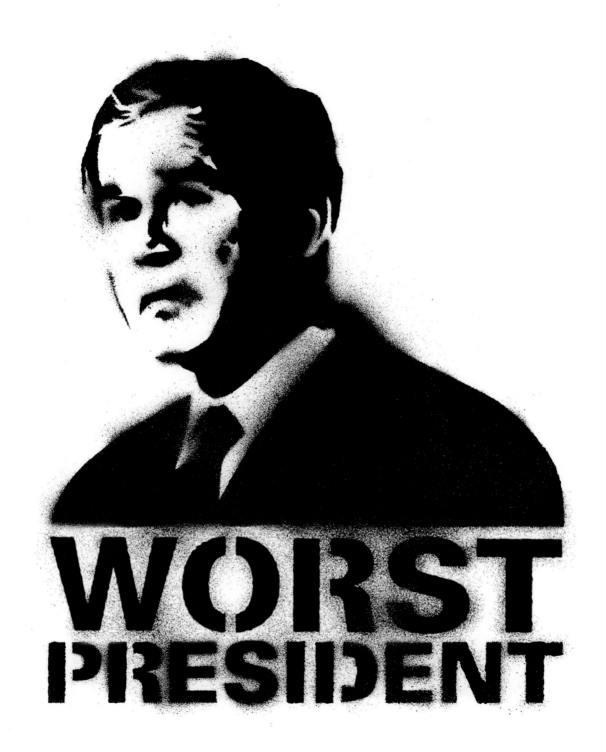

Until he wasn't.

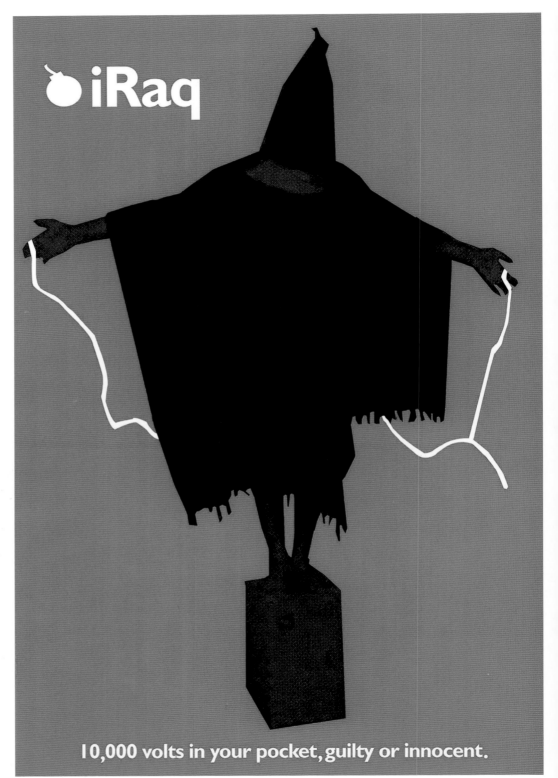

iRaq

2004
COPPER GREENE

The photo of Ali Shallal al-Qaisi being tortured by Americans in Abu Ghraib lodged itself in the consciousness of Americans, representing a dark, shameful episode in our country's history. Here, to stir up outrage, the artist capitalized on Apple's hugely successful iPod campaign, juxtaposing the prisoner's infamous silhouette with joyous—and damningly oblivious—consumers.

(OPPOSITE)
2004
COPPER GREENE

By slipping in the infamous Abu Ghraib silhouette alongside iPod posters, the artist forced everyday Americans to see themselves as complicit.

10,000 volts in your pocket, guilty or innocent.

153

Black Lives Matter
Don't Shoot

Black people love their children
with a kind of obsession.
You are all we have, and you
come to us endangered.

TA-NEHISI COATES

What is more moving?
The words on the sign or the small hands
holding them with popsicle sticks.

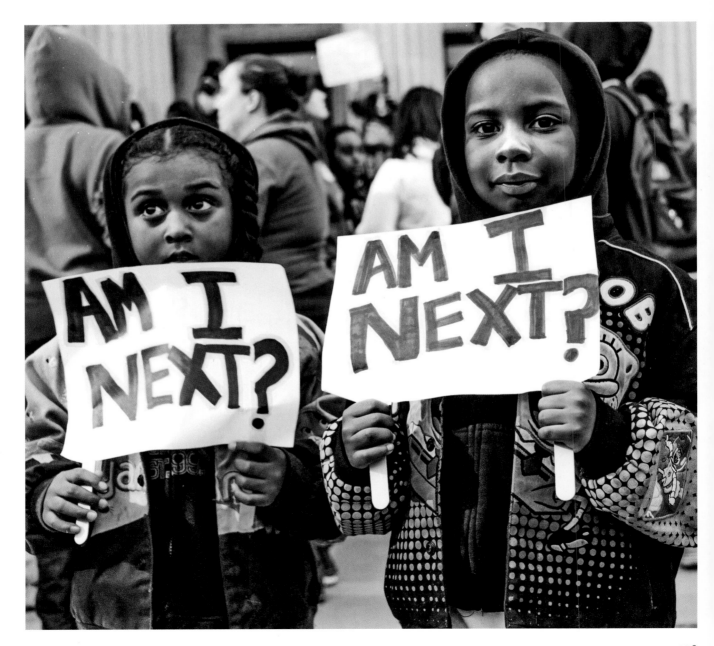

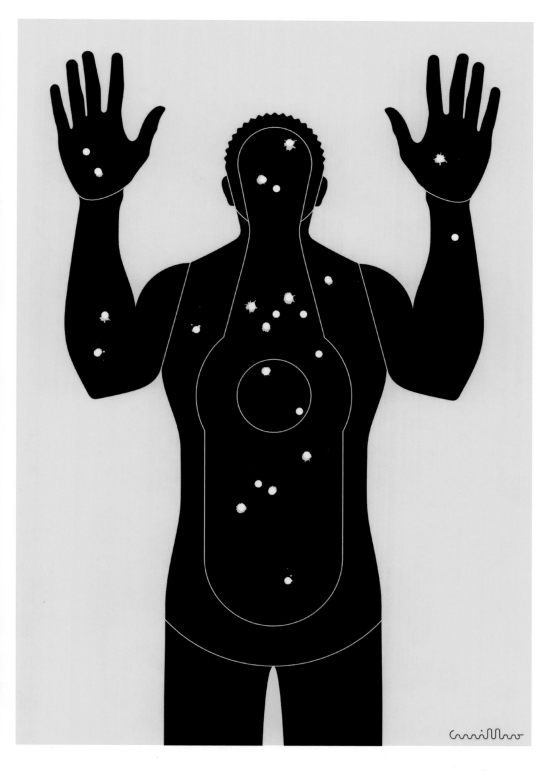

(OPPOSITE)
2012
DARLA JONES

Young demonstrators at the "One Million Hoodies March for Trayvon Martin" in Minnesota represent the fear of all African Americans, after the innocent, hoodie-wearing seventeen-year-old was fatally shot by a neighborhood watch volunteer in Florida.

2016
ANDRÉ CARRILHO

"Hands Up, Don't Shoot" became a rallying cry after Michael Brown was shot six times, twice in the head, by police officer Darren Wilson in Ferguson, Missouri. Allegedly, they were Brown's final words. Here, Carrilho reimagines a shot-up target-practice silhouette with its hands up.

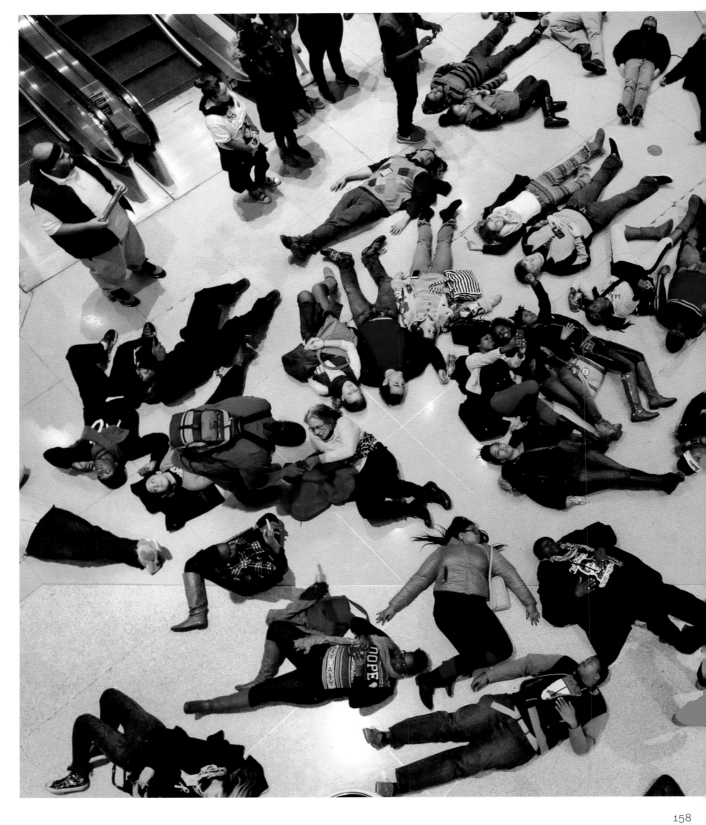

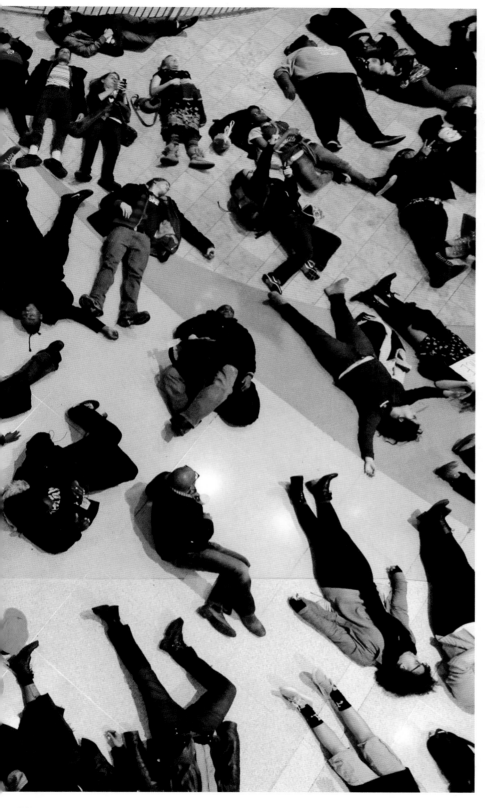

Protest as performance art: Mass reenactments became a hallmark of the Black Lives Matter movement.

2014
ROBERT COHEN

On Black Friday, about 150 protesters in Ferguson, Missouri, staged a die-in at the Chesterfield Mall in protest of the killing of Michael Brown and to demand the arrest of Darren Wilson, the police officer who shot him.

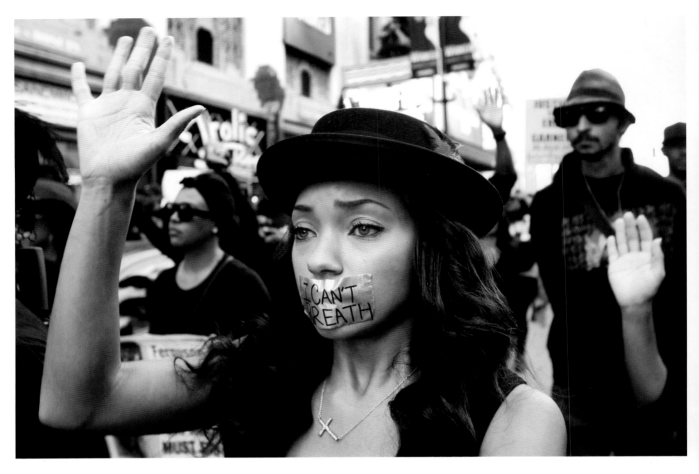

2014
DAVID McNEW

Eric Garner was killed by a choke hold during a routine arrest for selling loose cigarettes. During his last few moments, caught on video, he told police, "I can't breathe" eleven times and the words became an anthem for the Black Lives Matter movement. After a grand jury declined to indict Garner's killer, protests were held all over the country, including this one on Hollywood Boulevard. In addition to taping their mouths with Garner's words, protesters raised their hands in solidarity with Michael Brown.

PATRICK RECORD

William Royster stands
strong at a University of
Michigan demonstration,
protesting the deaths
of Eric Garner, Michael
Brown, and the others
who came before them.

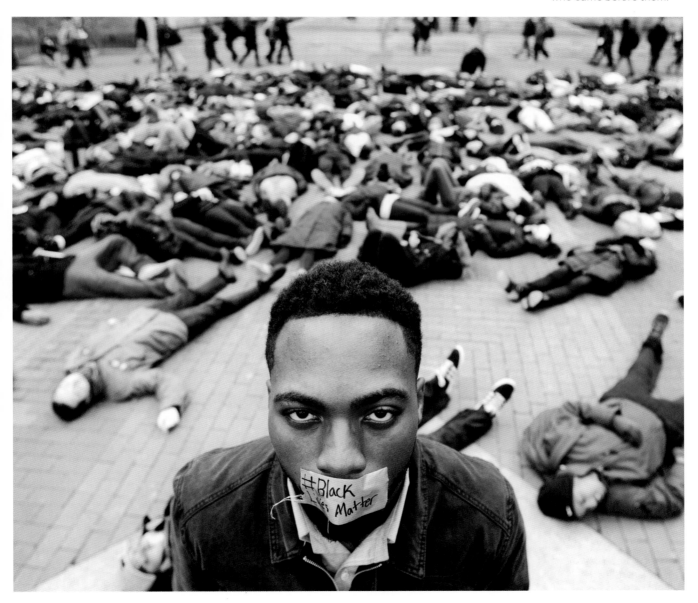

Two acts of defiance, nearly fifty years apart, deliver the same message: I refuse to be afraid.

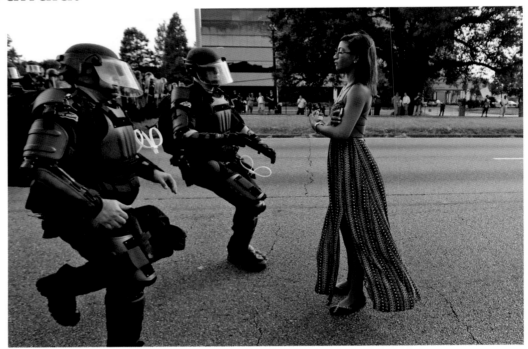

2016
JONATHAN BACHMAN

Ieshia Evans traveled from Pennsylvania to Louisiana to protest the police shooting of Alton Sterling four days earlier. The images of her arrest, after peacefully approaching the police, stirred emotions, reminding an older generation of a similarly volatile moment in history.

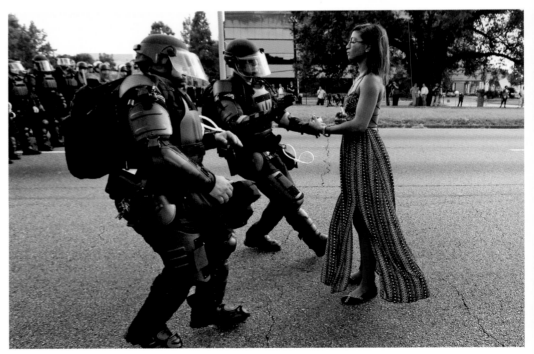

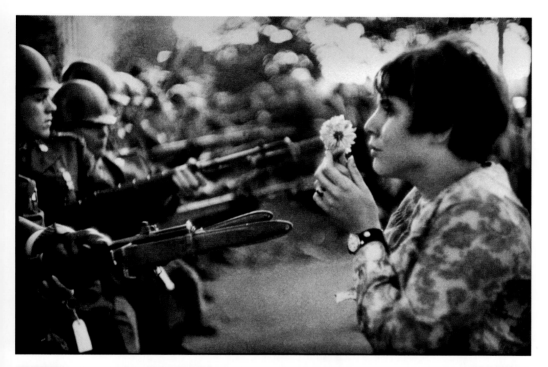

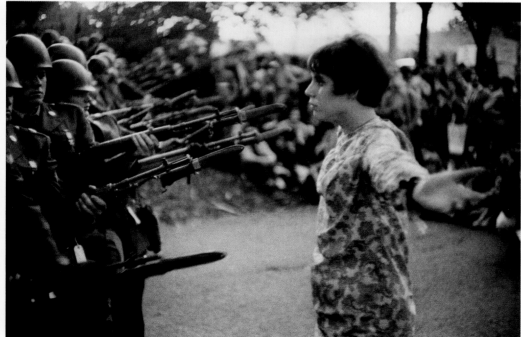

1967
MARC RIBOUD

When 100,000 antiwar protesters attempted to march to the Pentagon, they were blocked by more than 2,500 rifle-bearing soldiers. After seventeen-year-old Jan Rose Kasmir approached them to talk, photographer Riboud snapped this photo, later saying, "I had the feeling the soldiers were more afraid of her than she was of the bayonets." It became a defining image of the era, and one that we apparently didn't learn from.

***HEH HEH, CHAPTER 11**

Trump
Make America Protest Again

Keep reminding yourself:
This is not normal. Write it on
a Post-it note and stick it on your
refrigerator, hire a skywriter once
a month, tattoo it on your ass.
Because a Klan-backed misogynist
internet troll is going to be delivering
the next State of the Union address.
And that is not normal.
It is fucked up.

JOHN OLIVER

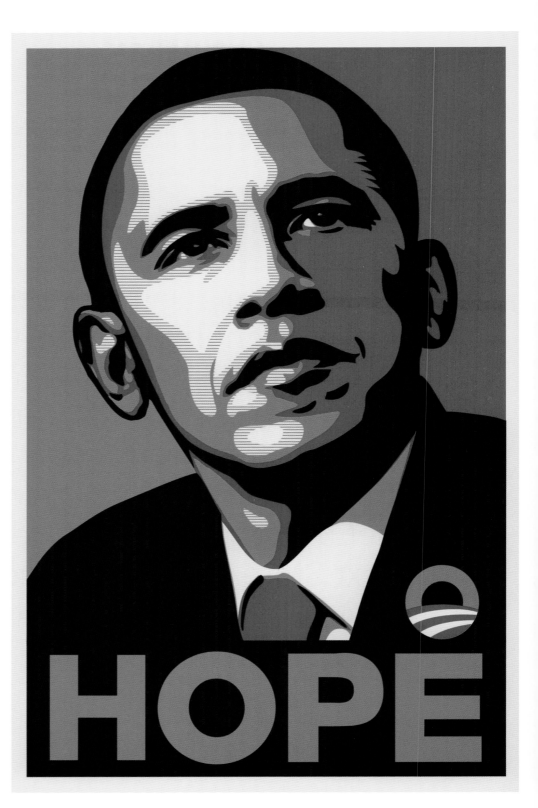

2008
SHEPARD FAIREY

The Hope poster became the symbol of Obama's campaign and spawned countless imitations and variations, all based on the instantly recognizable colorization and a single, bold word.

(OPPOSITE)
2016
GARETH ANDERSON (TOP)
KRISTEN REN (BOTTOM, LEFT)
GLADYS GLOVER (BOTTOM, RIGHT)

Playing off our emotional connection to the original made the riffs even more resonant. Also, isn't it amazing how many words that apply to Trump happen to rhyme with "HOPE"? Like NOPE! Mark Twain was right: history does rhyme.

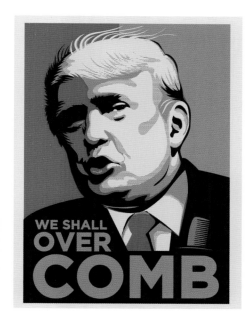

WE SHALL
OVER
COMB

Like Uncle Sam and Rosie the Riveter, Shepard Fairey's Obama had all the hallmarks of an enduring icon: strong face, minimal words, and endless options for riffing.

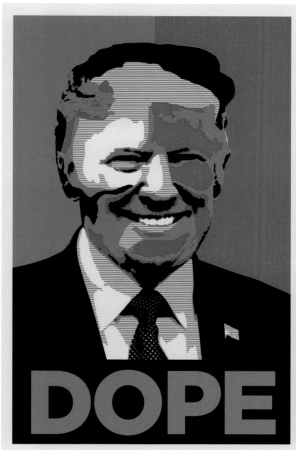

DOPE

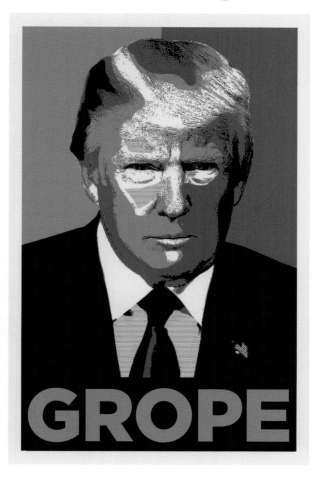

GROPE

Memes are the new posters–only they reach a lot more people a lot faster.

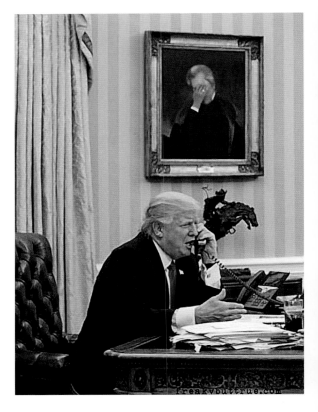

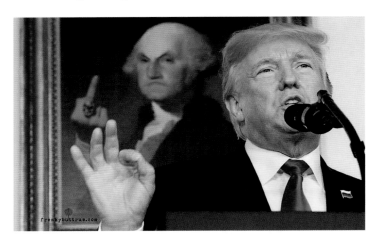

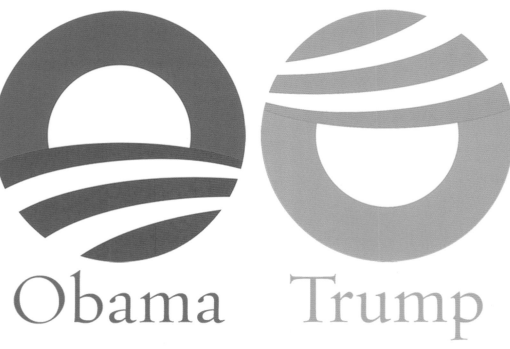

(TOP, LEFT AND RIGHT)
2017
MIKE WELLINS
FREAKYBUTTRUE.COM

These images brilliantly imagined the Founding Fathers' responses to President Trump.

(BOTTOM)
2015
MATTHEW GORDON

Only a designer would see the possibilities in the Obama logo when Trump came along. Here, Gordon illustrates how the two presidents are the opposite of each other in every possible way.

(TOP)
2017

When Trump met with German chancellor Angela Merkel for the first time in the Oval Office (and refused to shake her hand), some felt the meeting ushered in a new leader of the free world—and that person wasn't Trump.

(BOTTOM)
2017

Tiny Trump was practically its own movement online, and invited people to photoshop the miniature president into as many situations as possible, ultimately (and absurdly) illustrating Trump's "smallness" in the world.

170

Spy magazine called Trump a short-fingered vulgarian in the '80s, and the description has dogged him ever since.

(OPPOSITE)
2016, *The Big Short*
BARRY BLITT

This *New Yorker* cover sketch imagines how Trump would read his own palm. In Blitt's words, it was "a short-fingered palmistry of you-know-who written in his blustery defensive vernacular."

2017
BONNIE SIEGLER

I created this icon during the campaign because I was so sick of seeing his face and hearing his voice, and I fantasized about a "Trump-free zone." (I was also tired of seeing his name, so the tiny hand offered a convenient visual shorthand.) I made the icon downloadable for anyone craving a Trump-free zone in his or her own life. Bonus: It also comes in handy when making posters for marches.

**2016
MIKE MATTHEWS**

Here, Matthews designed a generic campaign poster and then imbued it with a different meaning by angrily eliminating a single letter. He also made the rest of the poster look vandalized. The art was aimed at people who were considering sitting out the election because they didn't like either candidate, and reminded them of the political math: If voter turnout was low, a Trump presidency was inevitable.

**(OPPOSITE)
2017
MARILYN MINTER
HALT ACTION GROUP**

This group of artists and activists decided Trump's shocking *Access Hollywood* monologue should be memorialized on the kind of plaque traditionally used to memorialize the great speeches of American heroes and leaders. The message? Never forget.

DONALD J. TRUMP

"I DID TRY AND FUCK HER. SHE WAS MARRIED.
I MOVED ON HER LIKE A BITCH,
BUT I COULDN'T GET THERE.
AND SHE WAS MARRIED.
YOU KNOW I'M AUTOMATICALLY ATTRACTED TO BEAUTIFUL.
I JUST START KISSING THEM. IT'S LIKE A MAGNET. JUST KISS.
I DON'T EVEN WAIT.
AND WHEN YOU'RE A STAR THEY LET YOU DO IT.
YOU CAN DO ANYTHING...
GRAB THEM BY THE PUSSY.
YOU CAN DO ANYTHING."

THE PRESIDENT OF THE UNITED STATES OF AMERICA

The red hat was one of the greatest pieces of campaign propaganda ever. But the parodies were even better.

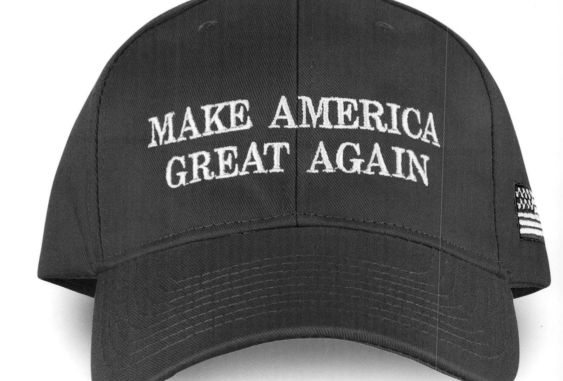

2017
VARIOUS

Trump came up with one of the most effective political icons of all time: the red baseball cap. It struck just the right note with Red State everymen, and when Trump himself wore one, it instantly made the billionaire New Yorker more relatable to his working-class base. (He didn't have to explain the real reason he likes baseball caps: His hair does not have a good relationship with the wind.)

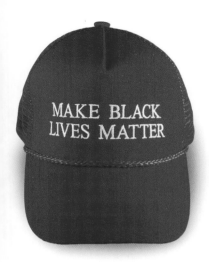

MAKE BLACK
LIVES MATTER

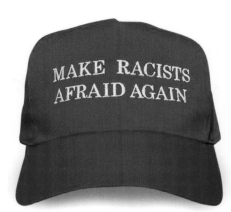

MAKE RACISTS
AFRAID AGAIN

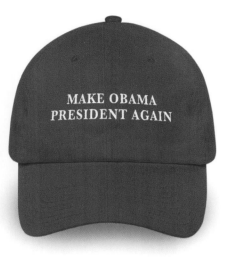

MAKE OBAMA
PRESIDENT AGAIN

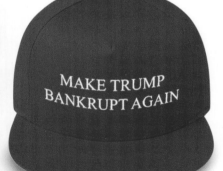

MAKE TRUMP
BANKRUPT AGAIN

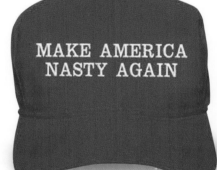

MAKE AMERICA
NASTY AGAIN

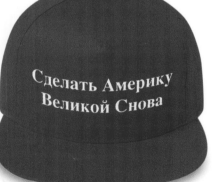

Сделать Америку
Великой Снова

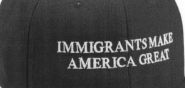

MAKE AMERICA
VOTE AGAIN

IMMIGRANTS MAKE
AMERICA GREAT

MAKE AMERICA
GAY AGAIN

175

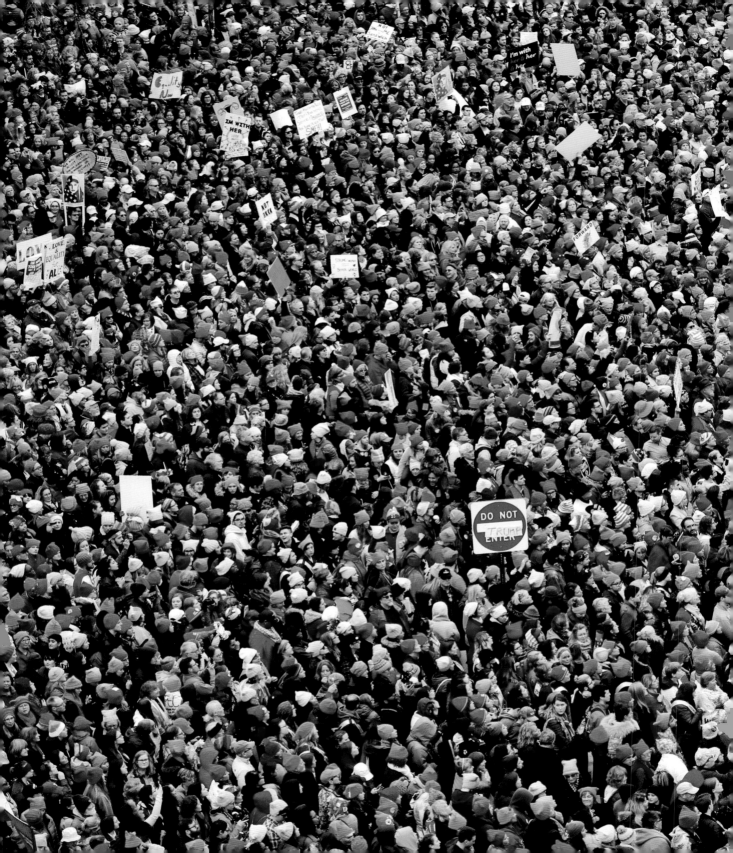

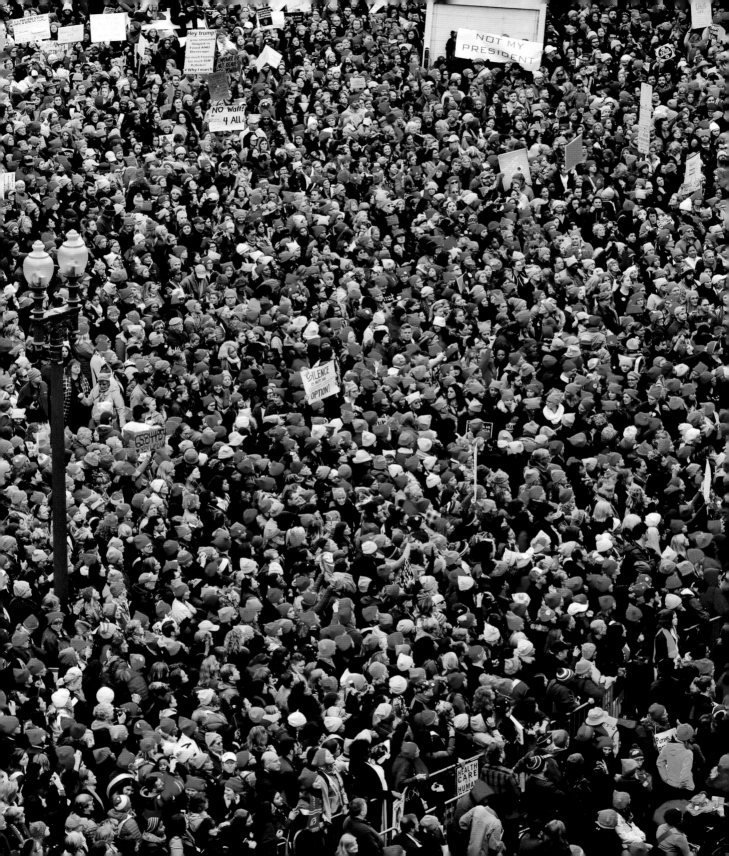

The pussy hat was the Left's answer to the red cap. Like so many protesters in history, women stripped Trump's words of their power by taking ownership of them.

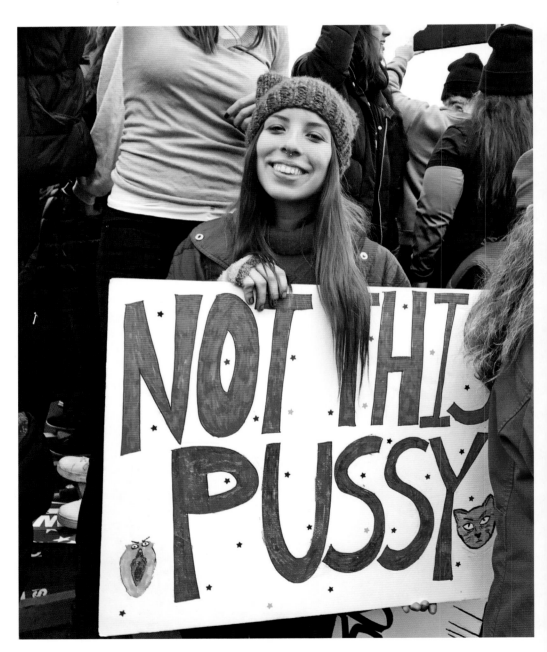

(PREVIOUS PAGES)
2017
BRIAN ALLEN, photo

Aerial view of the Women's March in Washington, DC, which drew more than 400,000 angry protesters, many of them wearing pink pussy hats.

2017
BONNIE SIEGLER, photo

Pussy-themed posters were everywhere at the Women's March in DC and around the country.

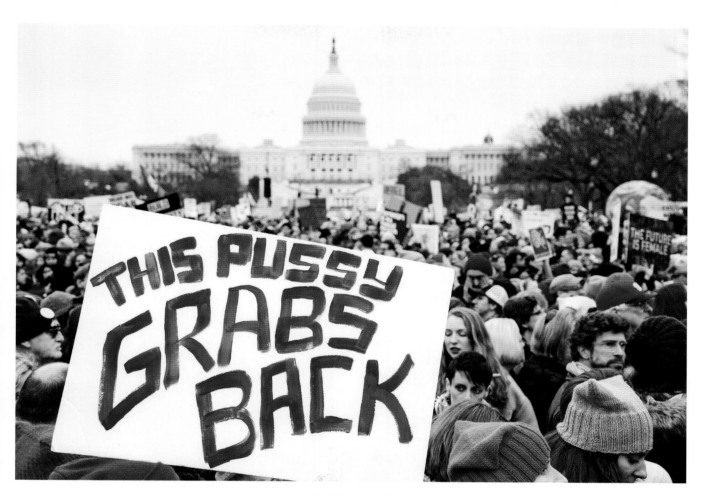

(TOP)
2017
BARBARA ALPER, photo

Donald Trump's boast ("Grab them by the pussy") was perhaps the most offensive statement ever uttered by an American president, and women were not going to let him forget it any time soon. At the Women's March, they all grabbed back.

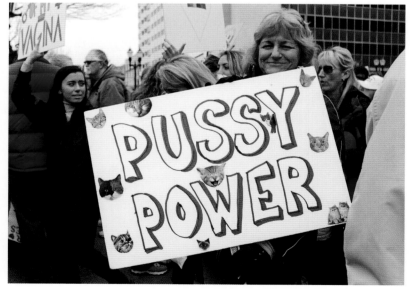

(BOTTOM)
2017
JULIZBETH PHOTOGRAPHY

Once women took ownership of the word, they also possessed its power.

During a debate, Trump called Hillary Clinton "a nasty woman," and women decided to own that one, too.

2017
CATE MATTHEWS /
A PLUS, photo

Hillary Clinton didn't flinch when Trump called her a "nasty woman," but women across America sure did. It neatly encapsulated all the misogynistic sexism on display throughout Trump's campaign.

(OPPOSITE)
2017
BONNIE SIEGLER, photo

"Nasty woman" immediately became both an identity and a rallying cry for solidarity across America, and, not surprisingly, was featured prominently at the Women's March in Washington, DC. Here, the phrase is lovingly spelled out in tampons.

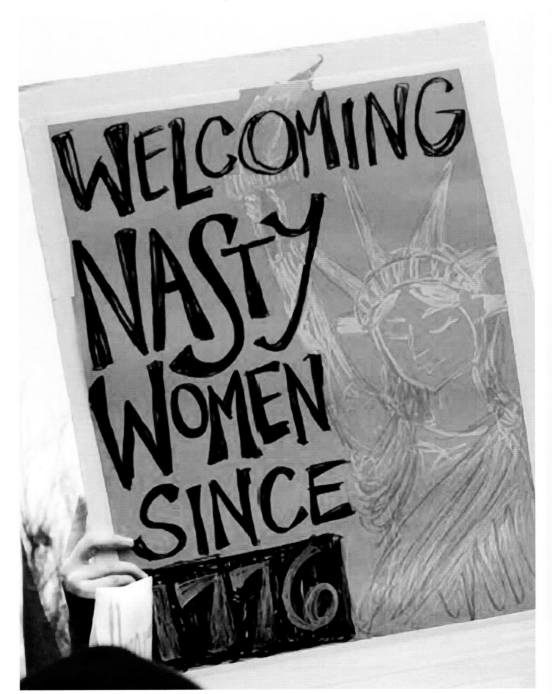

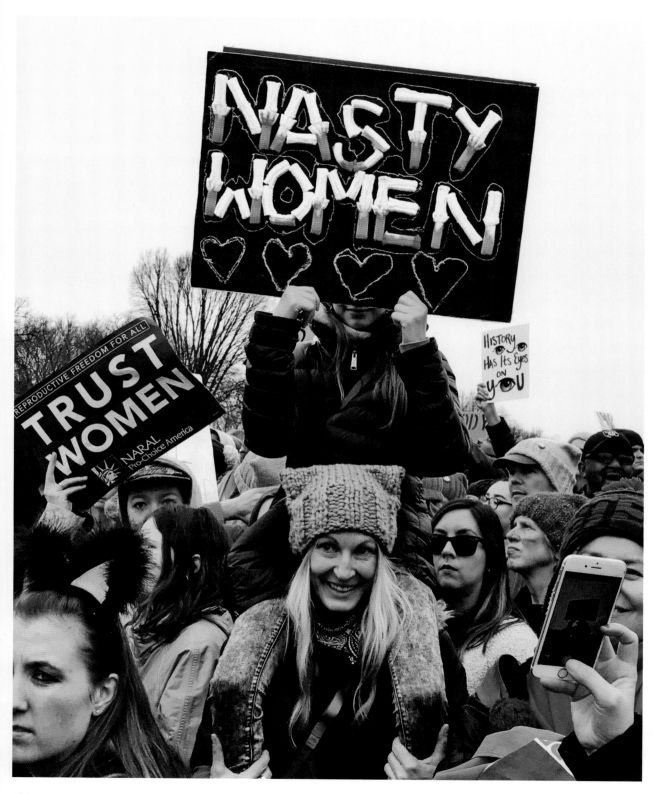

These signs didn't need to be professionally designed. Their effectiveness lies in the sincere and urgent communication of raw emotion.

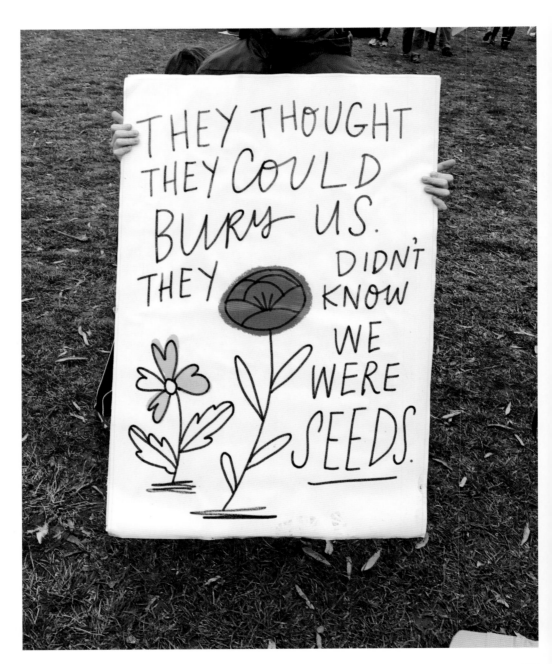

2017
BONNIE SIEGLER, photo

This sign at the Women's March was especially poignant, even though it had been used over the years by other groups seeking social justice. The original version of this was written by Greek poet Dinos Christianopoulos, a leading voice for the gay community.

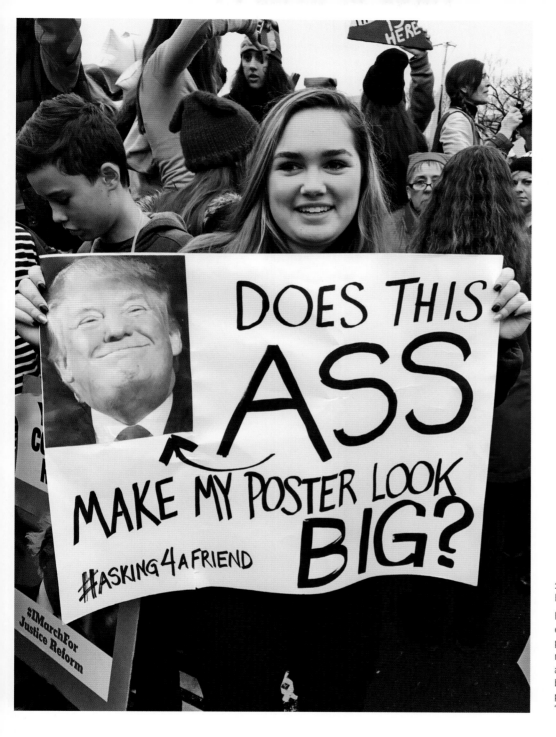

2017
BONNIE SIEGLER, photo

Humor is an incredibly effective way to make people consider a message without coming across as preachy. (The best part about this poster is the hashtag, "asking 4 a friend.")

Anger and humor play really well together.

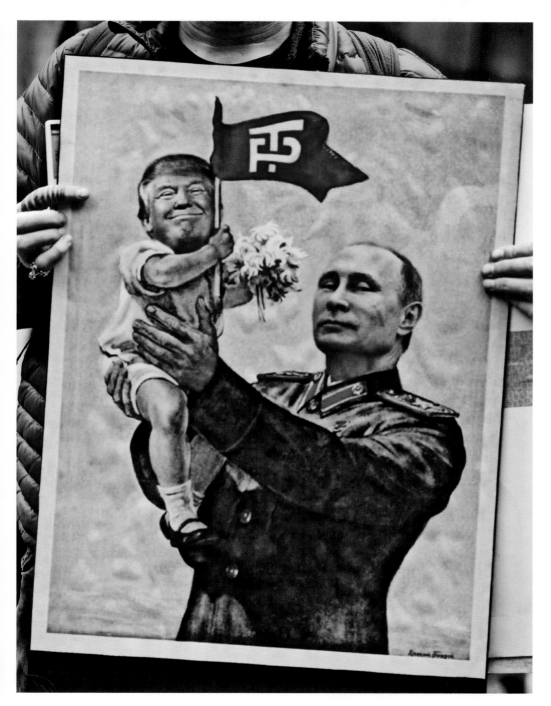

(OPPOSITE)
2017
SHANNON DOWNEY

This perfectly articulated statement was stitched by the proprietor of Badass Cross Stitch, encapsulating the rage so many people felt when Trump was elected.

2017
CRAIG S. O'CONNELL, photo

A Women's March poster showed baby Trump with his favorite dictator holding the original, accidentally suggestive Trump-Pence logo that was abandoned (but definitely not forgotten) within days of its release.

At least nineteen women (not counting the Statue of Liberty) have accused Donald Trump of sexual assault.

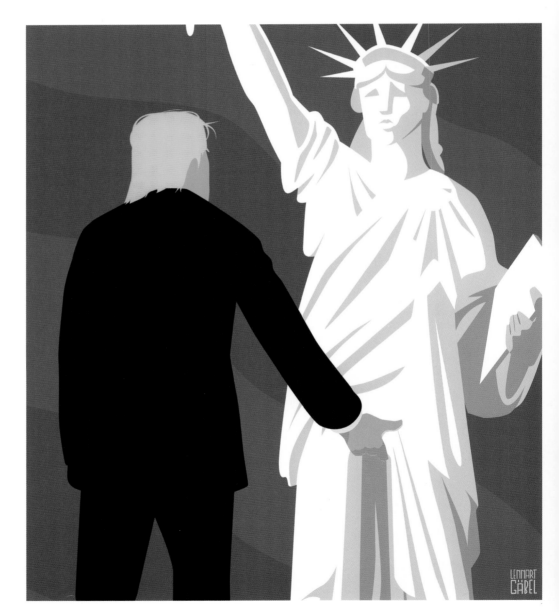

2016, *They Let You Do It*
LENNART GÄBEL

Artists used the weapons at their disposal to articulate what it felt like to watch a self-professed sexual predator become the most powerful man in the world. Gäbel's depiction of the president assaulting Lady Liberty in muted colors and minimal detail pretty much nails it.

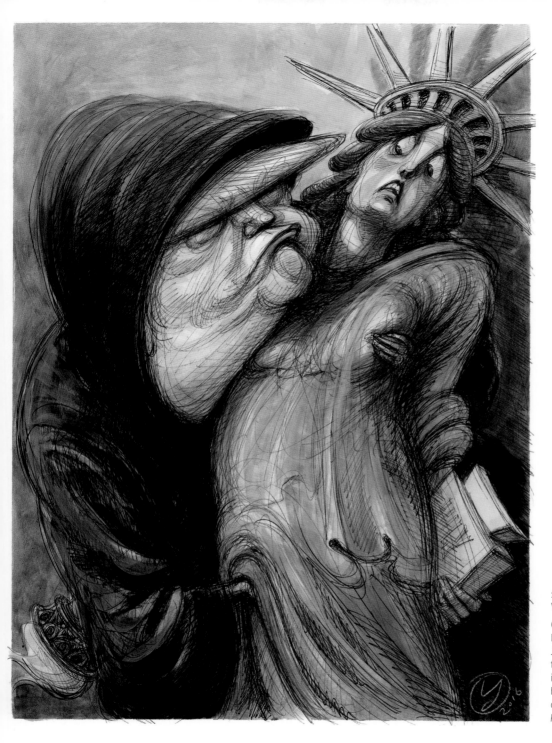

2016
VICTOR JUHASZ

Gäbel's version of Lady Liberty is stoic, whereas Juhasz's Liberty is terrified. Both succeed in triggering disgust and horror. This one was originally created for *Rolling Stone* magazine.

2017
OSCAR SCHER

For Mother's Day during Trump's first year in office, my then eleven-year-old asked my husband what would make me happy. The answer—"Trump behind bars"—inspired this card. I'm not sure how Oscar knew about striped prison uniforms or the ball and chain, but I love that he included Trump's ridiculously long red tie.

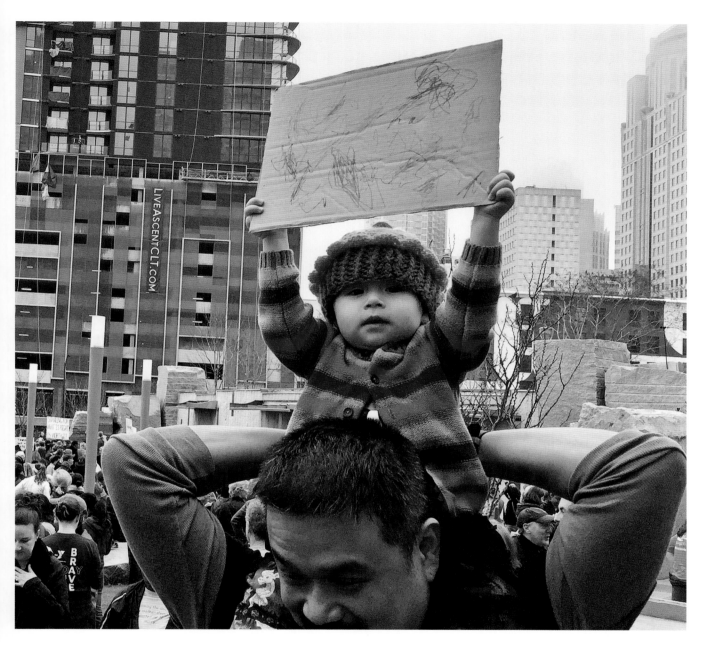

2017
JENNY SOWRY

This activist at the Women's March in Charlotte, North Carolina, proves you're never too young to fight for social justice. I'm particularly impressed with her carefully considered palette.

Artists seem to have a primal drive to humiliate Trump, and you could say that showing him naked is the most direct way to achieve that.

2016, *Make America Great Again*
ILLMA GORE

Though this painting created an uproar when the artist originally posted it on Facebook, some argued its irreverence was merely mirroring the president's egregious disrespect for women, minorities, civil discourse, and institutions of democracy. Gore is quoted as saying, "If anyone is going to be threatened by a small penis, it's Trump."

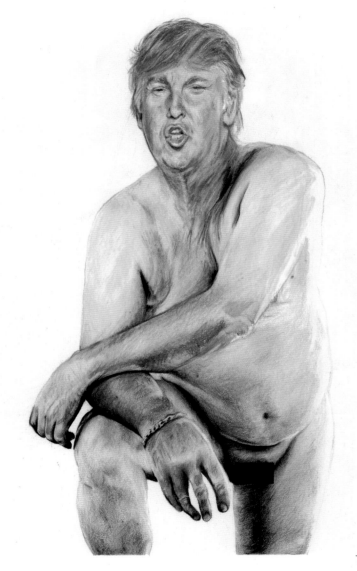

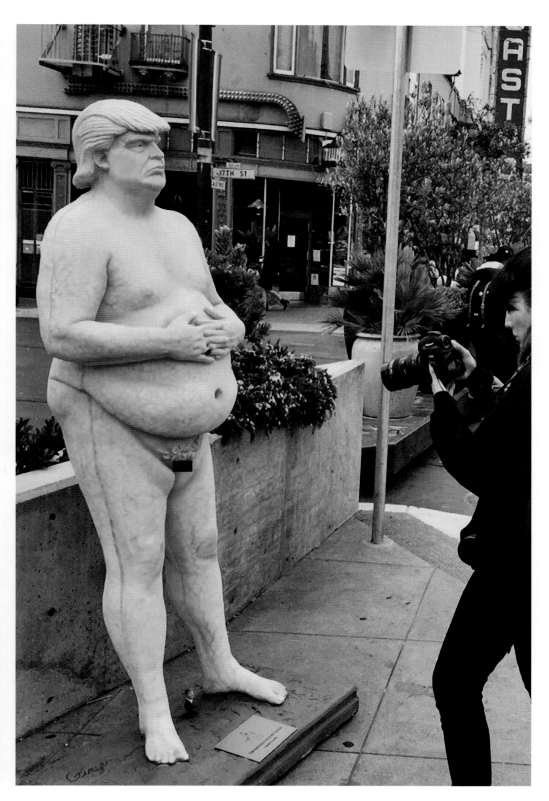

2016, *The Emperor Has No Balls*
INDECLINE

Naked Trump statues appeared simultaneously in New York, San Francisco, Los Angeles, Cleveland, and Seattle. In addition to humiliating Trump, this one highlighted his authoritarian tendencies (emperors tend to erect statues of themselves) while referencing the fable's delusional, naked leader.

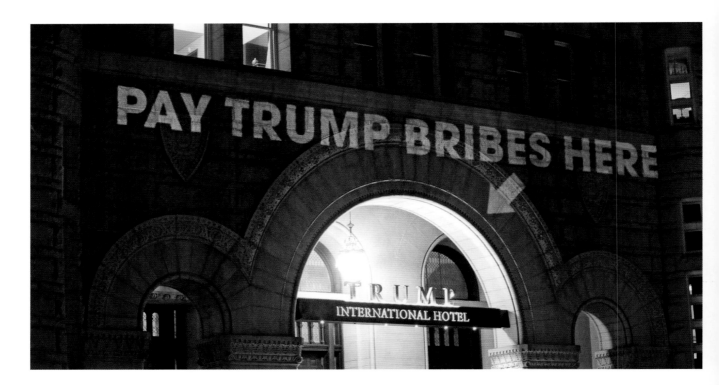

2017
ROBIN BELL
LIZ GORMAN/
BELLVISUALS.COM, photo

During Trump's first few months in office, projections of protest began appearing on Washington DC's Trump International Hotel. They included "Experts Agree: Trump is a Pig," "We Are All Responsible to Stand Up and End White Supremacy," and "The President of the United States Is a Known Racist and Nazi Sympathizer." In addition to shaming the administration, it reminded us that art activism is most effective when it's speaking directly, literally, to people on the street.

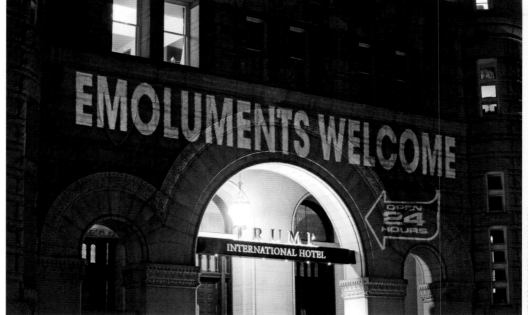

2017, *Flying Pigs on Parade: A Chicago River Folly*
NEW WORLD DESIGN

The goal in this rendering was to have flying pigs block Trump's name emblazoned on his building so Chicagoans didn't have to look at it every single day. The designers say the work was partially a visual interpretation of George Orwell's *Animal Farm* as well as an homage (with permission) to the Pink Floyd *Animals* album cover.

Extreme anger can kick up the creativity to a whole new level.

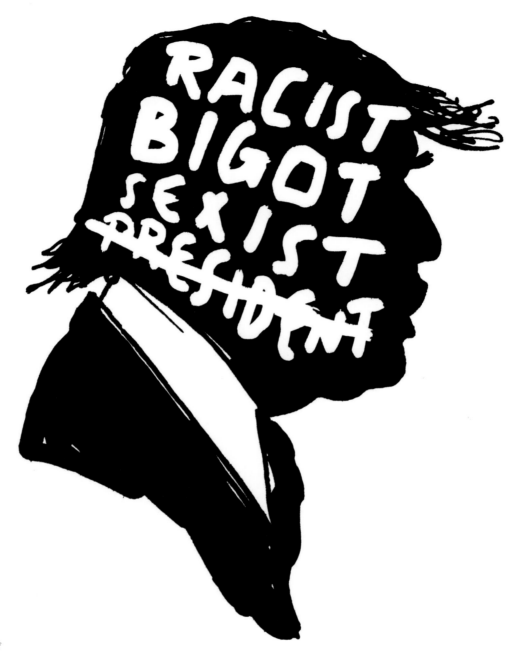

2016, *Coward in Chief*
JAMES VICTORE

The rough type illustrating
the things he is (and isn't)
inside Trump's instantly
recognizable silhouette
gives a crystal clear
portrait of the Republican
nominee. Victore created
this for MoveOn.org.

194

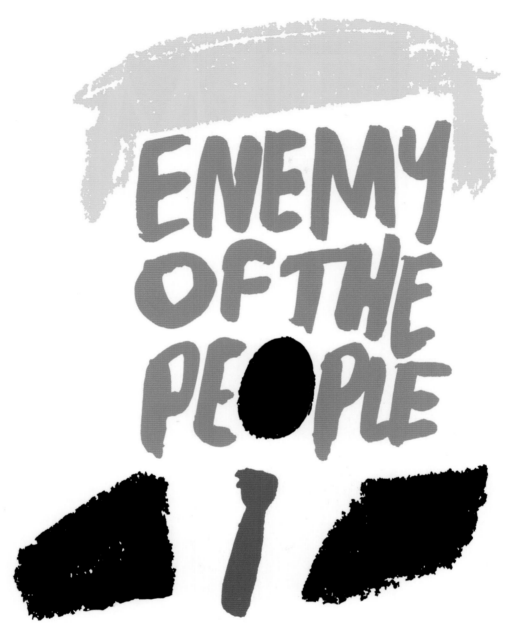

ENEMY OF THE PEOPLE

2017
EDEL RODRIGUEZ

This caricature gets its power from its rawness. There's a black hole where Trump's brazen mouth should be, and instead of his face, we have a statement identifying what he really is, in orange type.

Trump's cartoonish characteristics were a gift to satirists: He's so easy to caricature, even the most minimal silhouettes suffice.

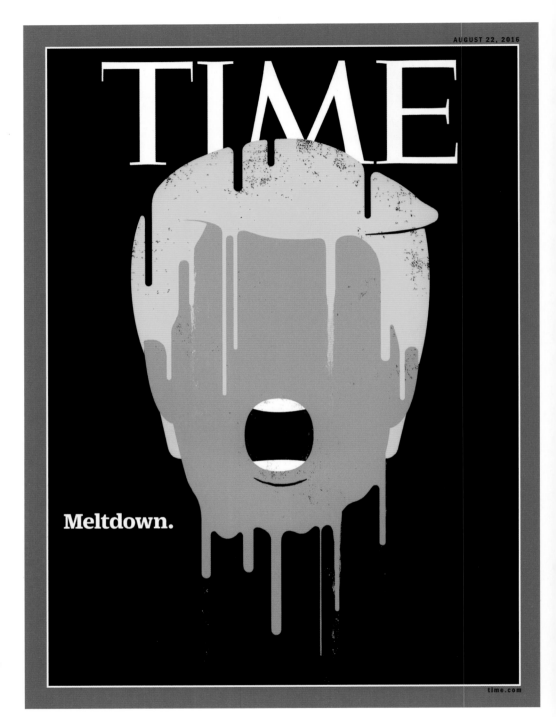

TIME

Meltdown.

time.com

2016
EDEL RODRIGUEZ

These covers represent a real-time response to the perceived meltdown of candidate Trump. The first (RIGHT) appeared in August 2016, after he attacked a Gold Star family and the second one (OPPOSITE) in October, after the *Access Hollywood* tapes surfaced. It was the first ever "call and response" pair of magazine covers. Too bad they were wrong. Instead of melting down, Trump was elected president.

TIME

Total Meltdown.

time.com

The Unite the Right rally in
Charlottesville, Virginia,
galvanized artists and protesters
in the same way the Kent State
shootings motivated antiwar
activists during Vietnam.

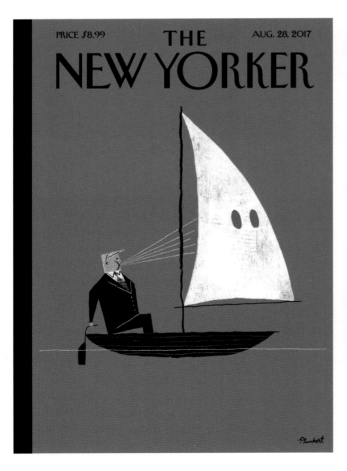

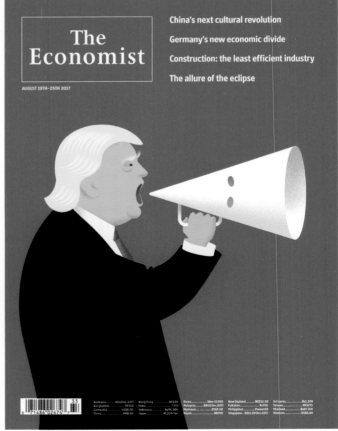

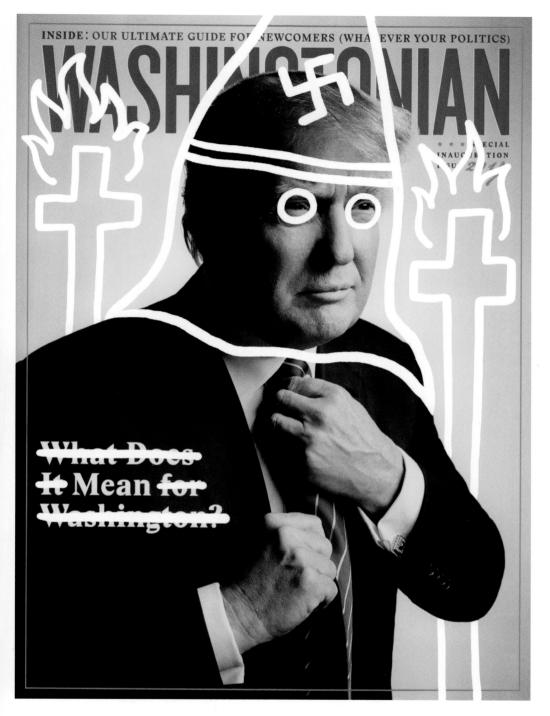

INSIDE: OUR ULTIMATE GUIDE FOR NEWCOMERS (WHATEVER YOUR POLITICS)

WASHINGTONIAN

★ ★ ★ SPECIAL
INAUGURATION
ISSU 2017

What Does It Mean for Washington?

(OPPOSITE, LEFT)
2017, *Blowhard*
DAVID PLUNKERT

After the Charlottesville riots, when Trump refused to condemn white supremacists, protesters everywhere felt compelled to work the chillingly iconic white hood into their art. The newsstand suddenly became crowded with Ku Klux Klan imagery, including this *New Yorker* cover showing Trump literally giving wind to the KKK's sails.

(OPPOSITE, RIGHT)
2017, *Ditching the Dog Whistle*
JON BERKELY

Here, the artist refashions the KKK hood as a bullhorn. In other words, Trump's message was loud and clear.

2017, *KKK Street*
CAROLYN SEWELL

The artist used a *Washingtonian* cover as her canvas to show the truth, graffiti style.

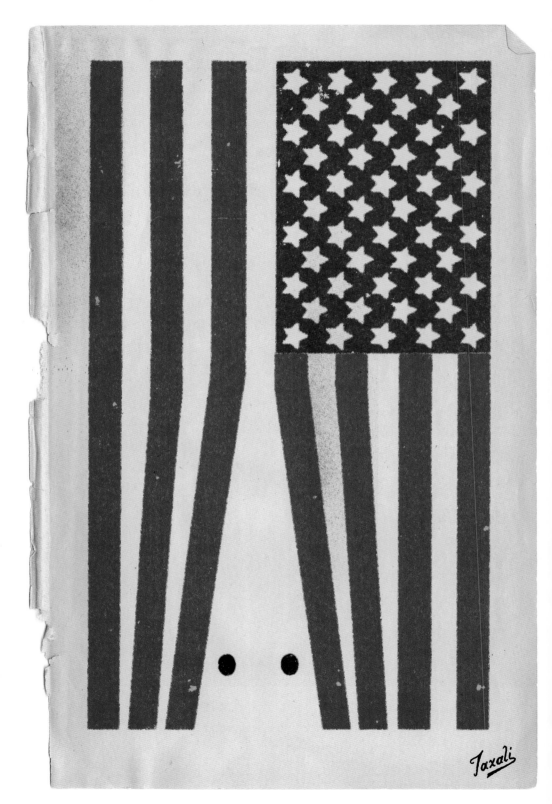

2016, *NO*
GARY TAXALI

After Charlottesville, everyone began to see racism where they hadn't before. This poster shows the Klan lurking behind the American flag as though they have always been there.

(OPPOSITE, LEFT)
2017, *Inflamer in Chief*
BOB STAAKE

Here, Trump is the flame that the KKK uses to light their way.

(OPPOSITE, RIGHT)
2016, *Trump Match*
BRIAN STAUFFER

Here, Trump is the match that actually lights the fire.

Some designs were interpretive, some more metaphorical, but all revealed the same truth: Trump was on the wrong side of history.

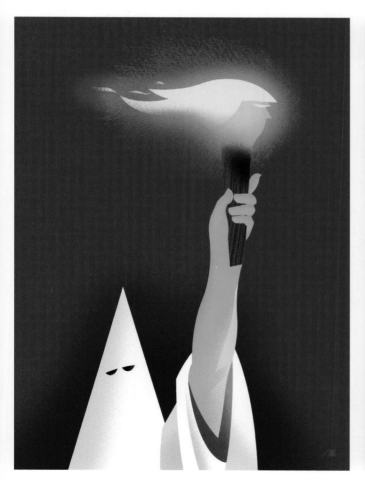

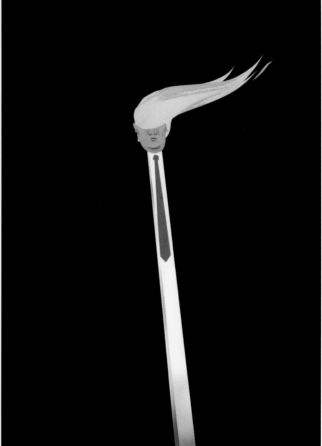

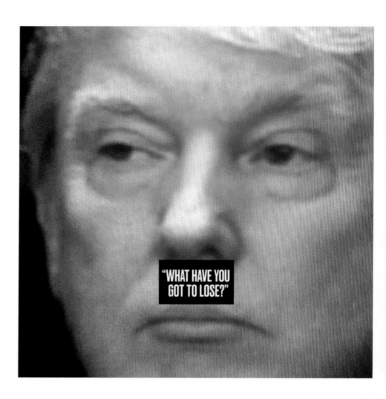

(TOP)
2016
BONNIE SIEGLER

My mother and grand-parents escaped Nazi Germany in 1938, and Trump's rhetoric on blaming people who are "other" hit a little too close to home. Trump said these words– "What have you got to lose?"–to African Americans at a campaign stop, inferring that their lives were worthless.

(BOTTOM)
2016
FELIX SOCKWELL

Sockwell's new logo for our forty-fifth present mimics the swastika in the same way Trump mimics Hitler.

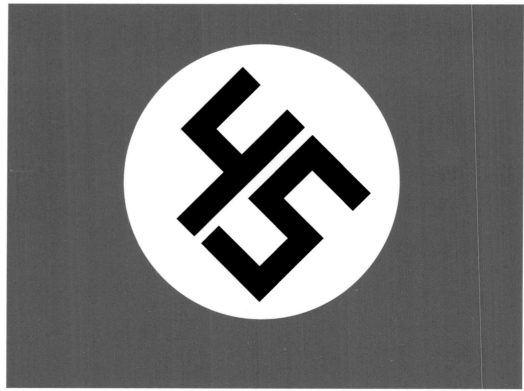

The only thing that telegraphs hate as clearly as the white hood is the swastika.

2016
STEVE BRODNER

Brodner reveals what's really underneath the crazy comb-over.

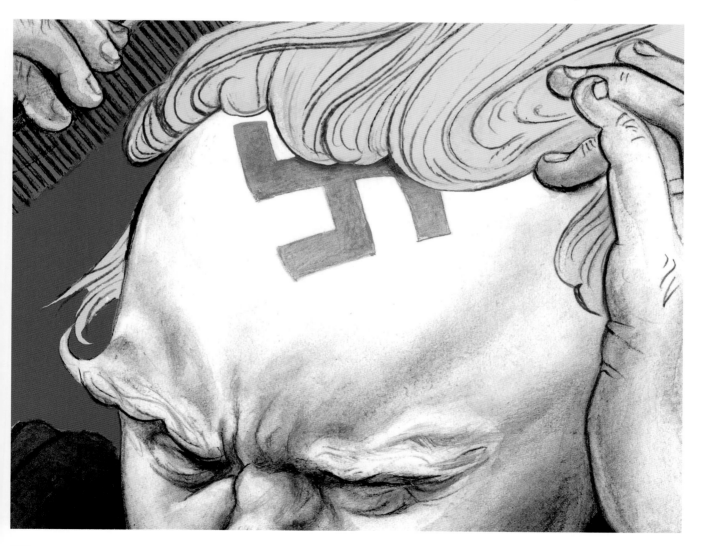

Project Scholl reminds us that silence equals complicity: The more people stand up, the more things will change.

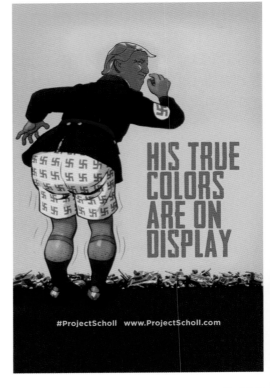

HIS TRUE COLORS ARE ON DISPLAY

#ProjectScholl www.ProjectScholl.com

2017
ROBERT RUSSELL

Sophie Scholl was a German student and anti-Nazi activist who worked with the White Rose nonviolent resistance during World War II. She and her brother were executed by guillotine after handing out anti-Nazi resistance leaflets at the University of Munich. She was twenty-one. This project by Arianna Jones carries on Scholl's mission of peaceful resistance by daring to speak about what is happening. Created in the style and iconography of American anti-Nazi propaganda, the posters were plastered all over Washington, DC. The project's goal was to force people to recognize the similarities between the Trump administration and the Nazi regime, and inspire a similar sense of urgency.

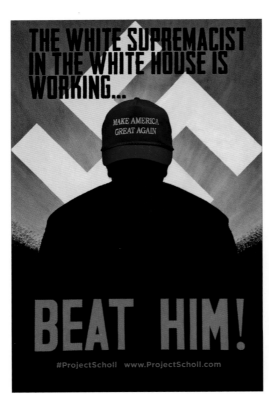

THE WHITE SUPREMACIST IN THE WHITE HOUSE IS WORKING...

MAKE AMERICA GREAT AGAIN

BEAT HIM!

#ProjectScholl www.ProjectScholl.com

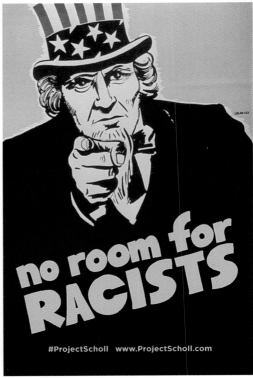

no room for RACISTS

#ProjectScholl www.ProjectScholl.com

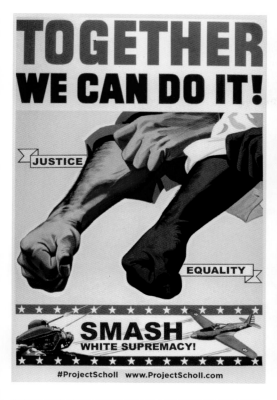

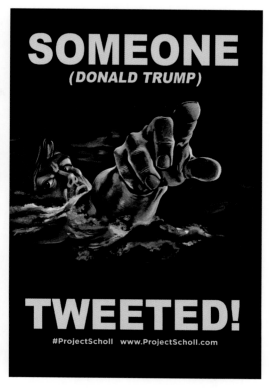

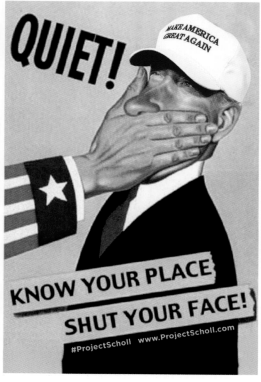

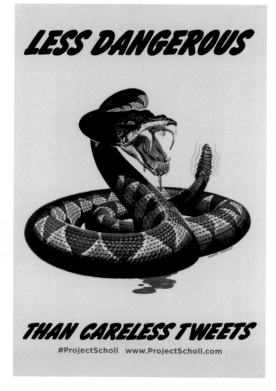

2017
MARK SELIGER, photo
BONNIE SIEGLER, art
direction

Since the fall of 2016,
Alec Baldwin's portrayal
of the president on
Saturday Night Live has
enraged Trump and
delighted America.
Taking it one step further,
Baldwin cowrote a
satirical memoir in the
voice of Trump (called *You
Can't Spell America Without
Me*) and it included this
portrait of the book's hero
in "Generalissimo"
costume, looking like a
Third World dictator.
Chapters in the book,
which was coauthored by
Kurt Andersen, include
"It Finally Felt Real, Like
a Movie," "Ivanka Has
Such a Gorgeous Smile,"
and "The Presidency
Really Is Like a TV Series."

(OPPOSITE)
2016
ROBBIE CONAL

They are the perfect
words to encapsulate how
70 percent of America
feels: can't even. The
quote from Trump's
presidential campaign
kickoff shocks to this day,
matching the exaggerated
ugliness sketched into
Conal's drawing.

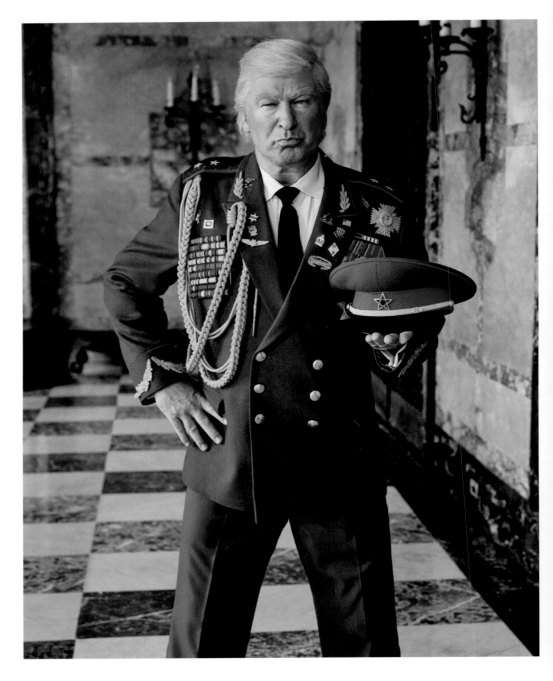

CAN'T EVEN

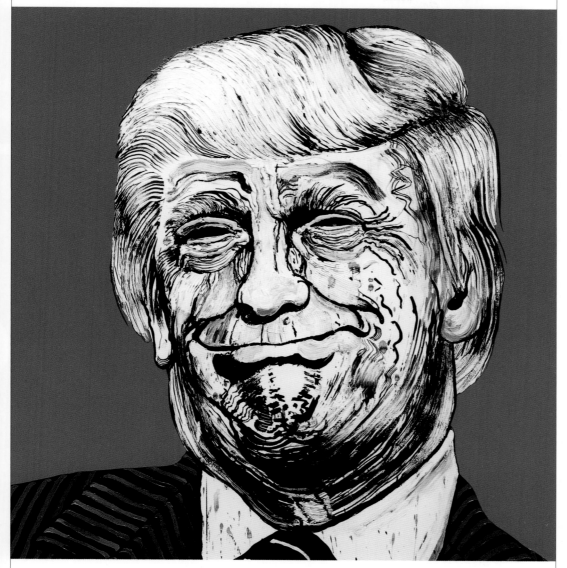

"When Mexico sends its people, they're not sending their best...
They're bringing drugs. They're bringing crime. They're rapists.
And some, I assume, are good people."
-Donald J. Trump, June 16, 2015.

AME

"It's all

2017
JESSICA HISCHE

RICA® *Fucked!"*

The Resistance
Don't Give Up Now

We must learn that passively
to accept an unjust system is
to cooperate with that system,
and thereby to become
a participant in its evil.

MARTIN LUTHER KING JR.

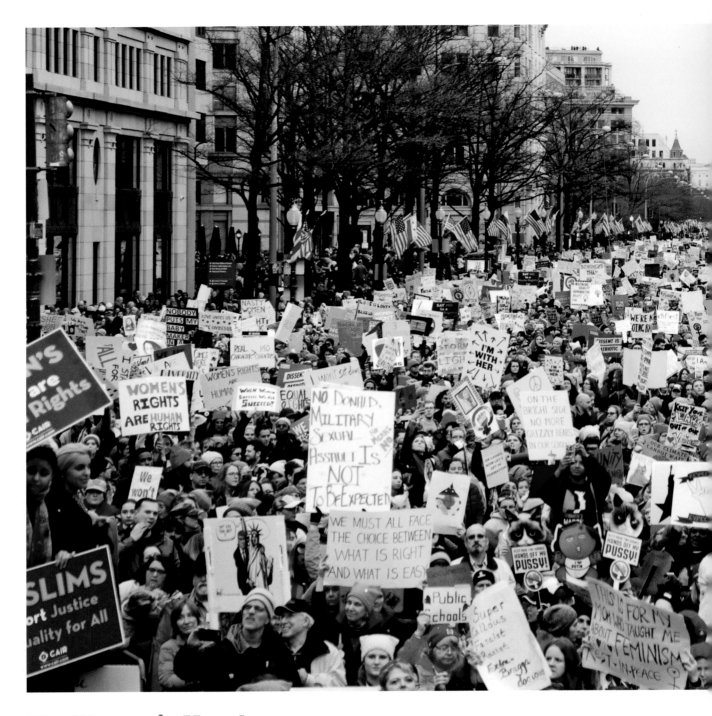

The Women's March
Washington, DC, January 21, 2017

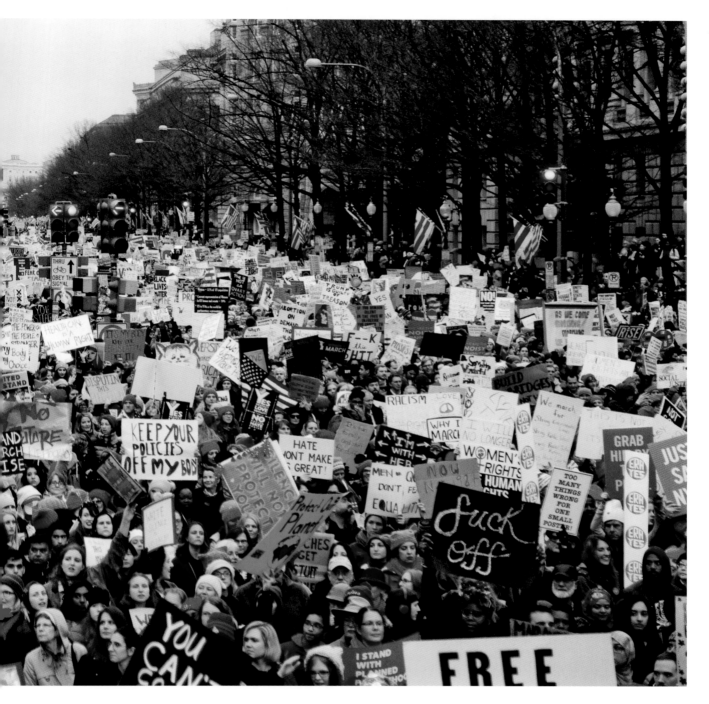

VLAD TCHOMPALOV

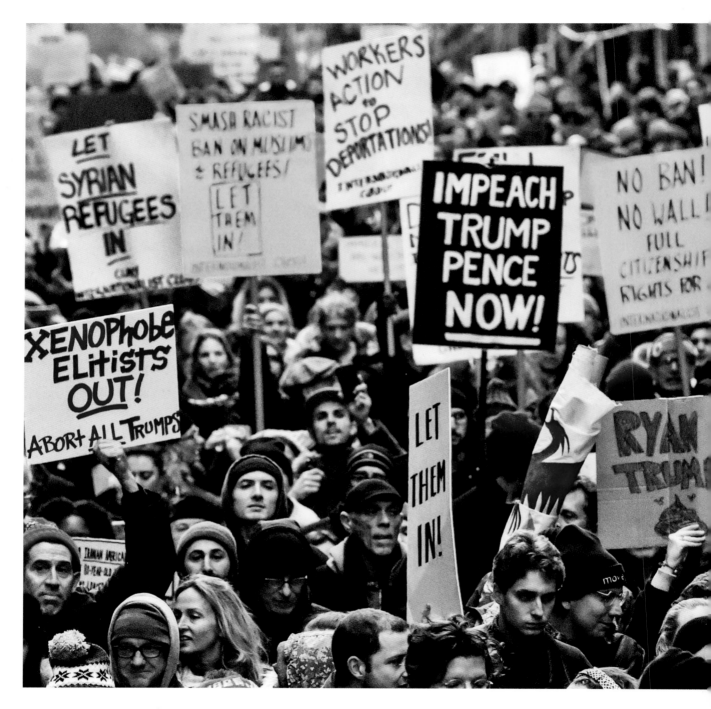

Protest Against Trump's Travel Ban
New York, NY, January 29, 2017

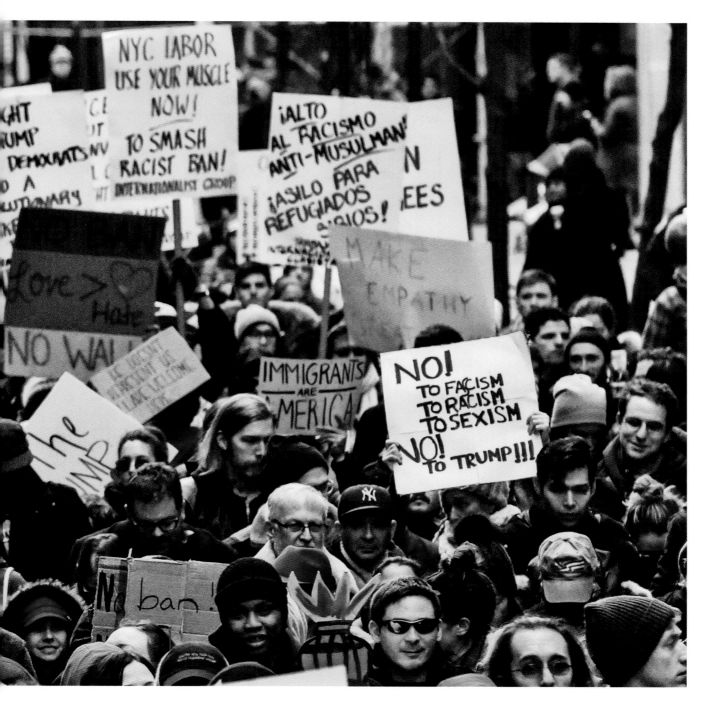

STEPHANIE KEITH

215

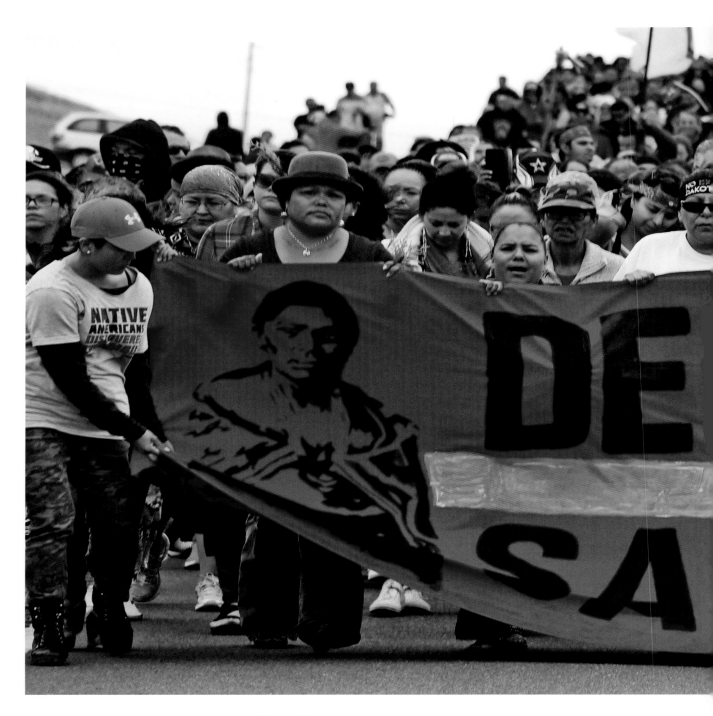

**The Dakota Access Pipeline Protest
Near Cannon Ball, ND, September 4, 2016**

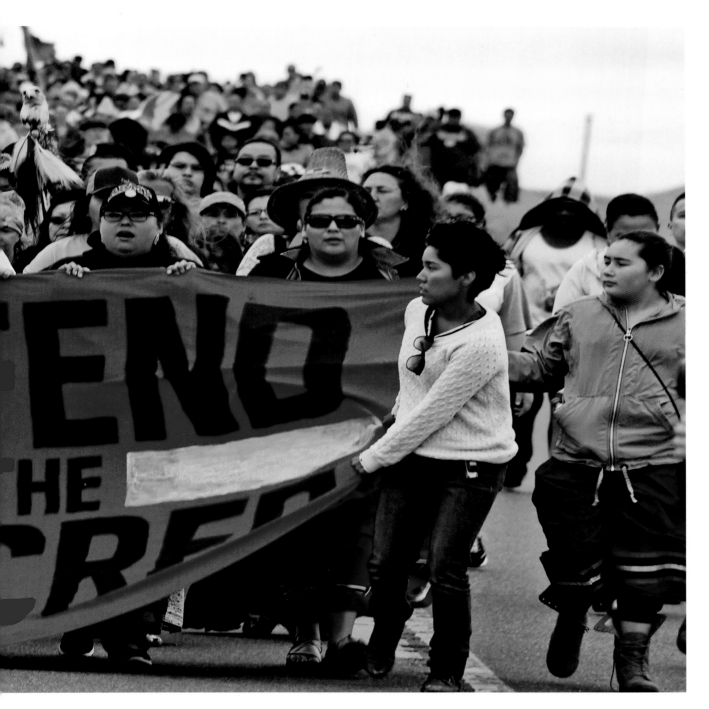

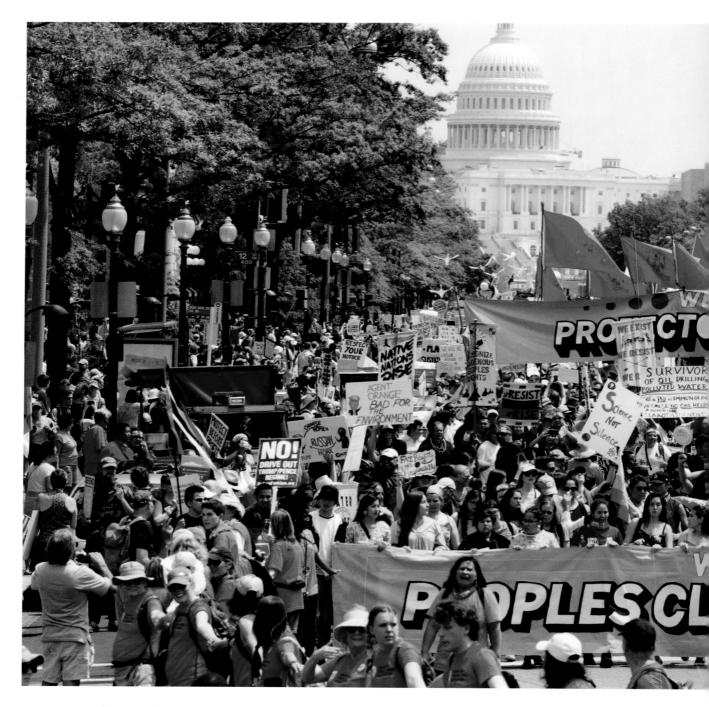

People's Climate March
Washington, DC, April 29, 2017

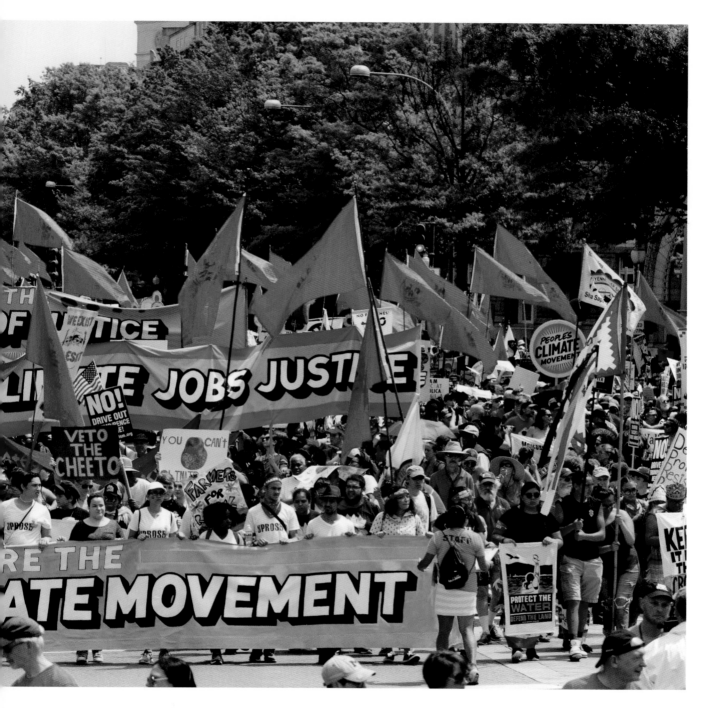

JOSE LUIS MAGANA

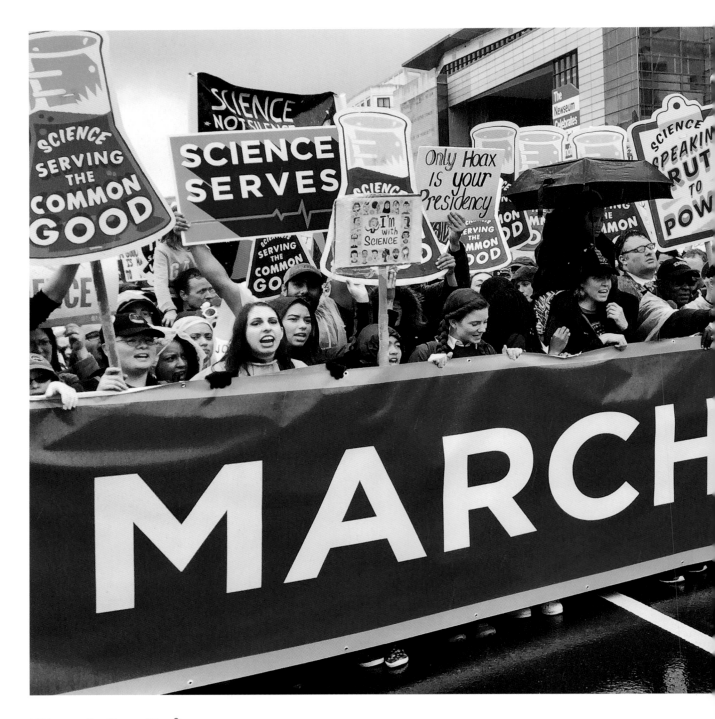

March for Science
Washington, DC, April 22, 2017

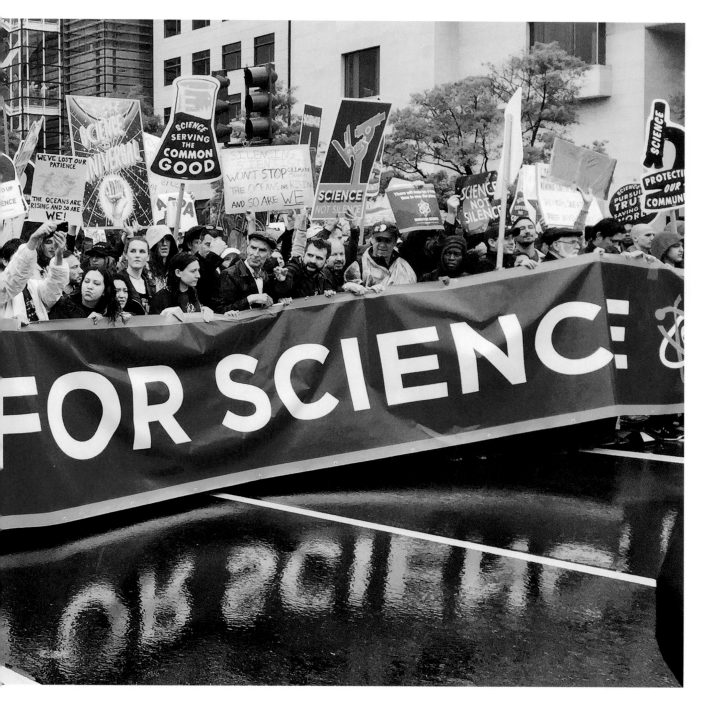

PAUL AND CATHY BECKER

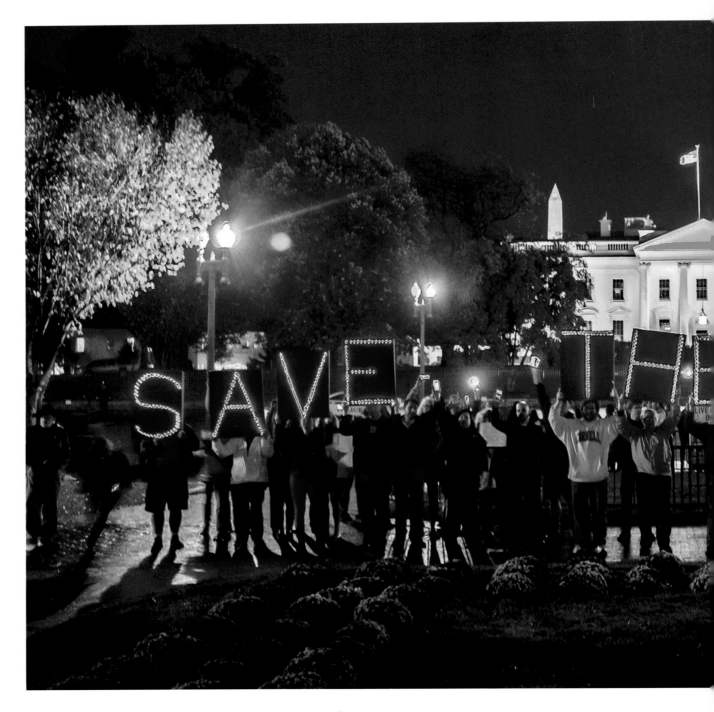

Protest to Save Net Neutrality
Washington, DC, November 2014

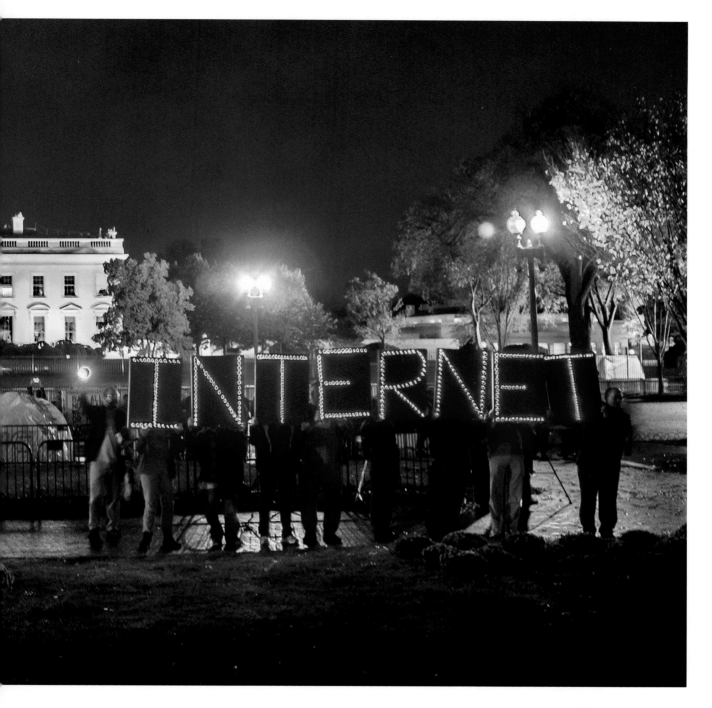

JOSEPH GRUBER

Credits

Every effort has been made to contact all copyright holders for images reproduced in this book. We regret any omissions. Images not credited are from the author's personal collection.

Contents
p. vi, Courtesy of the New York Public Library.

Introduction
p. viii, Permission of Robbie Conal.

CHAPTER 1: The Early Years
p. 2 (TOP), Collection of the Massachusetts Historical Society; p. 2 (BOTTOM LEFT), Photo from Fotosearch/ Getty Images; p. 2 (BOTTOM RIGHT), Courtesy of the New York Public Library; p. 3, Courtesy of the Library of Congress, Prints and Photographs Division; p. 4, Courtesy of the National Archives and Records Administration; p. 5, Courtesy of the Library of Congress, Prints and Photographs Division; p. 6, Courtesy of the Library of Congress, Prints and Photographs Division; p. 7, Permission and image from The Connecticut Historical Society; p. 8, Courtesy of the New York Public Library; p. 9, Courtesy of the National Archives and Records Administration.

CHAPTER 2: Immigrants
p. 12, Courtesy of the Library of Congress, Prints and Photographs Division; p. 13, Image from CRWFlags.com; p. 14–15, Courtesy of the Library of Congress, Prints and Photographs Division; p. 16, Photo Courtesy of The Newberry Library, Chicago. Call #: "A5.7634, 1889"; p. 17, Permission and image from The Ohio State University Billy Ireland Cartoon Library & Museum; p. 18, Image PDP03732 courtesy of the Royal BC Museum and Archives; p. 19, Courtesy of the Library of Congress, Prints and Photographs Division; p. 20–21, Courtesy of the Library of Congress, Prints and Photographs Division.

CHAPTER 3: Suffrage
p. 24–25, Courtesy of the Library of Congress, Manuscript Division; p. 26 (TOP), Lincoln Said Women Should Vote, Seattle, Washington, 1910 (Courtesy of The Gilder Lehrman Institute of American History, GLC09103); p. 26 (BOTTOM), Permission and image from Coline Jenkins / The Elizabeth Cody Stanton Trust; p. 27 (TOP), Courtesy of the Library of Congress, Manuscript Division; p. 27 (BOTTOM), Photo by David J. & Janice L. Frent / Corbis via Getty Images; p. 28, Courtesy of the Library of Congress, Manuscript Division; p. 29, Permission and image from VCU Libraries; p. 30, Courtesy of the Library of Congress, Prints and Photographs Division; p. 31, Permission and image from the Collection of Ann Lewis and Mike Sponder; p. 32,

Permission and image from VCU Libraries; p. 33, Permission and image from the Missouri History Museum, St. Louis.

CHAPTER 4: American Icons
p. 36–37, Courtesy of the Library of Congress, Prints and Photographs Division; p. 38–39, Courtesy of the Library of Congress, Prints and Photographs Division; p. 40, Design by Sago Design, Amsterdam, Netherlands, www.Redbubble.com/people/sago-design; p. 41, © The Economist Newspaper Limited, London, February 27, 2016; p. 42, Permission of Woke Giant; p. 43, © 2017 Douglas Christian. All rights reserved. photographystudio.com; p. 44, Courtesy of the Smithsonian Libraries, Washington, D.C.; p. 45, Printed by permission of the Norman Rockwell Family Agency Copyright © 1943 the Norman Rockwell Family Entities. Image courtesy of Curtis Licensing; p. 46, Courtesy of the National Archives and Records Administration; p. 47, Photo from Bettmann / Getty Images; p, 48, Abigail Gray Swartz / The New Yorker © Conde Nast; p. 49, Permission of Kiara Nelson; p. 50, © Micah Wright. From The Propaganda Remix Project; p. 51, Permission and painting by Robert Valadez; p. 52, Photo by Carolyn Master / Associated Press; p. 53, Image by American Renaissance.

CHAPTER 5: Civil Rights
p. 56 (LEFT), Division of Home and Community Life, National Museum of American History, Smithsonian Institutions; p. 56 (RIGHT), Permission and image from C. Warren Irvin Collection of Darwin and Darwiniana, University of South Carolina Libraries, Columbia, S.C.; p. 57, Courtesy of the Boston Public Library, Rare Books Department; p. 58, Courtesy of the Yale Collection of American Literature, Beinecke Rare Book and Manuscript Library; p. 59, Courtesy of the Library of Congress, Prints and Photographs Division, Visual Materials from the NAACP Records; p. 60 (TOP), Courtesy of the Library of Congress, Prints and Photographs Division, Visual Materials from the NAACP Records; p. 60 (BOTTOM), AP Photo / Chicago Sun-Times, File; p. 61 (TOP), Photo by Franklin McMahon / Chicago History Museum / Getty Images; p. 61 (BOTTOM), Courtesy of the Library of Congress, Prints and Photographs Division, Visual Materials from the NAACP Records; p. 62, Courtesy of the Collection of Civil Rights Archive / CADVC-UMBC; p. 63, Photo © Bob Adelman; p. 64–65, Photo © Dr. Ernest C. Withers, Sr. courtesy of the WITHERS FAMILY TRUST; p. 66, Photo © Dr. Ernest C. Withers, Sr. courtesy of the WITHERS FAMILY TRUST; p. 67, Allied Printing, Honor King, End Racism, Memphis, Tennessee, April 8, 1968 (Courtesy of The Gilder Lehrman Institute of American History, GLC06125); p. 68, Photo by Otis Noel Pruitt. Poster by the Student Non-Violent Coordinating Committee (SNCC). [Mississippi: The lynching of Bert Moore and Dooley Morton], ca. 1965. Courtesy International Center of Photography, Museum Purchase, 2000 (991.2000); p. 69,

Permission and image from Danny Lyon / Magnum Photos; p. 70 (LEFT), Button for the Student Non-Violent Coordinating Committee (SNCC); p. 70 (RIGHT), Permission and image from Danny Lyon / Magnum Photos; p. 71, Courtesy of the Library of Congress, Prints and Photographs Division; p. 72–73, Permission and image from Danny Lyon / Magnum Photos; p. 74, © 2017 Faith Ringgold, member Artists Rights Society (ARS), New York; p. 75, Courtesy of The Merrill C. Berman Collection; p. 76–77, © 2017 Emory Douglas / Artists Rights Society (ARS), New York.

CHAPTER 6: Vietnam
p. 80, Unknown photographer; p. 81, Permission of Robert Altman; p. 82, © Jim Marshall Photography LLC; p. 83, Courtesy of the Library of Congress, Prints and Photographs Division; p. 84, © Students for a Democratic Society / © Victoria and Albert Museum, London; p. 85, Robert L. Ross, The Print Mint Berkeley, publisher, Eat Me, 1967. Offset lithograph: sheet, 41¾ x 29¾ in. (106 x 75.6 cm); image, 39³⁄₁₆ x 27¼ in. (99.5 x 69.2 cm). Whitney Museum of American Art, New York; purchase with funds from The American Contemporary Art Foundation, Inc., Leonard A. Lauder, President 2017.10.67; p. 86, Kiyoshi Kuroyima (1943–2000), The Dirty Linen Corp., publisher, Fuck the Draft, 1968. Offset lithograph, 29¾ x 20¼ in. (75.6 x 51.4 cm). Whitney Museum of American Art, New York; purchase with funds from The American Contemporary Art Foundation, Inc., Leonard A. Lauder, President 2017.10.210; p. 87, Kiyoshi Kuroyima, The Dirty Linen Corp., for The Berkeley Barb. Image from DangerousMinds.net; p. 88, Sunflower design and words by Lorraine Art Schneider, ® © 1968, 2003, Another Mother for Peace, Inc.; p. 89, Cooper Hewitt, Smithsonian Design Museum / Art Resource, NY; p. 90–91, All courtesy of the Thomas W. Benson Political Protest Collection, Penn State University Libraries; p. 92 (TOP), Courtesy of Shapero Modern, London, U.K.; (BOTTOM LEFT), Courtesy of Shapero Modern, London, U.K.; (BOTTOM MIDDLE), Courtesy of the Thomas W. Benson Political Protest Collection, Penn State University Libraries; (BOTTOM RIGHT), Courtesy of The Connelly Library, LaSalle University, Philadelphia, PA; p. 93, Courtesy of the Thomas W. Benson Political Protest Collection, Penn State University Libraries; p. 94 (LEFT), Photo by Popperfoto / Getty Images; p. 94 (RIGHT), You Can't Jail the Revolution, Artist Unknown, Silkscreen, 1968, Courtesy Center for the Study of Political Graphics; p. 95, Napalm Graphics, publisher, Johnson Pull Out Like Your Father Should Have, 1987. Offset lithograph, 19½ x 14½ in. (49.5 x 36.8 cm). Whitney Museum of American Art, New York; purchase with funds from The American Contemporary Art Foundation, Inc., Leonard A. Lauder, President 2017.10.57; p. 96, Permission of Seymour Chwast; p. 97, Illustration reprinted with permission of the Corita Art Center, Immaculate

Community, Los Angeles; p. 98–99, Courtesy of the Herb Lubalin Study Center, The Cooper Union; p. 100, Courtesy of the Herb Lubalin Study Center, The Cooper Union; p. 101, Permission of Seymour Chwast; p. 102, Courtesy of the Herb Lubalin Study Center, The Cooper Union; p. 103, from Tomi Ungerer Poster. Copyright © 1994 Diogenes Verlag AG Zurich, Switzerland. All rights reserved.; p. 104–105, Digital Image © The Museum of Modern Art/Licensed by SCALA / Art Resource, NY; p. 106, Clergy and Laymen Concerned, publisher, Is This What You'd Call "Phased Withdrawal?", 1972. Offset lithograph: sheet, 22 x 17 in. (55.9 x 43.2 cm); image, 14⅛ x 17 in. (35.9 x 43.2 cm). Whitney Museum of American Art, New York; purchase with funds from The American Contemporary Art Foundation, Inc., Leonard A. Lauder, President 2017.10.189; p. 107, © 2017 Estate of William N. Copley / Copley LLC / Artists Rights Society (ARS), New York; p. 108–109, Permission of George Lois; p. 110 (TOP), Photo by Frank Barratt / Keystone / Hulton Archive / Getty Images; p. 110 (BOTTOM), Photo by Three Lions / Getty Images; p. 111, Image from MotherJones.com; p. 112, Courtesy of the Library of Congress, Prints and Photographs Division; p. 113, Permission of Simboli Design, 1968, www.simbolidesign.com; p. 114, Courtesy of the Oakland Museum of CA; p. 115, Courtesy of the Thomas W. Benson Political Protest Collection, Penn State University Libraries; p. 116, Courtesy of the Thomas W. Benson Political Protest Collection, Penn State University Libraries; p. 117, Permission of Primo Angeli and Lars Speyer.

CHAPTER 7: Women's Equality
p. 120–121, Photo © Bob Adelman; p. 122–123, Copyright Chicago Women's Graphics Collective, contact CWLU Herstory Project, www.clwuherstory.org; p. 124, So Long as Women Are Not Free (1978), screen-printed poster by See Red Women's Workshop (1974–1990), London, UK. https://seeredwomensworkshop.wordpress.com; p. 125, © Boston Women's Health Book Collective; p. 126–127, Copyright © Guerrilla Girls and courtesy of guerrillagirls.com; p. 128, BARBARA KRUGER, "Untitled" (Your body is a battleground), 112" by 112" (284.5 cm by 284.5 cm), photographic silkscreen/vinyl, 1989. COPYRIGHT: BARBARA KRUGER. COURTESY: MARY BOONE GALLERY, NEW YORK. (MBG#5028); p. 129, Permission of Bethany Johns.

CHAPTER 8: AIDS
p. 132, Poster by ACT UP New York; p. 133, Courtesy of the artist and Marianne Boesky Gallery, New York and Aspen. © Donald Moffett; p. 134–135, Keith Haring artwork © Keith Haring Foundation; p. 136, Poster by ACT UP New York; p. 137, Courtesy of the U.S. National Library of Medicine; p. 138, Poster by Avram Finkelstein and Vincent Gagliostro for ACT UP New York; p. 139, Poster by Gran Fury/ACT UP New York; p. 140,

Permission of Trillium Health, Legacy AIDS Rochester, Inc.; p. 141, Permission of Art Chantry; p. 142–143, Photos courtesy of The NAMES Project.

CHAPTER 9: The Bushes

p. 146–147, Permission of John Yates / stealworks.com; p. 148, Permission of Marty Neumeier, designer ant author of Metaskills; p. 149 (TOP), Permission of John Emerson; p. 149 (BOTTOM), Permission of Jeff Jackson; p. 150, Permission of Nenad Cizl; p. 151, Courtesy of www.worstpresident.org and Thrive Mediarts; p. 152, Design by Copper Greene; p. 153, Image from portside.org.

CHAPTER 10: Black Lives Matter

p. 156, Permission of Darla Jones; p. 157, "Black Lives Matter," Permission of André Carrilho; p. 158–159, Photo by Robert Cohen / St. Louis Post-Dispatch; p. 160, Photo by David McNew / Getty Images; p. 161, Photo by Patrick Record / The Ann Arbor News; p. 162, Photos by Jonathan Bachman / REUTERS; p. 163, Photos by Marc Riboud / Magnum Photos.

CHAPTER 11: Trump

p. 166, Image by Shepard Fairey; p. 167 (TOP), Permission and artwork by Gareth Anderson (Perth, Australia); (BOTTOM LEFT), Permission of Kristen Ren; (BOTTOM RIGHT), Permission of Gladys Glover; p. 168 (TOP), Permission of Mike Wellins / FreakyButTrue.com; p. 168, (BOTTOM), Permission of Matthew Gordon; p. 170, Permission of Barry Blitt; p. 172, Permission of Mike Matthews; p. 173, Permission of Minter Studio; p. 174, Courtesy of White House Gift Shop; p. 175 (TOP LEFT), Neal Wagner, Drump.Wtf; (TOP MIDDLE), B. Dolan, "Make Racists Afraid Again," hat and #makeracistsafraidagain; (TOP RIGHT), Robert Leigh, MissDeplorable.com; (MIDDLE LEFT), Jim Coyne, CEO of Resistance Designs, www.JoinTheResistance.store; (MIDDLE), SeeMeComing.com; (MIDDLE RIGHT), Jim Coyne, CEO of Resistance Designs, www.JoinTheResistance.store; (BOTTOM LEFT), © Lee Bearson; (BOTTOM MIDDLE), Michael Conti / DefineAmerican.com; (BOTTOM RIGHT), "The MAKE AMERICA GAY AGAIN™ hat was reprinted with permission from the Human Rights Campaign. The MAKE A MERICA GAY AGAIN mark and design and the Human Rights Campaign famous logo are registered trademarks of the Human Rights Campaign. All rights reserved."; p. 176–177, Photo by Brian Allen, Voice of America; p. 179 (TOP), Photo by Barbara Alper / Getty Images; p. 179 (BOTTOM), Permission of Julizbeth Photography; p. 180, Permission of Cate Matthews / A Plus; p. 184, Permission of Badass Cross Stitch / Shannon Downey; p. 185, Permission of Craig S. O'Connell; p. 186, Permission of Lennart Gäbel; p. 187, Permission of Victor Juhasz, www.juhaszillustration.com; p. 189, Permission of Jenny Sowry; p. 190, Permission of

Illma Gore; p. 191, Permission of Indecline; p. 192, 5-15-17, Pay Trump Bribes Here Projections on Trump Hotel in Washington, D.C. by Robin Bell. Photo by Liz Gorman / bellvisuals.com; p. 193, Permission of New World Design Ltd.; p. 194, Permission of James Victore; p. 195, Permission of Edel Rodriguez; p. 196–197, Permission of Edel Rodriguez; p. 198 (LEFT), David Plunkert / The New Yorker © Conde Nast; p.198 (RIGHT), © The Economist Newspaper Limited, London, August 19–25, 2017; p. 199, Permission of Carolyn Sewell, carolynsewell.com; p. 200, NO © Gary Taxali, 2017–All Rights Reserved. www.garytaxali.com; p. 201 (LEFT), Copyright © 2017 by Bob Staake–All Rights Reserved; p. 201 (RIGHT) © 2017 Brian Stauffer. www.brianstauffer.com; p. 202 (BOTTOM), Permission of Felix Sockwell; p. 203, Permission of Steve Brodner; p. 204–205, Permission of Artist, Robert Russell, and Creator, Arianna Jones, Project Scholl; p. 206, Permission of Alec Baldwin; p. 207, Permission of Robbie Conal; p. 208–209, Permission of Jessica Hische.

CHAPTER 12: The Resistance

p. 212–213, Photo by Vlad Tchompalov on Unsplash; p. 214–215, Photo by Stephanie Keith / REUTERS; p. 216–217, Photo by Robyn Beck / AFP / Getty Images; p. 218–219, Photo by Jose Luis Magana / AFP / Getty Images; p. 220–221, Permission of Paul and Cathy Becker; p. 222–223, Permission of Joseph Gruber.

p. 227, Permission of Adam Lucas; p. 230, Courtesy of the Library of Congress. Originally created by the General Cable Corporation.

2015
ADAM LUCAS

Acknowledgments

I am indebted to all the incredibly talented designers, artists, photographers, and protesters who generously shared their work, passion, and dedication with us and continue to inspire.

A huge thanks to all the museums, galleries, estates, and assistants who worked so hard to locate and deliver the best version of the work possible. I am forever grateful for your efforts and enthusiasm.

To the artists whose amazing work and causes couldn't fit into this book, I apologize and look forward to including them in the next one.

This book was possible only because of the dedication of Artisan Books and publisher Lia Ronnen, whose support, guidance, and wisdom were invaluable.

Thank you, Lisa DiMona, for all that you do.

I am eternally grateful to Jenny Rosenstrach, who lent her talent and skills to help me sound smarter than I am.

Thank you, Steve Heller, for your guidance and for always answering my emails.

Thank you, Lucy Andersen, for your incredible research skills, intelligence, and mastery of the spreadsheet. Thank you, Kristen Ren, for helping with absolutely everything. Thank you, Steve Walkowiak, for making every single image look its best.

Thank you, Adobe, for being the catalyst for this project and allowing me to share some of this work (and decidedly partisan views) at Adobe Max.

Thank you to my fellow freedom fighters—Judy Goldberg, Carley Roney, Penny Shane, Anne Kreamer, Zach Allen, Stacy Kramer, and Wesley Weisberg—for your dedication and for helping me stay sane over the last year.

This entire book uses the wonderful typeface FF Real Super Family, designed by Erik Spiekermann and Ralph du Carrois.

Hugs, kisses, and thanks to my husband, Jeff Scher, for inspiring me every day and for your impeccable visual memory (and sleuthing skills). Hugs, kisses, and jelly beans to Oscar Scher and Buster Scher, for understanding why I was working late every single night.

About the Author

Bonnie Siegler is a proud member of the Resistance. In her spare time, she is a graphic designer and founder of the award-winning studio Eight and a Half (8point5.com), which works in branding, web design, editorial design, and motion graphics for a wide variety of clients including HBO, *Saturday Night Live*, the Brooklyn Public Library, the Climate Museum, *Late Night with Seth Meyers*, *Newsweek*, and the Frank Lloyd Wright Foundation. Most recently, she was the creative director of the Trump parody memoir *You Can't Spell America Without Me* by Alec Baldwin and Kurt Andersen and created the main title sequence for *Will & Grace*. She was voted one of the fifty most influential designers working today by Graphic Design USA. She taught at the graduate level for many years at the School of Visual Arts and Yale University, has conducted workshops at the Maryland Institute College of Art and Rhode Island School of Design, and lectures and judges design competitions all over the place. She is also the author of *Dear Client*, a book written to help people get the best work from creative people.

Instagram: bonnie8point5
Twitter: @8point5b

(FOLLOWING PAGE)
1942

After Pearl Harbor, this patriotic poster (published by the General Cable Corporation) encouraged everyday Americans to get involved. It's every bit as relevant nearly eight decades later.

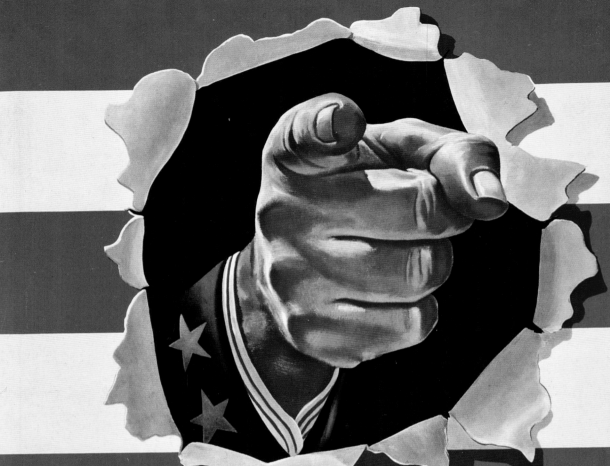

ARE **YOU**

DOING ALL YOU CAN ?